More Spectacular

Pools

More Spectacular

Pools

Photographs by Pere Planells

HDi

HARPER DESIGN international

An Imprint of HarperCollins*Publishers*

Publisher: Paco Asensio

Editorial Coordination: Cynthia Reschke and Haike Falkenberg

Photographs: Pere Planells

Text: Marina Ubach

Translation: Matthew Clarke

Art Director: Mireia Casanovas Soley

Layout: Mariana Felcman and Ignasi Gràcia

First published in 2003 by:
Harper Design International, an imprint of HarperCollins Publishers
10 East 53rd Street
New York, NY 10022

Distributed throughout the world by:
HarperCollins International
10 East 53rd Street
New York, NY 10022
Fax: (212) 207-7654

Editorial project:

2003 © LOFT Publications
Via Laietana 32, 4th Of. 92.
08003 Barcelona. Spain
Tel.: +34 932 688 088
Fax: +34 932 687 073
loft@loftpublications.com
www.loftpublications.com

Softcover ISBN: 0-06-055487-8
Hardcover ISBN: 0-06-053608-X

D.L.: B-07.872-03

Printed by:
Anman Gràfiques del Vallès, Spain

Architecture is not only an art form, it also reflects lifestyles. For centuries it has pioneered research into new interpretations of space and volume and discovered the best ways to live in comfort in a particular period.

Our era is marked by a desire to return to our origins and recover a connection with nature. Architects have responded to this by creating open spaces integrated into the landscape and by emphasizing the role of natural elements like water and light. In this quest, the swimming pool is an important—in fact, sometimes almost indispensable—factor, providing a basis for enjoying a relaxed, natural lifestyle that revels in the open air. Although this book presents some well-balanced conversions that retain the essential features of traditional swimming pools, it also includes examples that highlight

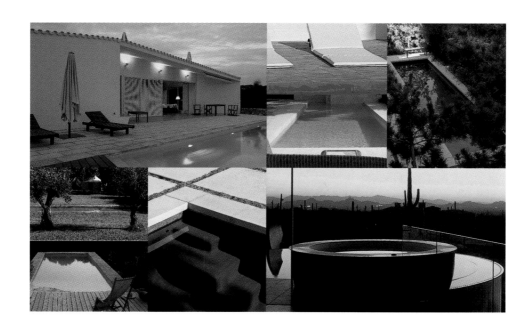
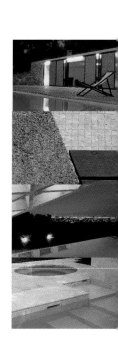

the attractions of the latest generation of pools, as well as illustrating the combinations of materials and colors that set off their creative shapes. Collected here are one-off designs, striking for their unusual forms, or unassuming strips of water that seek to blend into the overall concept of an architectural project. Pure, clean minimalist lines, or rustic settings rooted in the past; exclusive pools for private use or large, imposing facilities designed for communal use; what all these varied pools have in common is water bathed in light, creating an endless diversity of forms and contrasts that engage in a dialogue with nature. This book explores these original architectural creations, designed to establish a direct communication with each its surroundings.

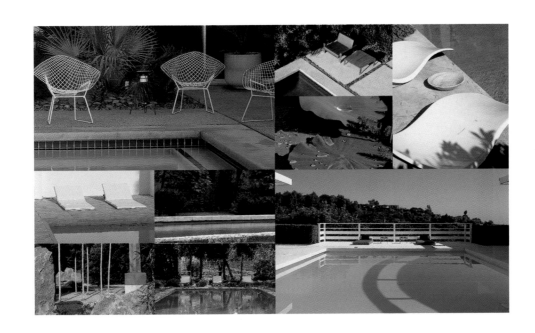

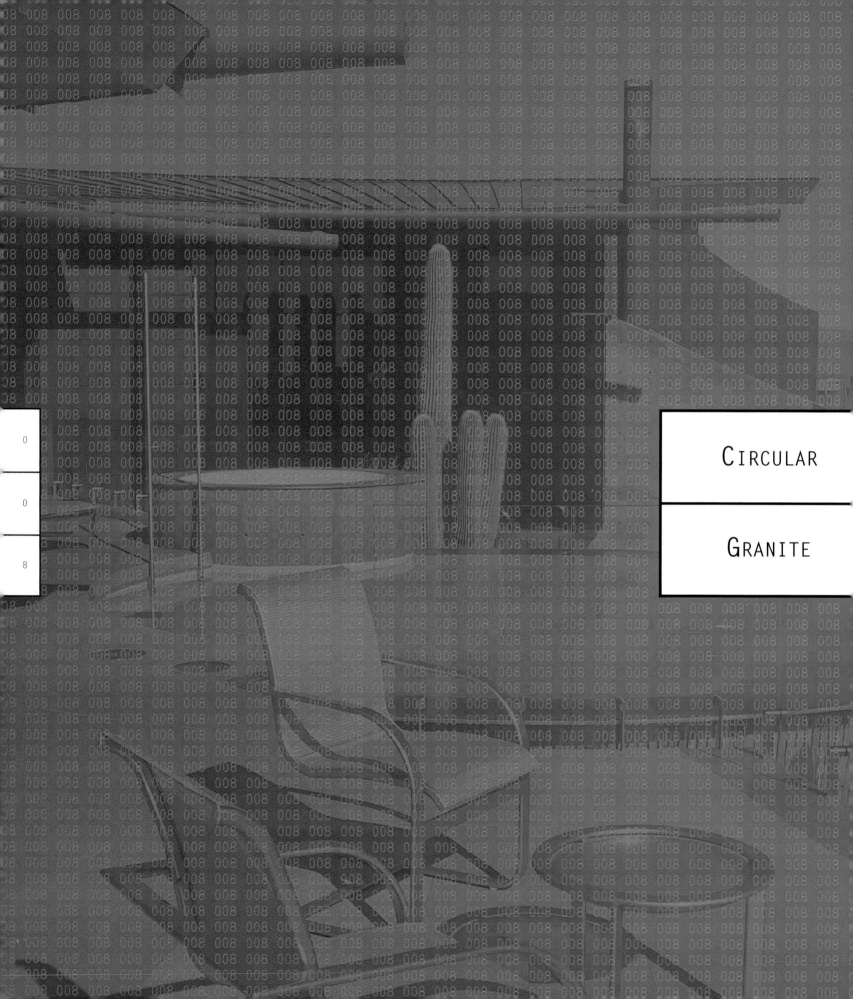

CIRCULAR

GRANITE

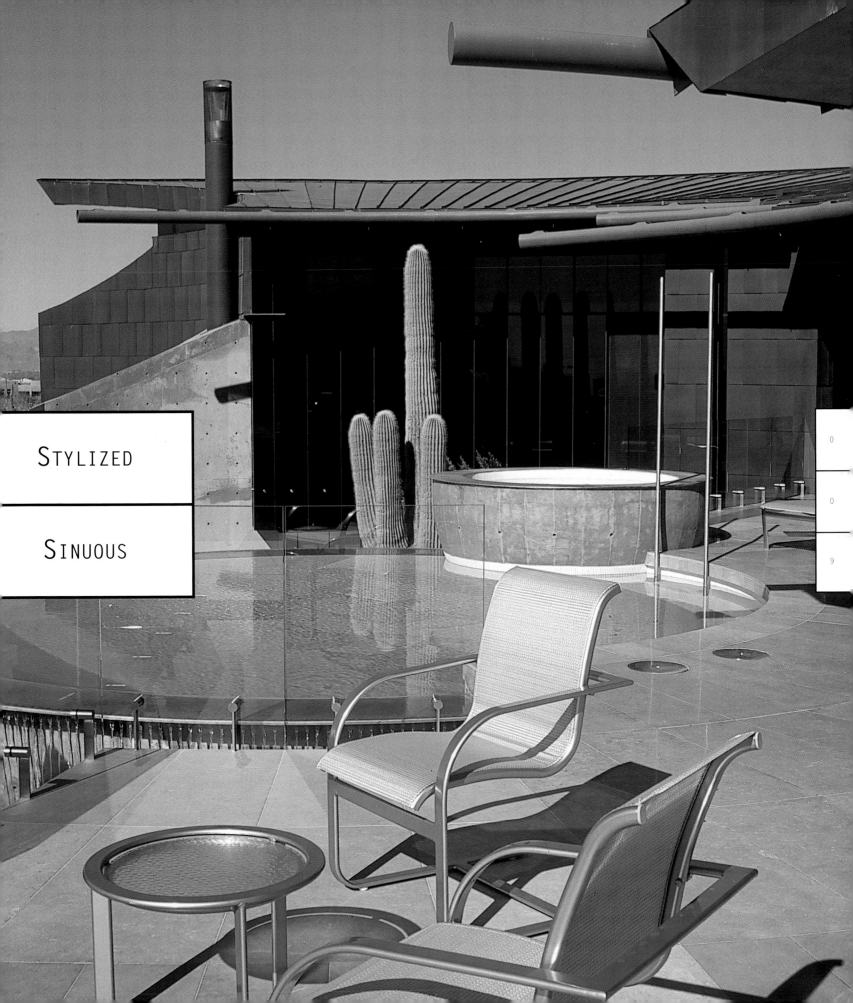

STYLIZED

SINUOUS

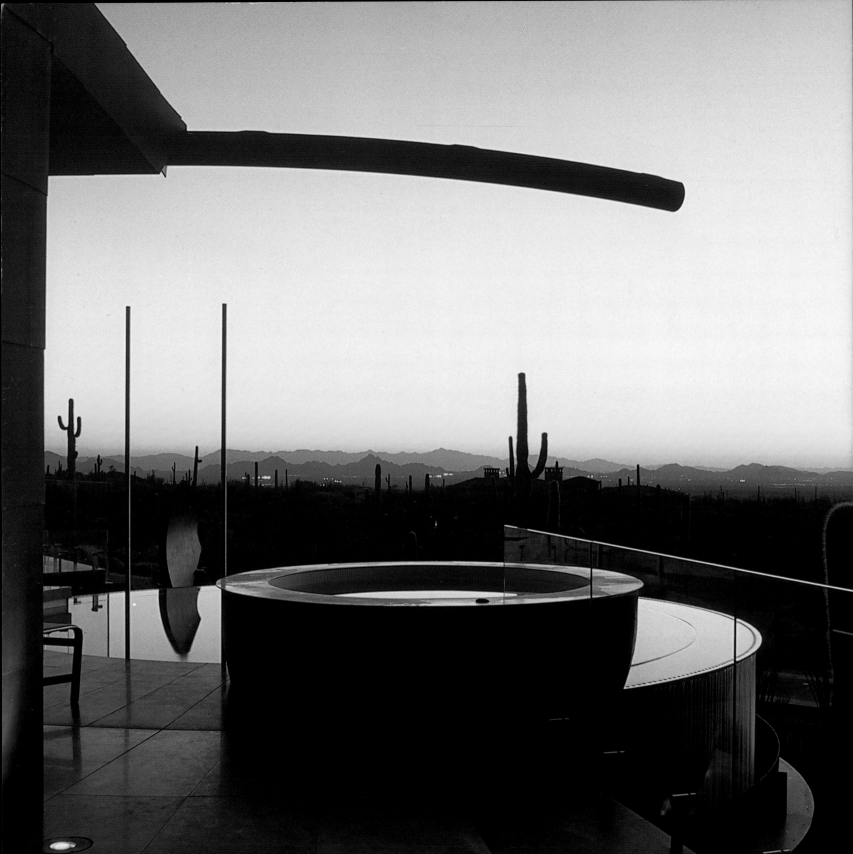

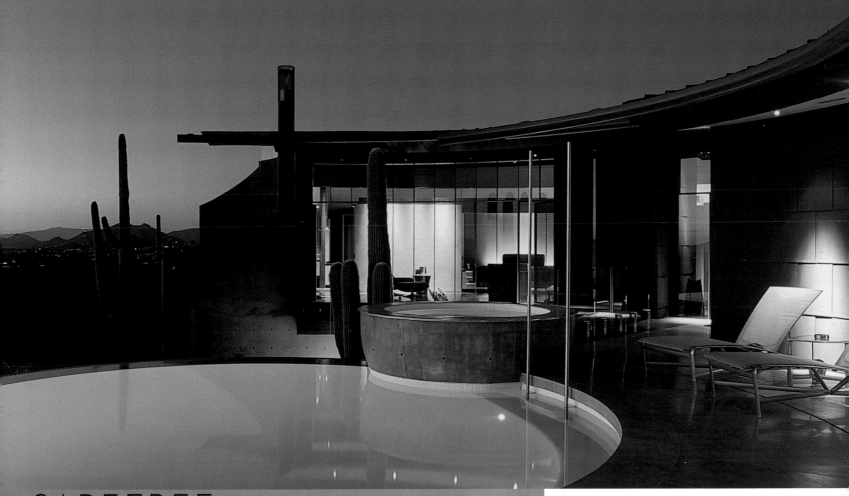

CAREFREE,
ARIZONA. USA

The cacti undoubtedly give away the location of this spectacular residential project, which incorporates a circular pool. The house is built on a slight slope, so it is divided into several levels to conform to the contours of the landscape. The bottom of the pool is made of concrete and rammed earth, while the interior sports white-stained concrete, complemented by the concrete slabs in the terrace area. The pool border is a stainless steel sheet with perforations that filter the water, performing an aesthetic function as well as a practical one. A high, sharply stylized staircase marks off the entrance to the pool; its steps echo the forms of the swimming pool and the distinctive rolling landscape. The sinuous circular forms of the pool are also extended to the sunbathing area, complete with chaise longues and views of the arid Arizonian landscape. The circular jacuzzi also complements the larger pool.

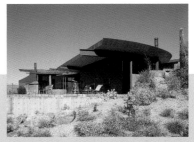

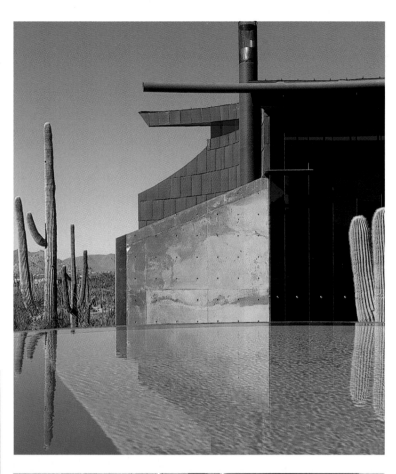
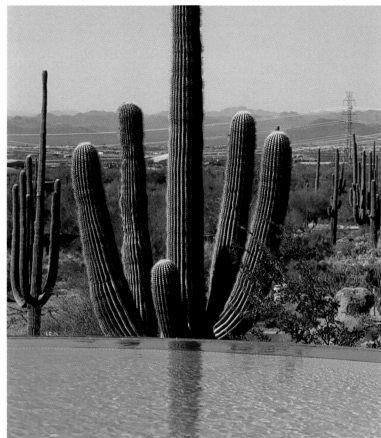

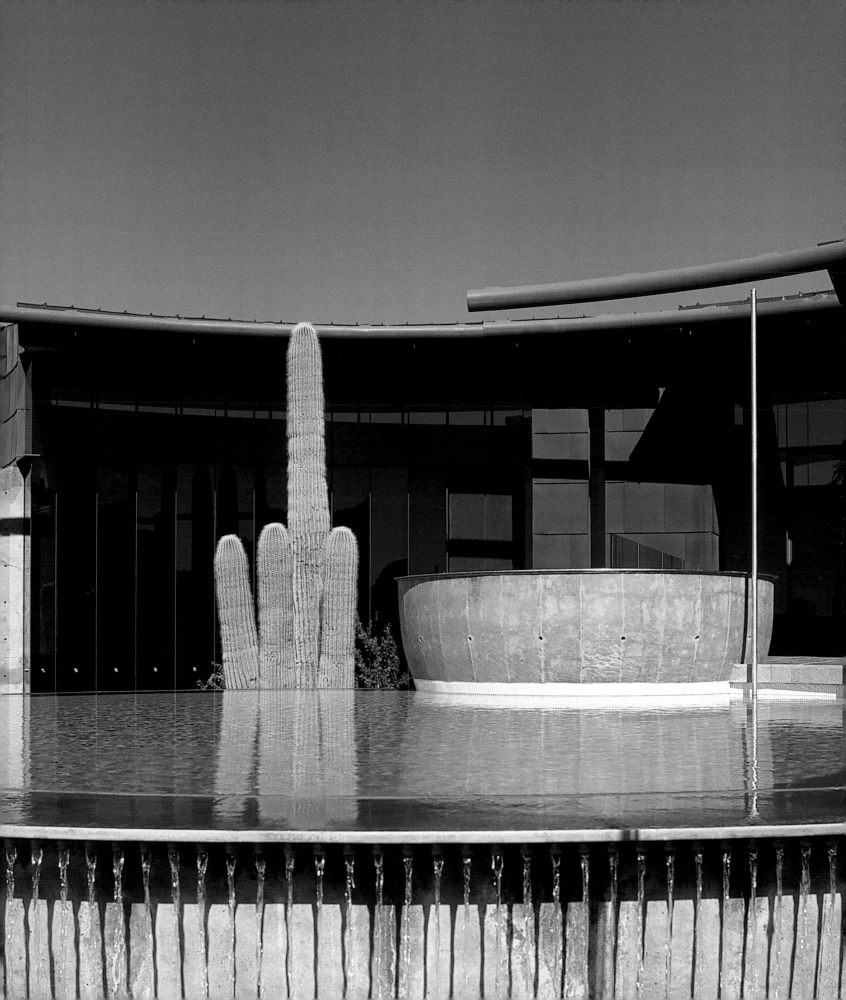

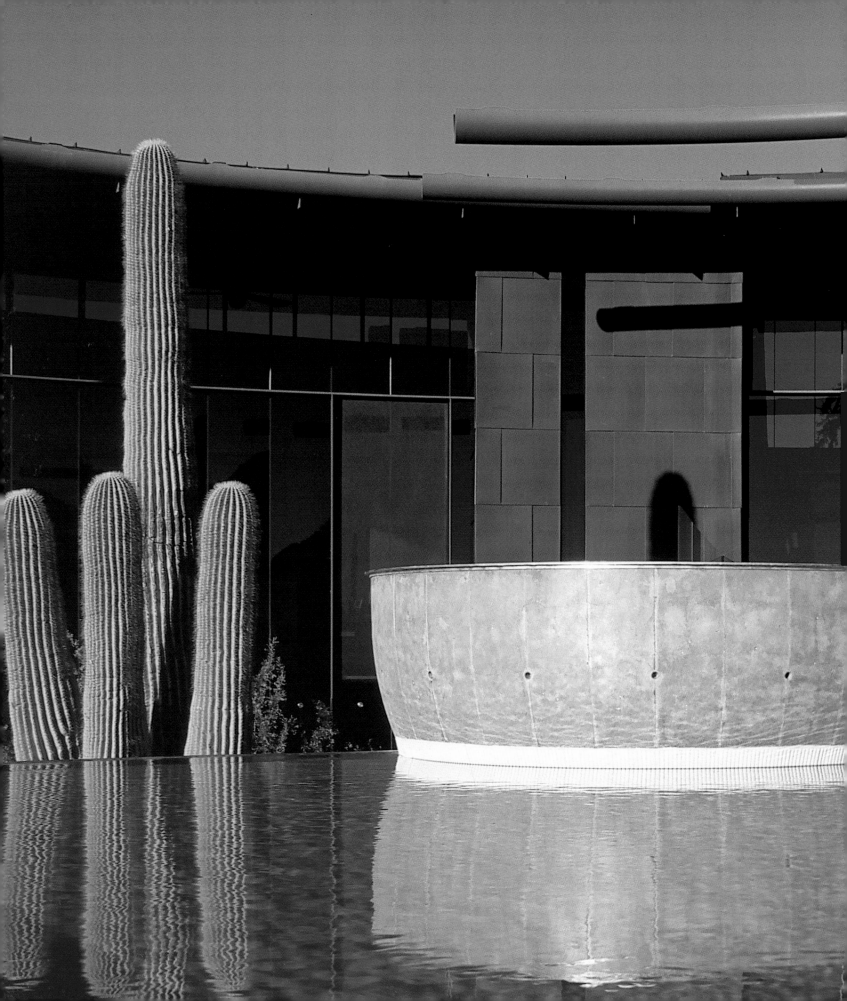

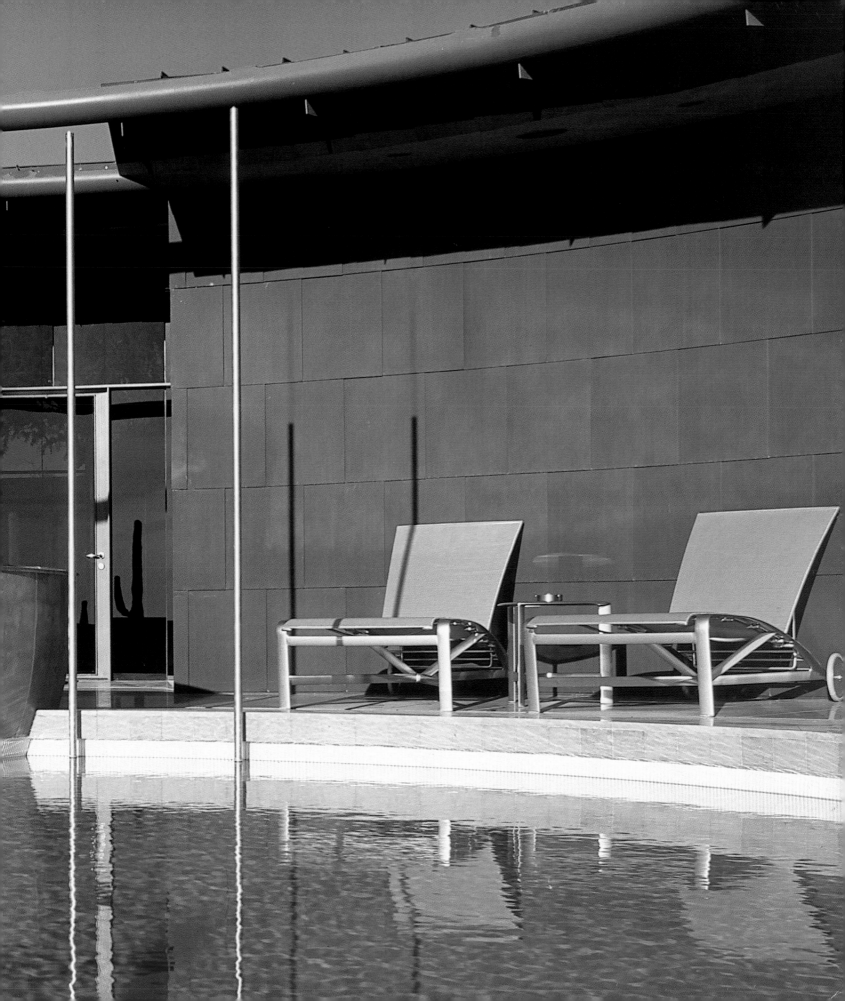

0

1

6

CLASSICAL

RESTORED

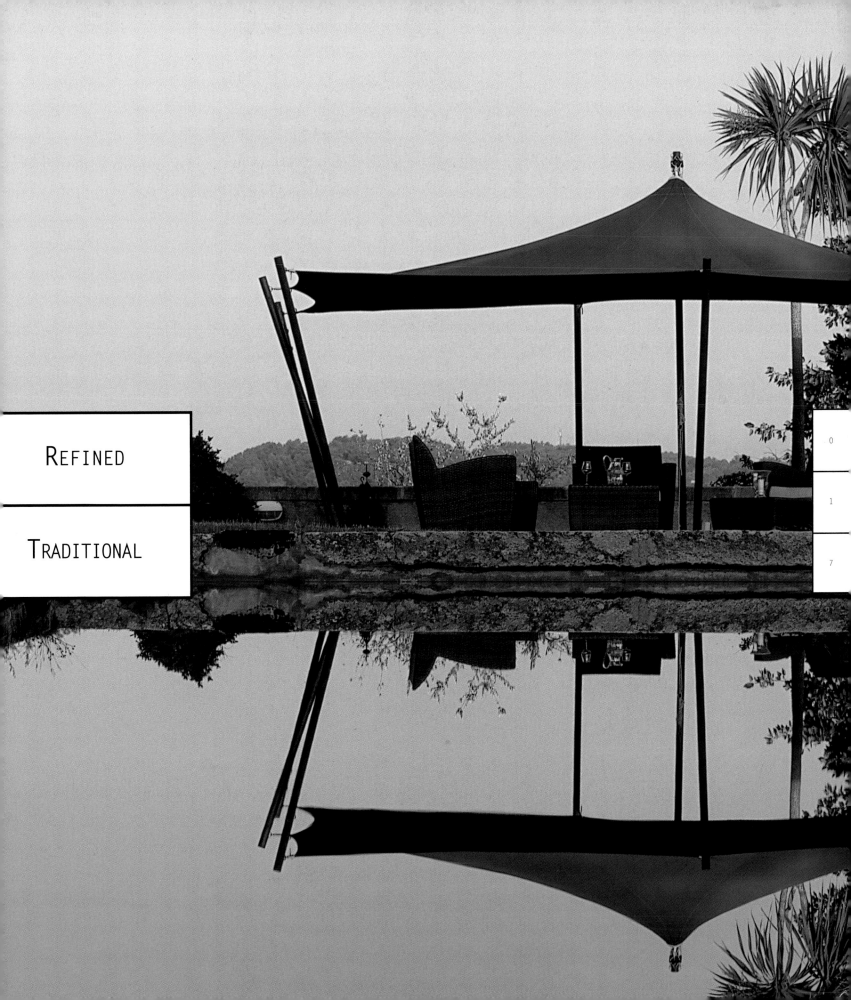

REFINED

TRADITIONAL

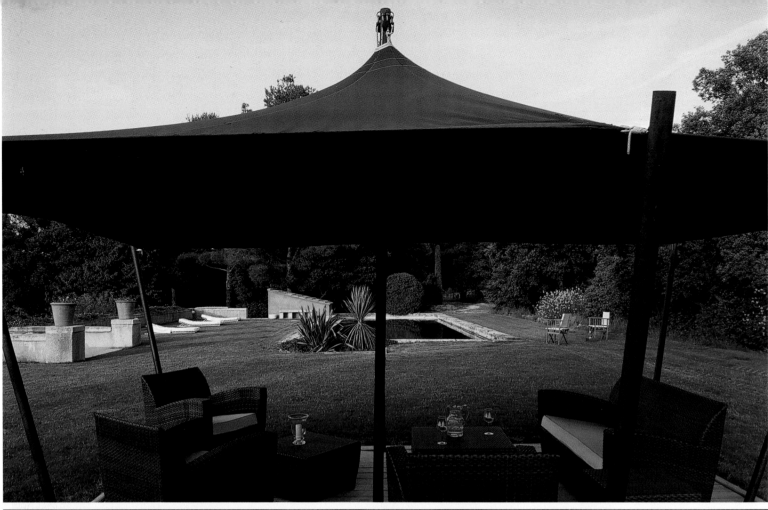

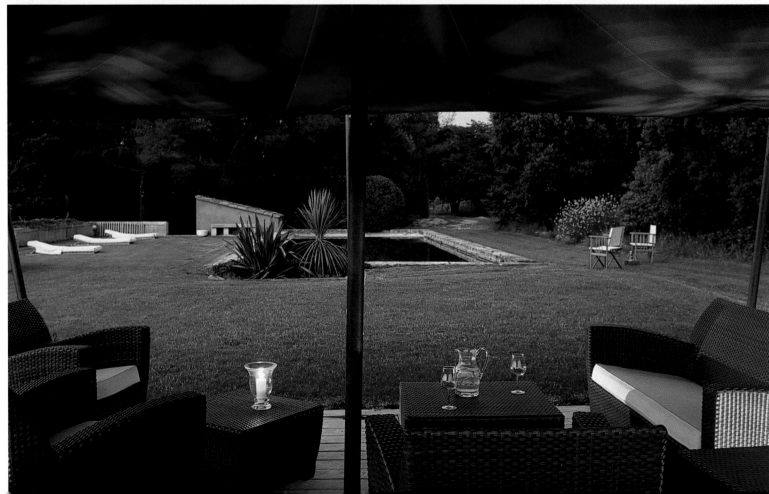

History relates that Pauline Bonaparte (1780-1825)—the Princess of Borghese, Duchess of Guastalla and Napoleon's sister—was a great beauty with very refined tastes. She commissioned this residence in Aix-en-Provence at the end of the eighteenth century as a rendezvous for her numerous lovers, and her personality and elegance are still pervasive—it is even called La Pauline in her honor. The house has now been restored without sacrificing the classical elegance characteristic of its times, and it is complemented by twenty acres of typical Provençal gardens. The present owners decided to take advantage of the hollow of an old pond, tucked into a steeply sloping area with wonderful panoramic views, to build a swimming pool modeled on traditional reservoirs. The pool's interior is clad with a mixture of lime, cement and sand, with limestone used around the edges to match the classical style of the surrounding landscape. Olives, cypresses and the vegetation typical of this Mediterranean region set off the vast expanses of the lawns. The classical atmosphere is accentuated by the new summerhousian in front of the pool, with its modern furniture and distinctive Arabian-style awning.

AIX-EN-PROVENCE, FRANCE

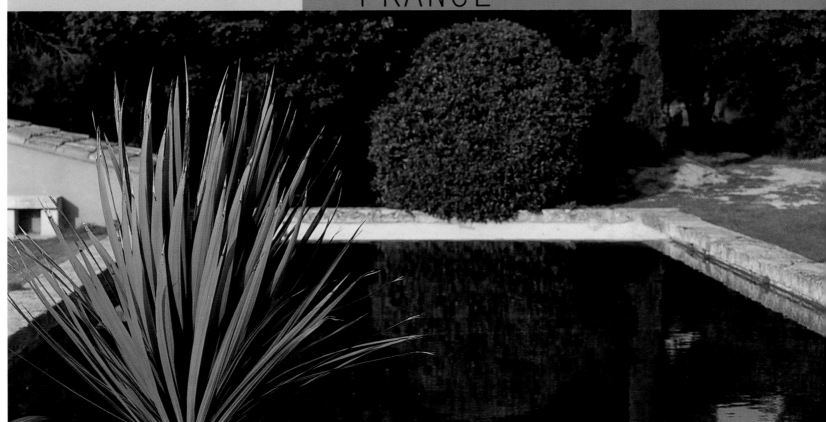

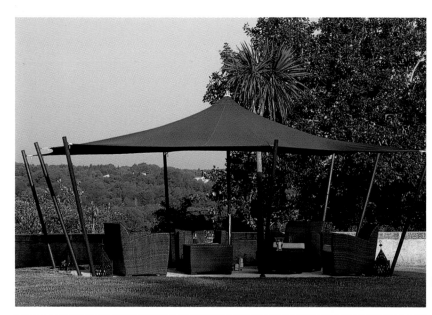

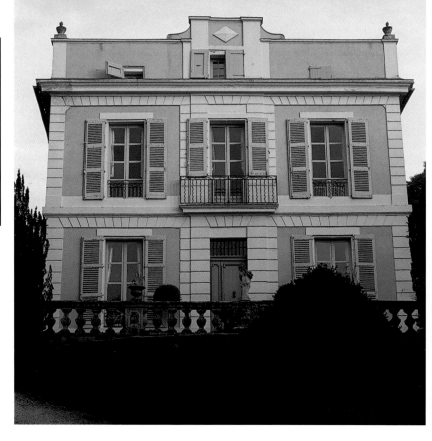

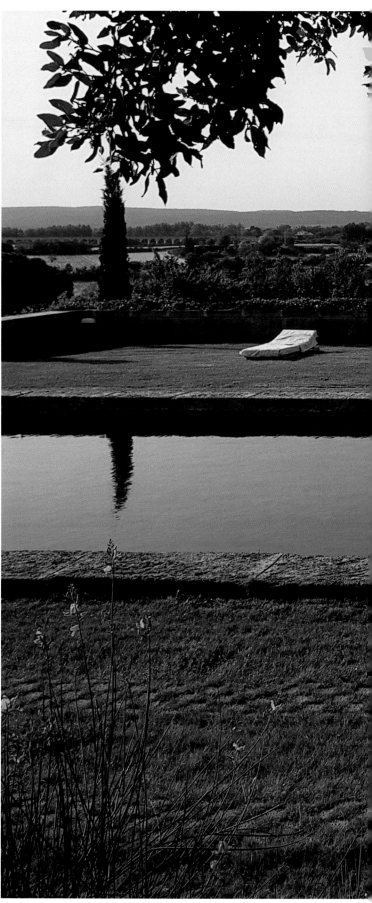

0
2
0

The pool is surrounded
by vast expanses of
typically Mediterranean
vegetation.

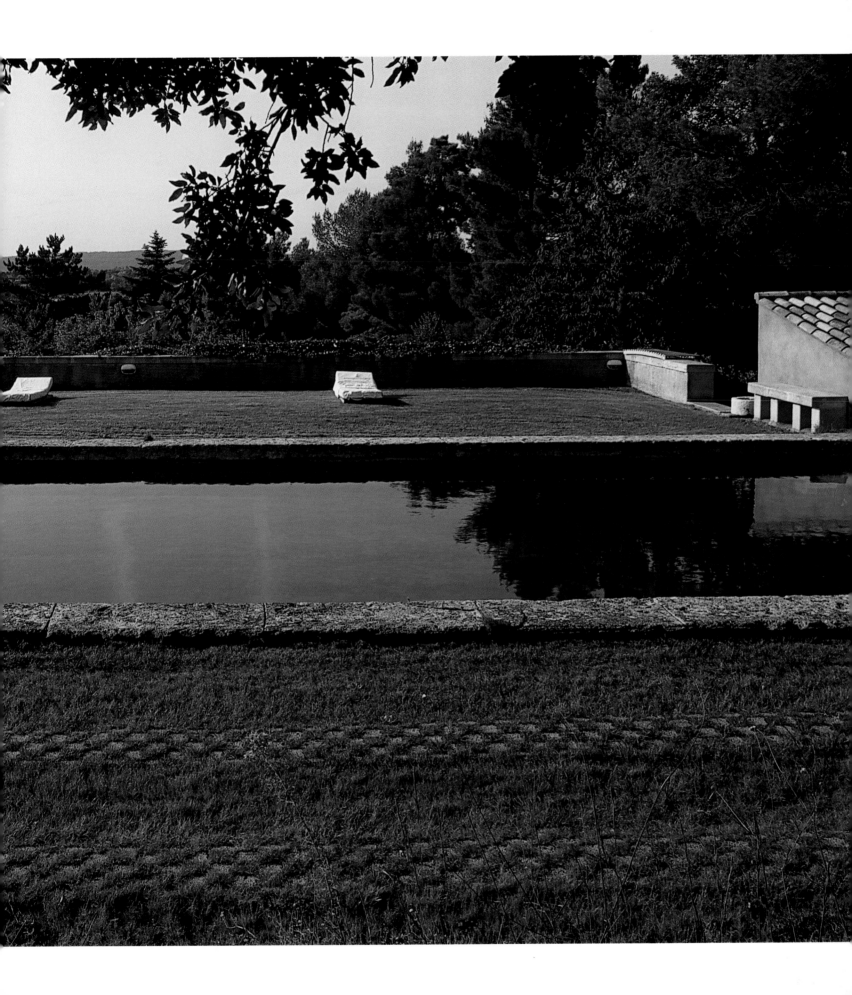

0

2

2

TYPICAL

PAINTED BLUE

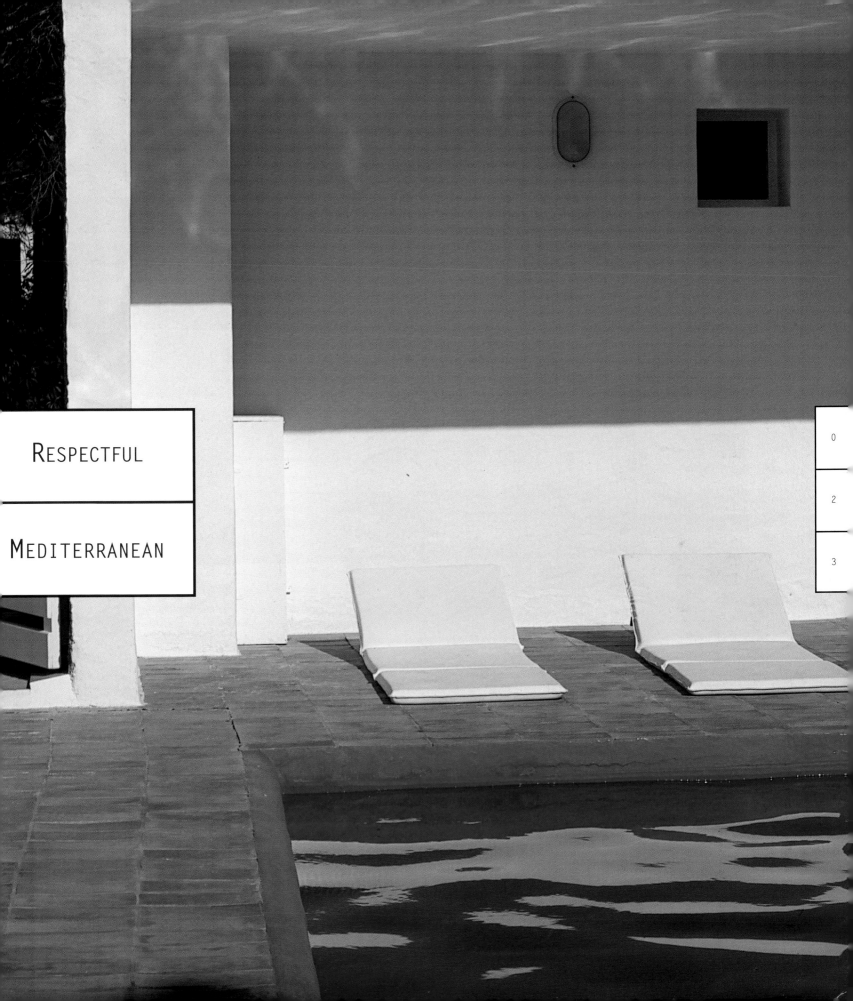

RESPECTFUL

MEDITERRANEAN

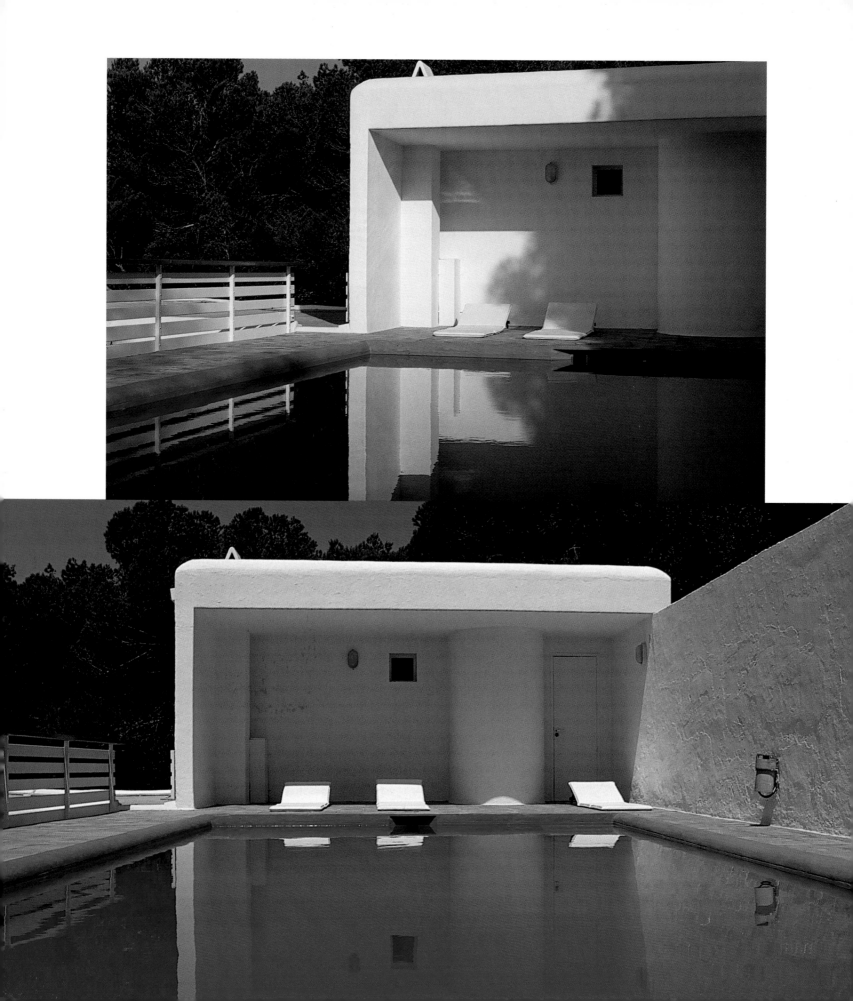

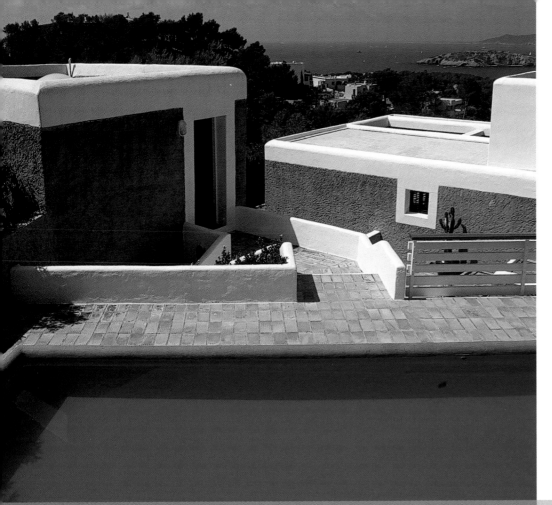

Sert championed a style of architecture typical of Ibiza, with no dividing walls between the houses and with distinctive rural terracing and strong colors.

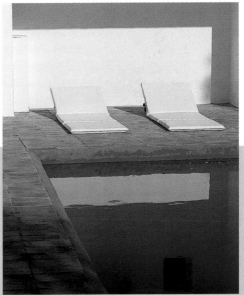

IBIZA, SPAIN

The starting point for the internationally recognized work of the Catalan Josep Lluís Sert (1902-1983) was his genuine respect for local tradition. On several occasions the architect used building techniques proper to Mediterranean culture. A good example of this is the Can Pep Simó housing estate, popularly known as Punta Martinet, which Sert built in Ibiza from 1965 to 1968. In order to achieve an architecture that merges into its surroundings, he followed the contours of the terrain and did not build dividing walls to mark off the individual houses. The facades were painted with white lime and shades of ochre, a color scheme typical of this island. The architect set aside one of the nine houses on the estate as his own summer home, and it boasts the only swimming pool in the complex, the result of the reconstruction of an old irrigation reservoir. The pool, situated at the top of a slope, successfully brings out the Mediterranean spirit of the house with its generous dose of blue paint daubed over its interior. The sunbathing area and the edges of the pool are paved, and a shady area and dressing room have also been added in a style in keeping with the other buildings on the estate. Lampposts characteristic of the island bring another traditional touch to this poolside setting.

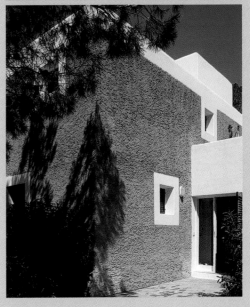

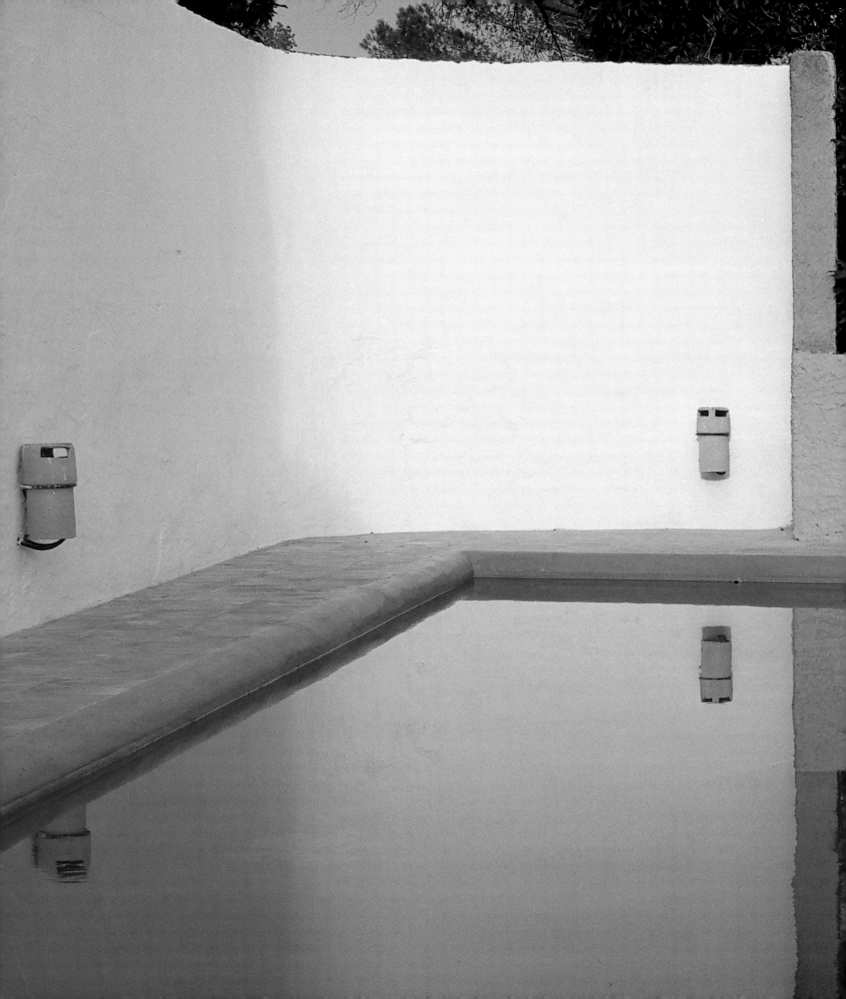

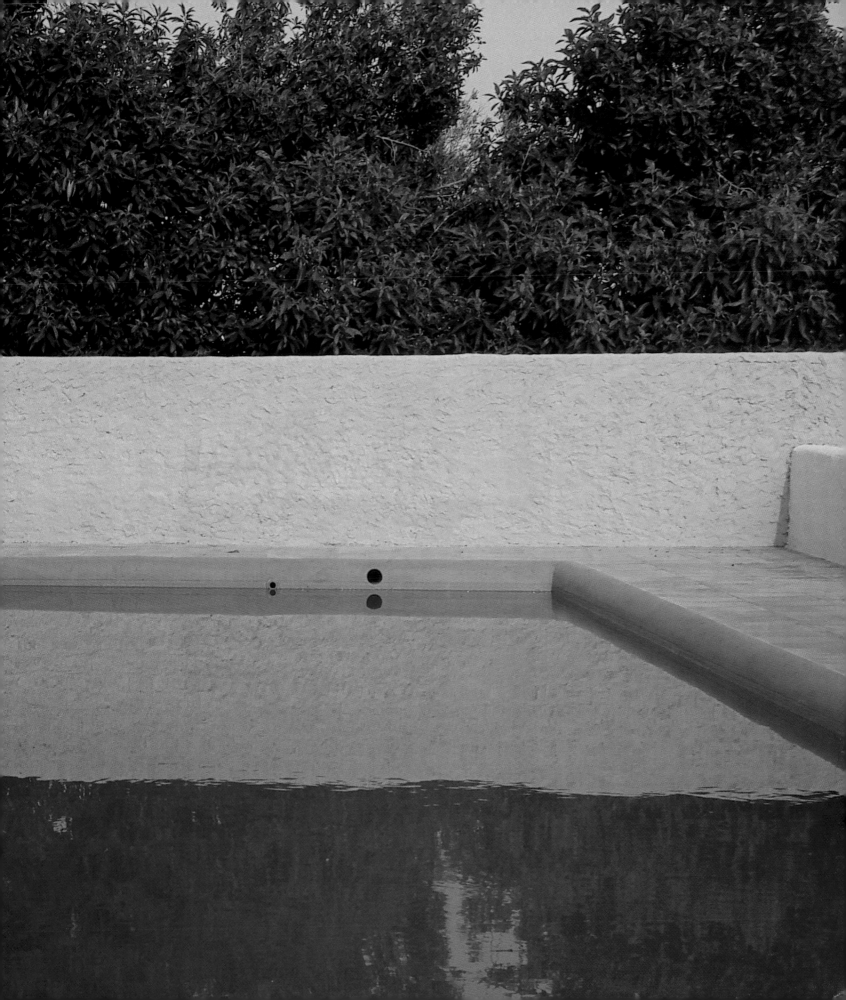

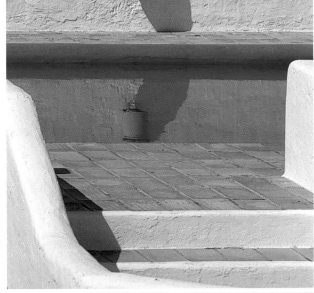

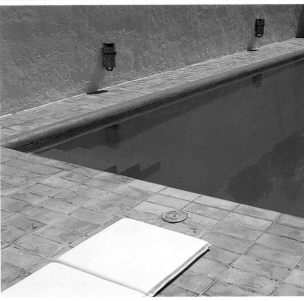

CLASSIC

RATIONALIST

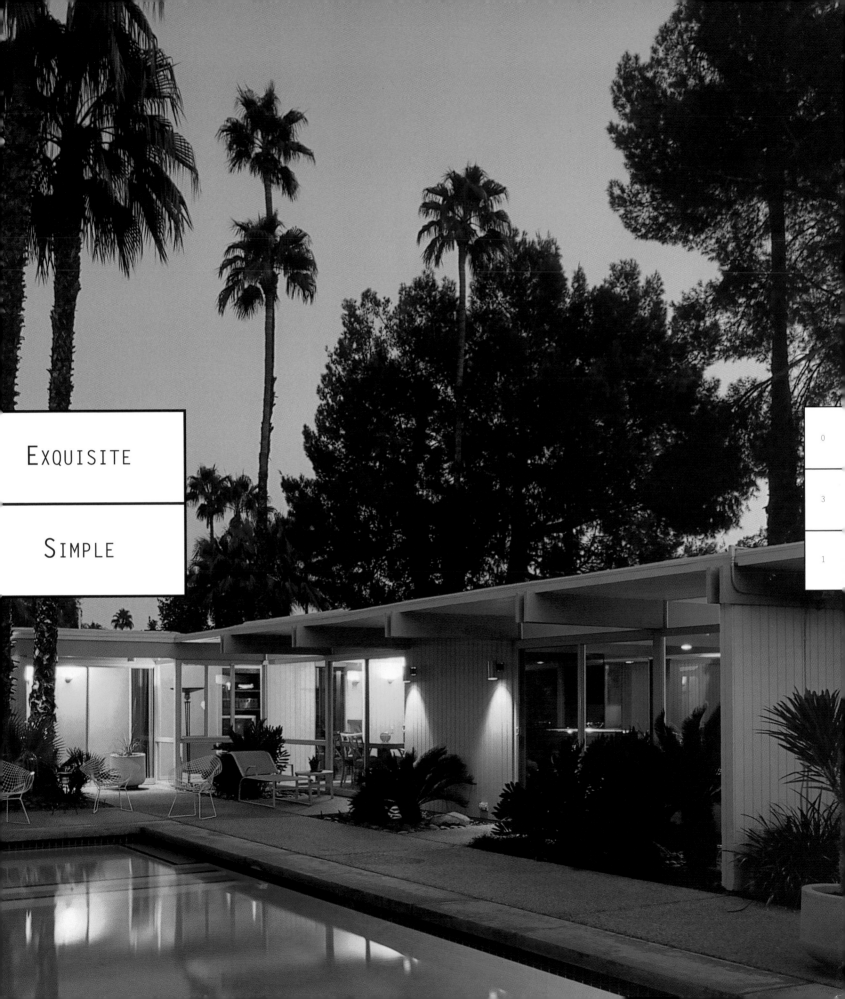

EXQUISITE

SIMPLE

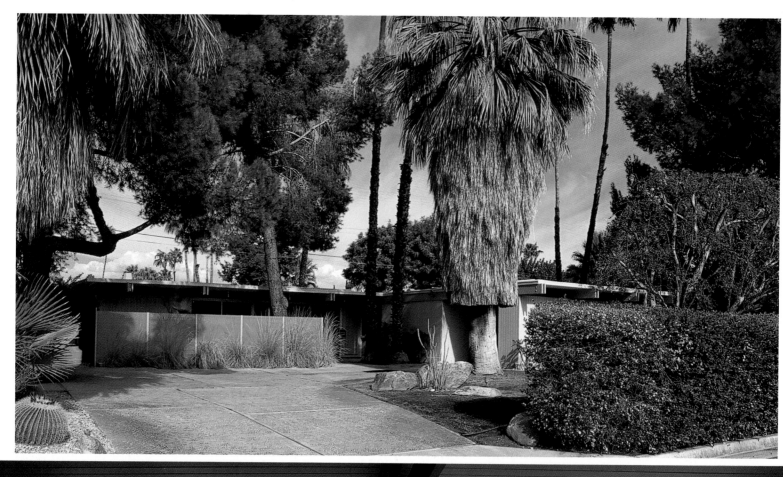

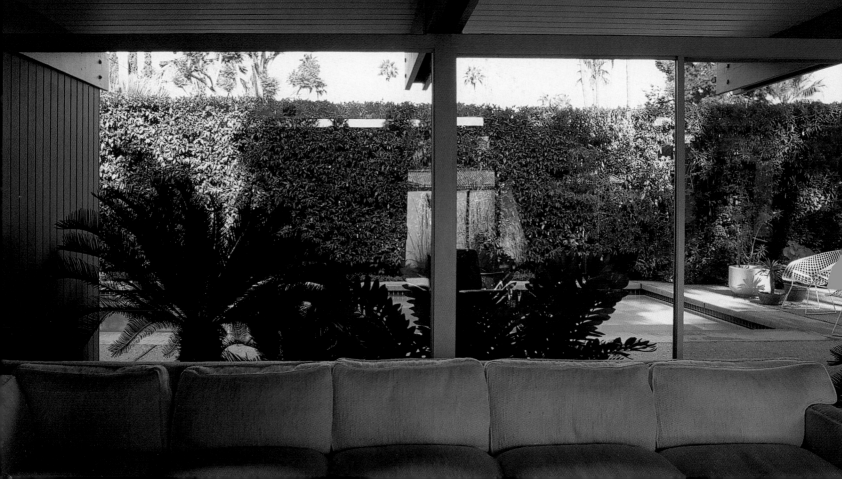

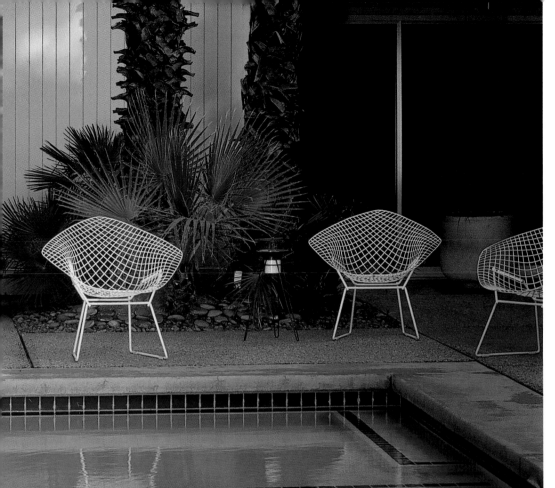

The light forniture
adds a modern note to
the pool of this house
in Palm Springs.

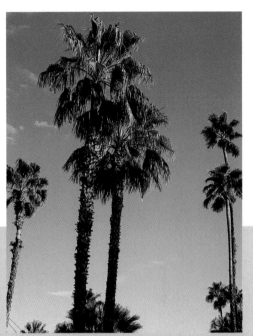

PALM SPRINGS, CALIFORNIA. USA

Donald Wexler was one of a group of architects—along with Albert Frey, Richard Neutra, John Lautner, R. M. Schindler and Frank Lloyd Wright—who transformed Palm Springs from the 1950s onwards, making this city in the middle of a desert a veritable symbol of architectural modernity. This classic project, designed by Wexler in the 1960s, is simple and rationalist. The passage of time has not rendered it obsolete. The rectangular swimming pool, set along the central axis of the terrace, is made of white-tinted concrete, with a dark-blue frieze of small tiles marking out the interior perimeter of the pool and the access area. The latter is a separate level that spans the width of the pool, although steps on one side provide a more conventional entrance into the water. Some light outdoor chairs indicate the sunbathing area, situated at the entrance to the pool. The terrace has been designed with exquisite care: small gardens dot the area around the pool, along with flowerpots, planted with a variety of species, and palm trees, the emblematic tree of this region.

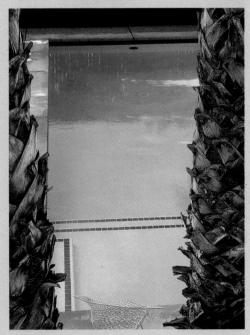

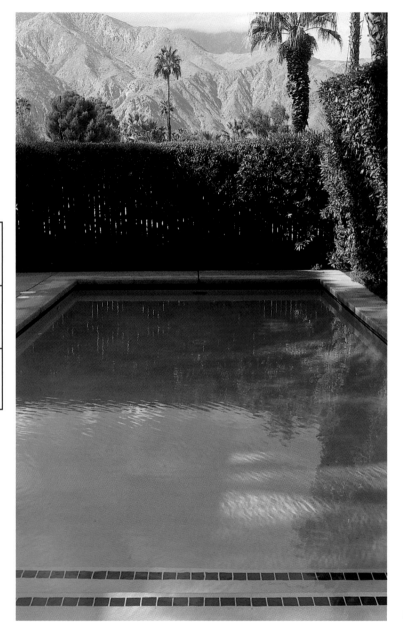
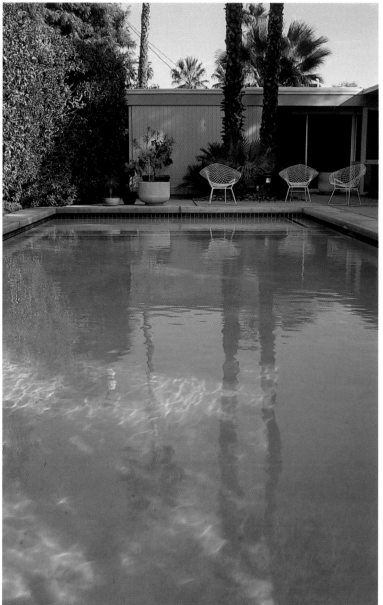

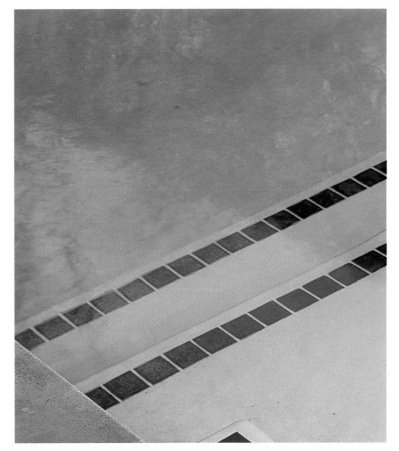
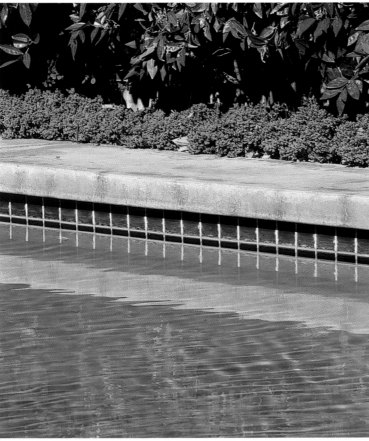
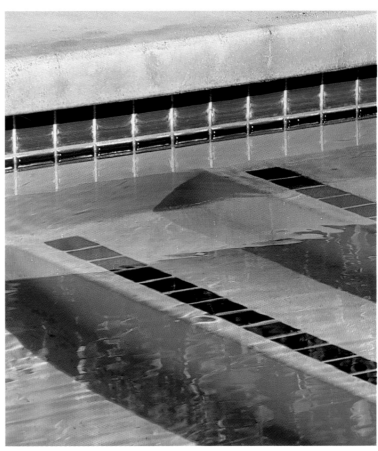

0

3

6

ELEGANT

SIMPLE

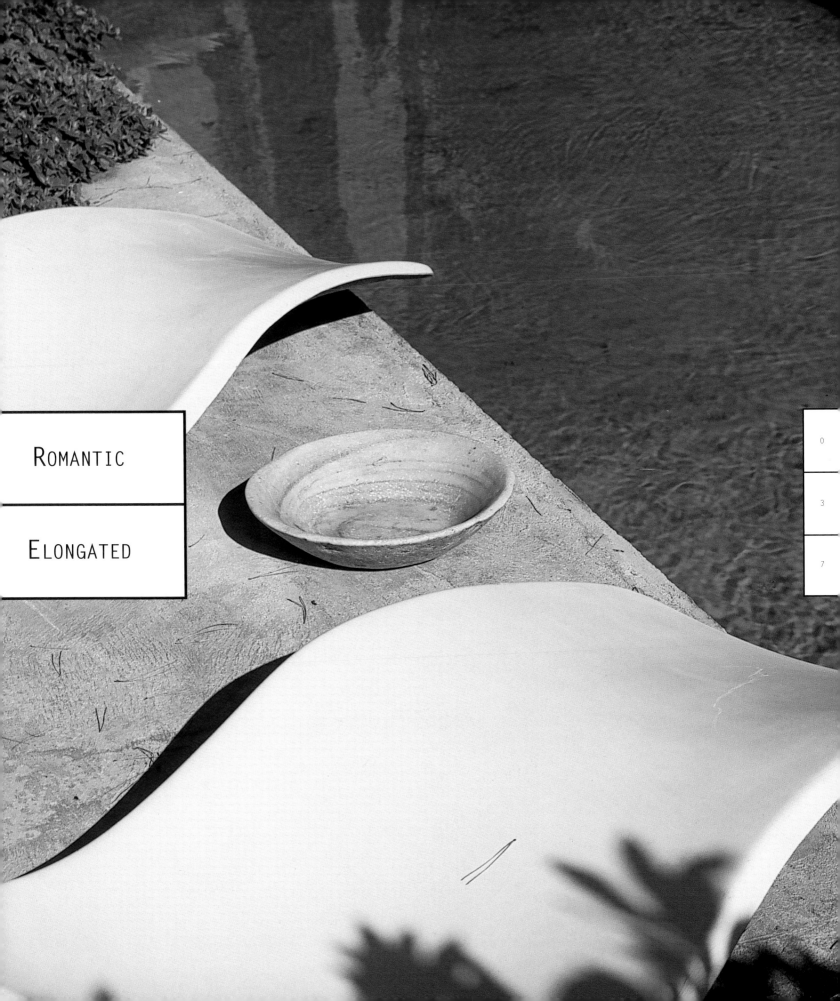

ROMANTIC

ELONGATED

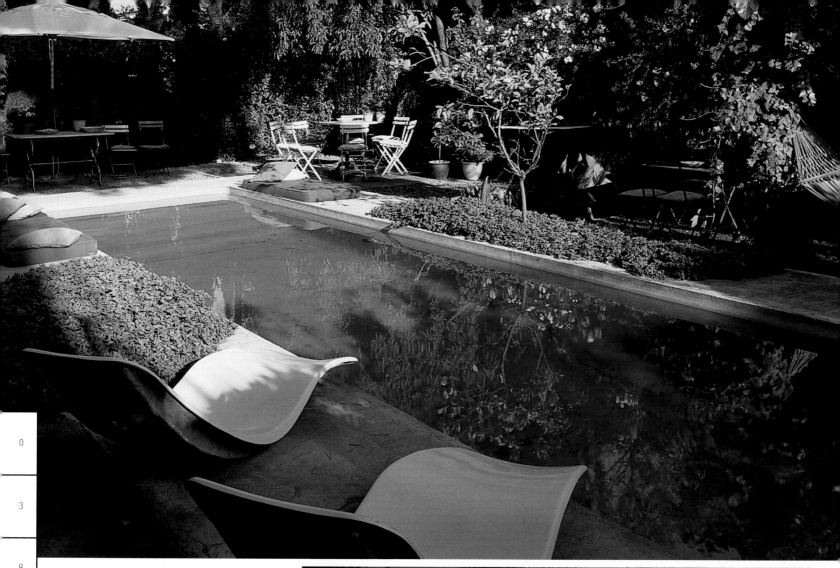

0
3
8

The swimming pool of this Noucentista house follows the central axis of the garden, which combines vegetation and outdoor furniture.

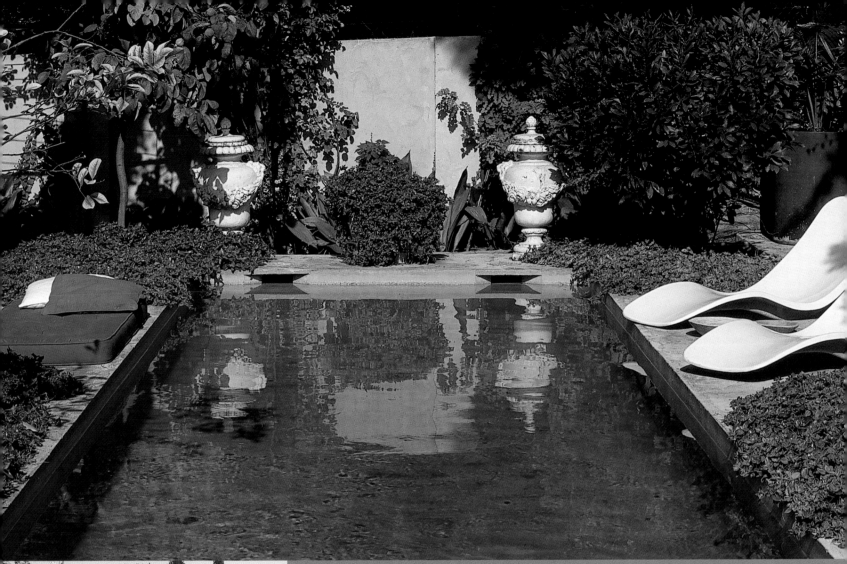

BARCELONA, SPAIN

The designer, determined to be faithful to the Noucentista style of this house—built in 1911 at the foot of the Collserola mountain near Barcelona —created a highly individual swimming pool with a striking elongated form (46 x 8 feet) and simple, discreet lines. It is extremely shallow, as if it were an old-style artificial pond. This new addition was placed in the center of a Spanish garden divided up by flowerbeds characteristic of the early twentieth century to provide an elegant, silent accompaniment to the vegetation, dominated by aspidistras and centuries-old pine trees. The pool is clad with concrete stained a leaf-green color. At one end there is a cool, shady summerhouse, complete with paving stones and a period fountain and topped with two antique urns, which not only add a touch of style but also mark off the changing area. On the sides, among the shrubs and plants, lie the sunbathing areas, with two white sunbeds sporting a wavy, 1950s design and outdoor furniture that marries iron structures with strawberry-red upholstery—a modern detail that sets off this composition inspired by the past.

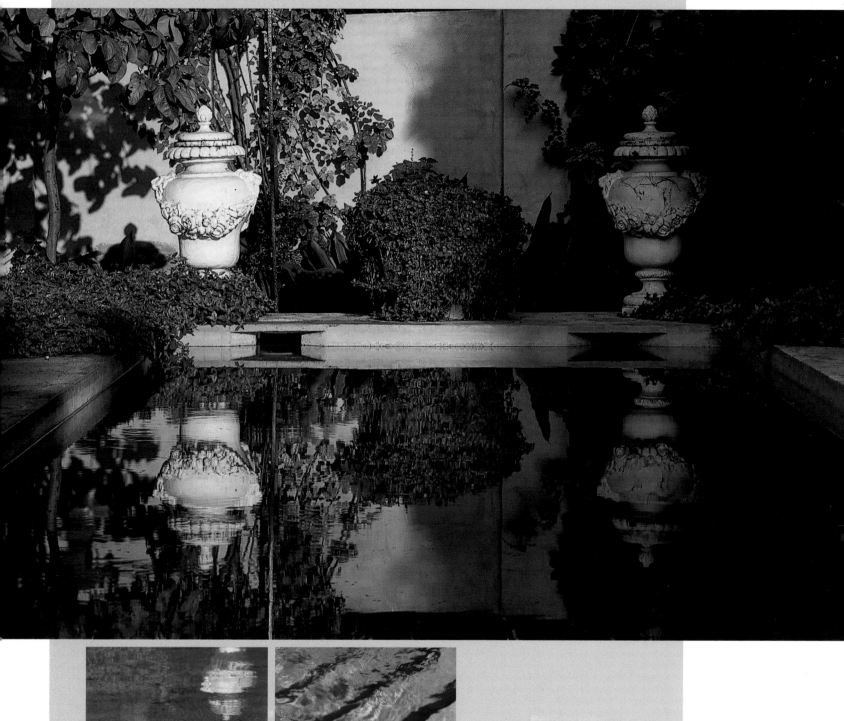

All the garden elements come together to create a unified whole. The water in the pool is almost a mirror of nature.

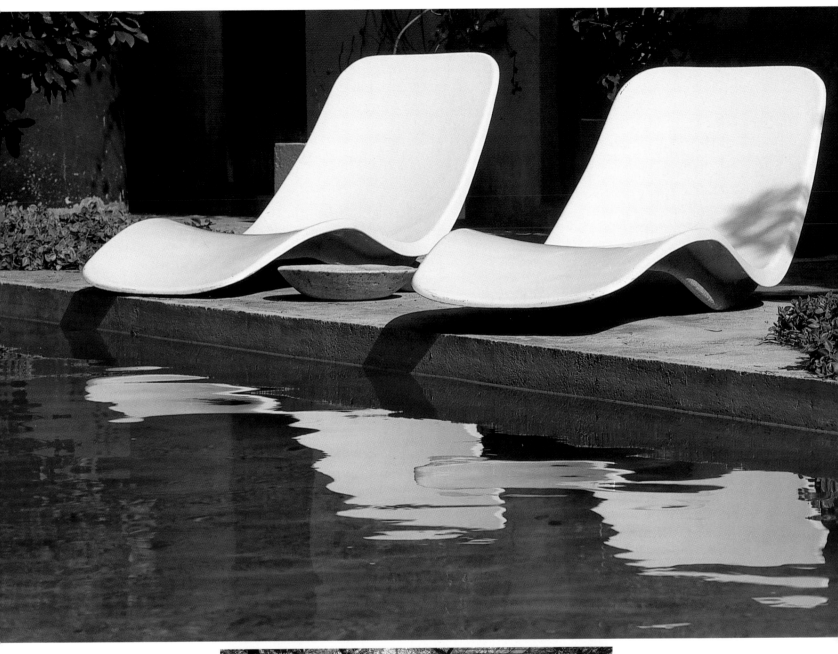

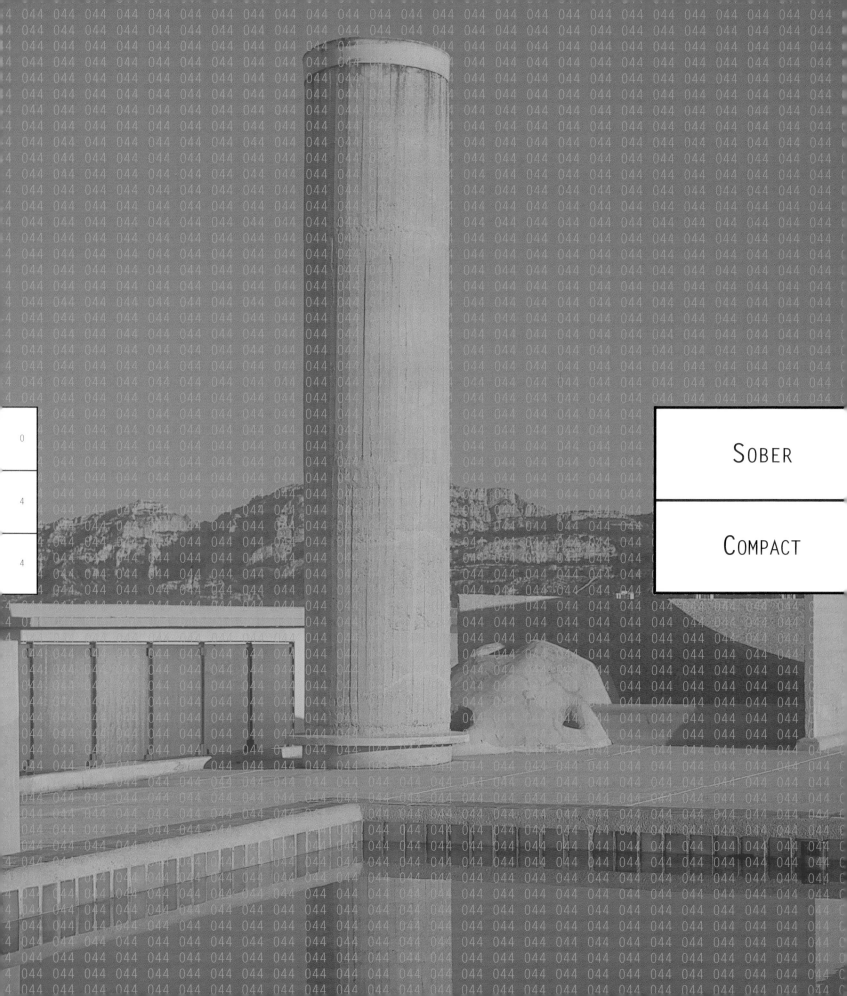

0

4

4

SOBER

COMPACT

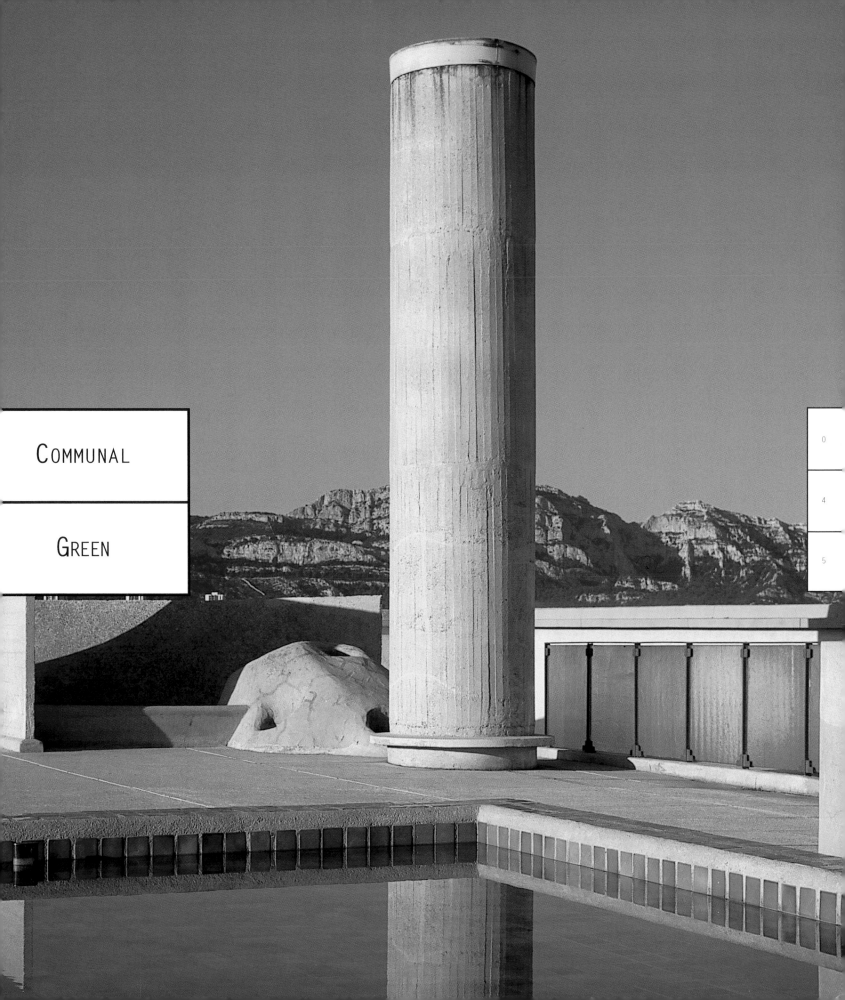

COMMUNAL

GREEN

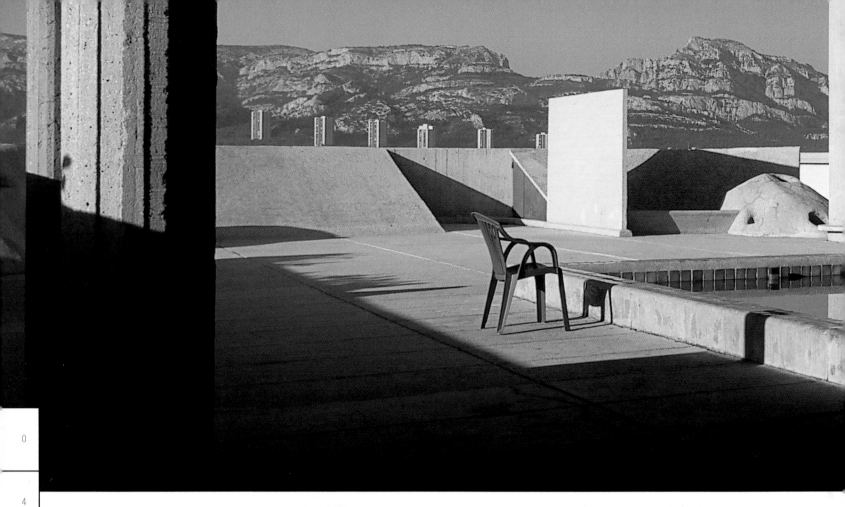

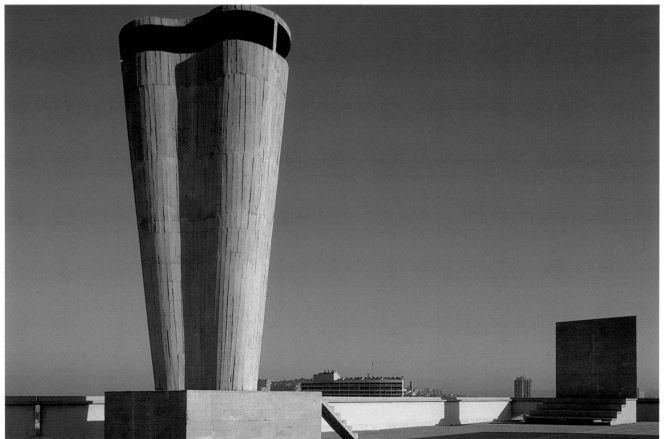

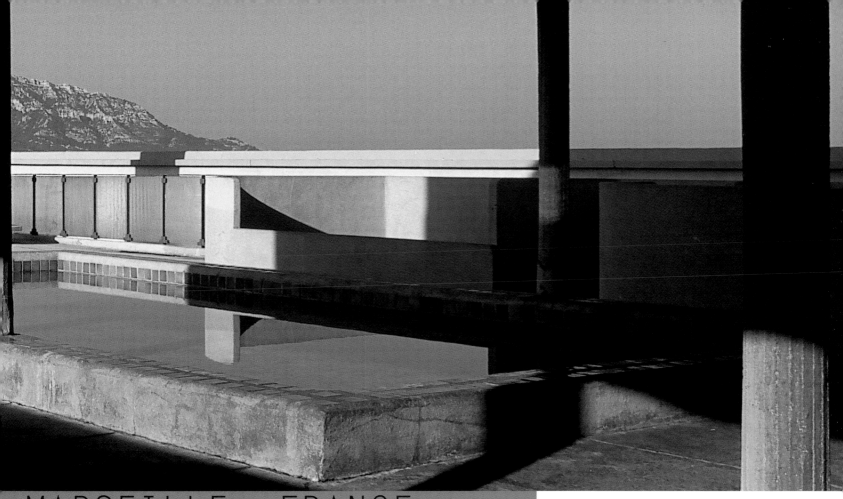

MARSEILLE, FRANCE

The Unité d'Habitation, built between 1945 and 1952 on the Boulevard Michelet in Marseille, is one of the crowning achievements of Le Corbusier's later architecture, far removed from the purist esthetic of his work in the 1920s. This apartment block takes the form of a tall reinforced-concrete complex—in keeping with the architect's concept of a "vertical city"—nd contains 337 apartments, along with shopping streets and spaces for leisure activities. The swimming pool lies on the building's terrace, which houses most of the communal facilities, such as the bar and the kindergarten. The sculptural forms of the ventilation chimneys and the arrangement of the staircases endow the roof with an array of highly original abstract sculptures. The swimming pool maintains the style of the rest of the block with its unpolished concrete slabs, although the various shades of green on the floor tiles add a touch of color and tone down the harshness of the rough concrete. Moreover, Le Corbusier echoed the design inside the pool by inserting glazed ceramics into some of the dividing walls.

Although the social concept of the Unité proved to be a failure (as only one of the businesses survived), the experiment exerted an enormous influence on the emerging architects of the time.

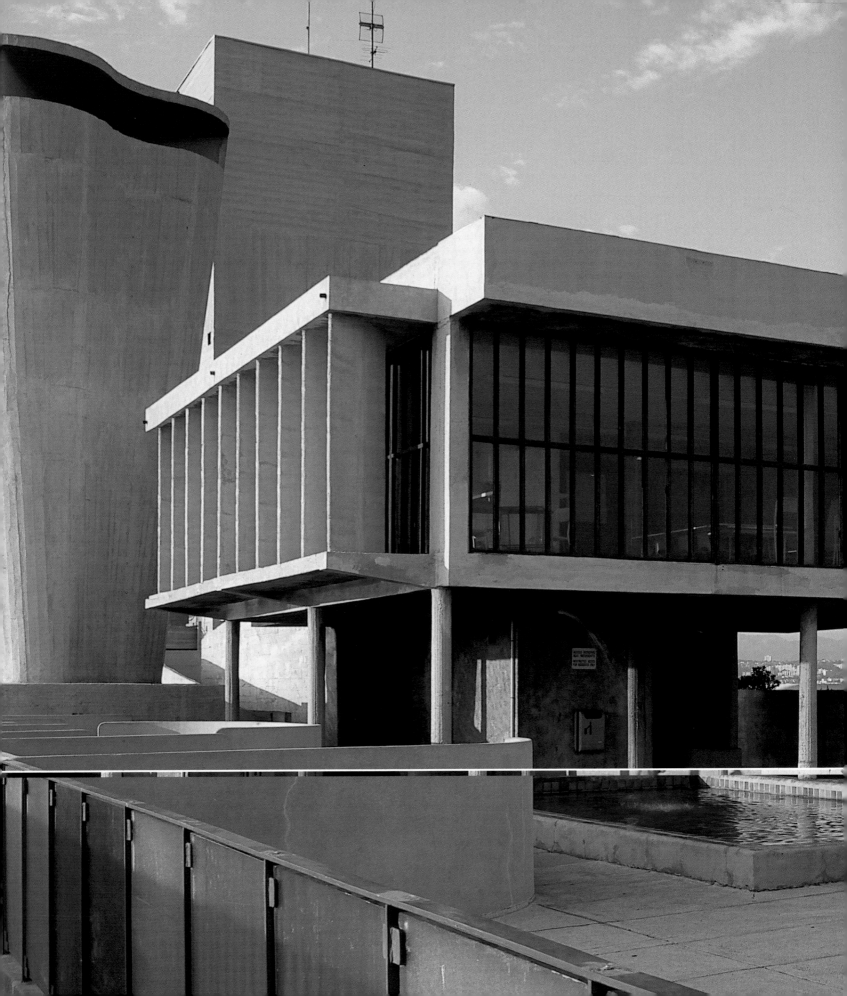

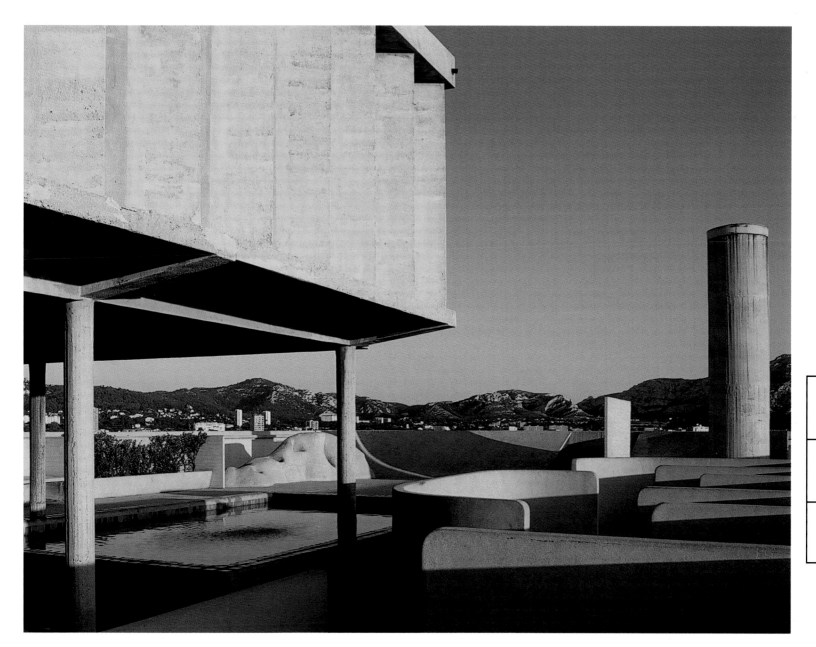

The communal swimming pool
occupies a large part of
the terrace of La Unité.
Le Corbusier used green
tiles to soften the
austerity of the concrete.

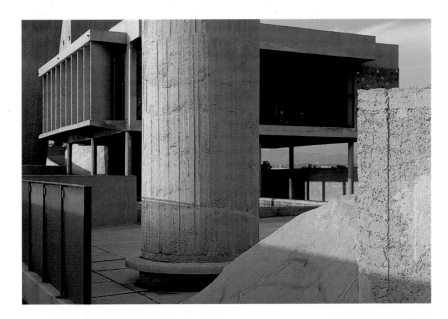

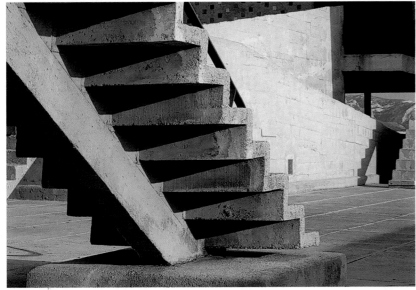

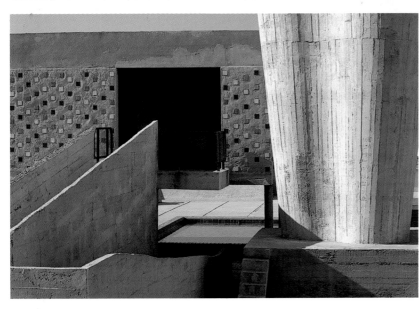

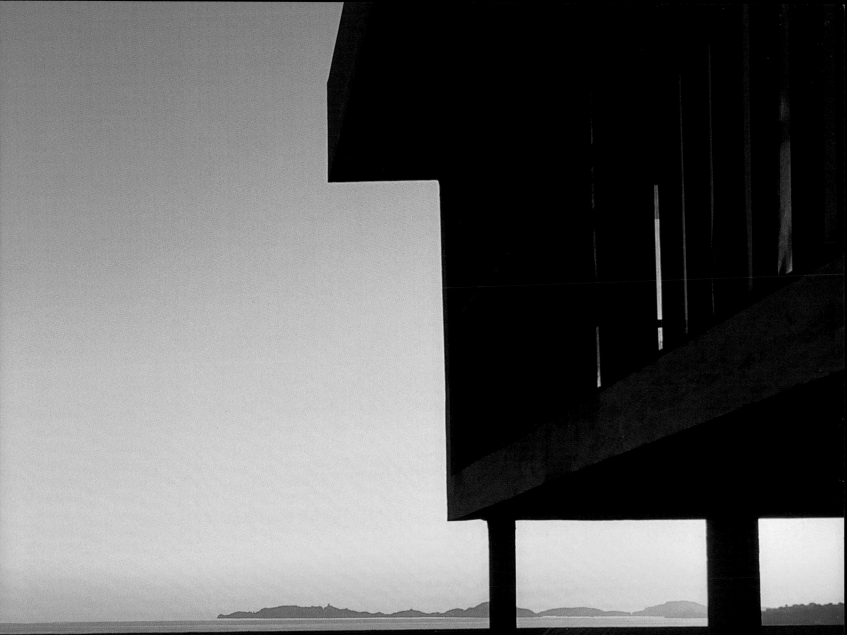

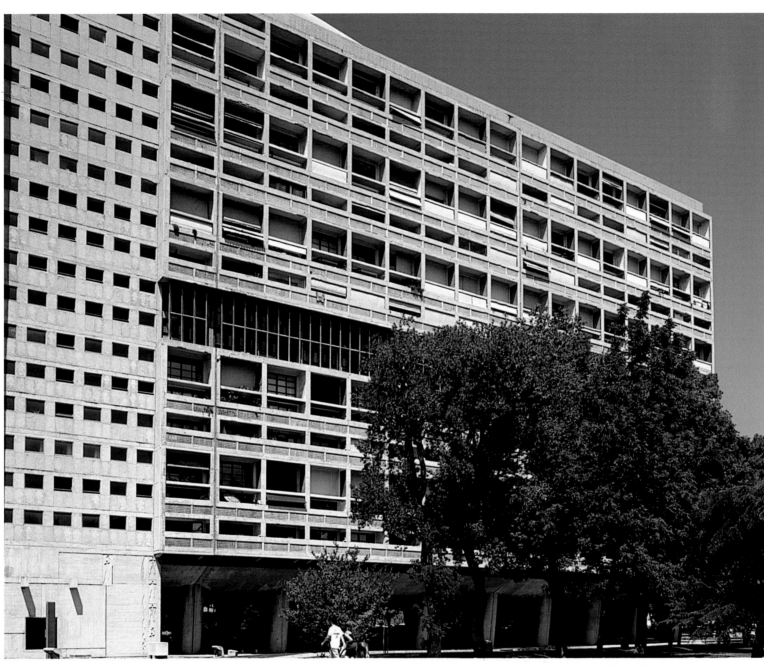

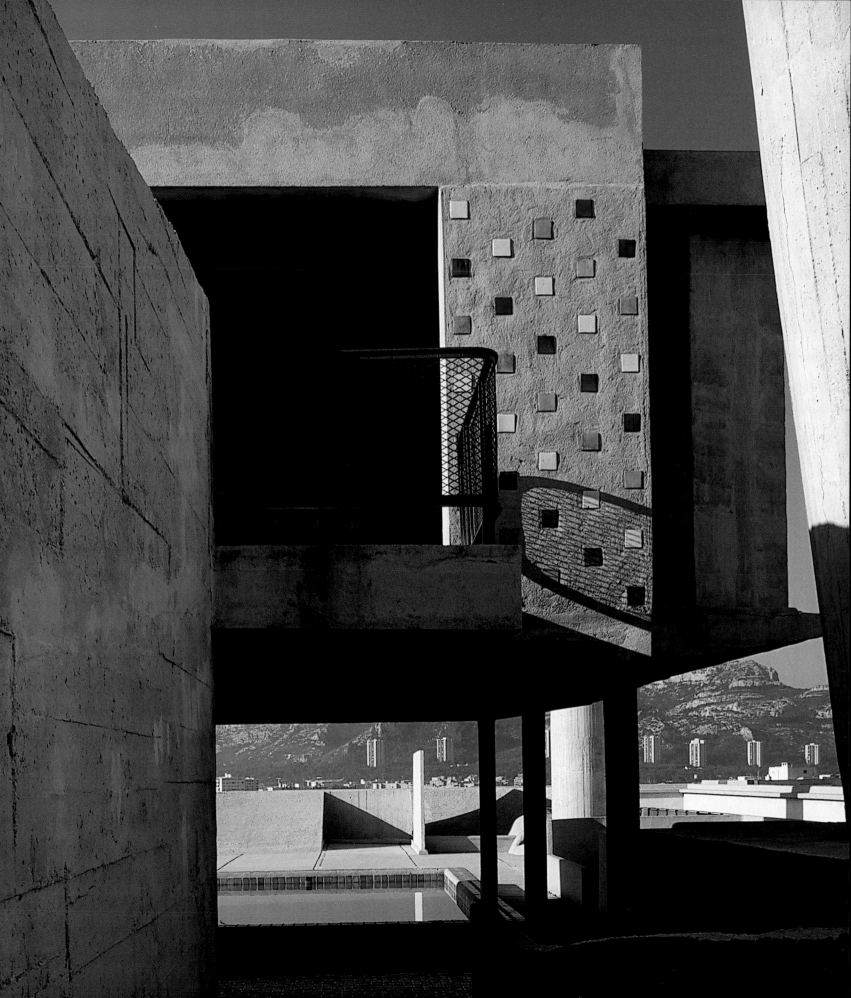

SIMPLE

INDUSTRIAL

VERSATILE

DARING

This unusual project has taken the casing of an old tank and turned it into a striking swimming pool. One half of an old steel tank was set up beside the house, supported by small pillars and a fixed structure installed on the hillside. This concept resulted in a unique structure with a strong visual impact that nevertheless fits into its natural surroundings. The interior of the receptacle was painted black, emphasizing the roughness of the materials used. A small concrete terrace was built on one side of the pool to create a sunbathing area, decorated with unassuming wrought-iron furniture. The water seems to almost overflow onto the terrace, with only a steel plate on the outer rim to indicate the steps that provide access to the interior of the pool. The design of the steps is highly stylized and complements the solidity of the structure. The end result is a daring project with a distinctive personality that has used industrial materials for its own purposes, a versatile demonstration of how such elements can be converted into something new.

SILVERLAKE, CALIFORNIA. USA

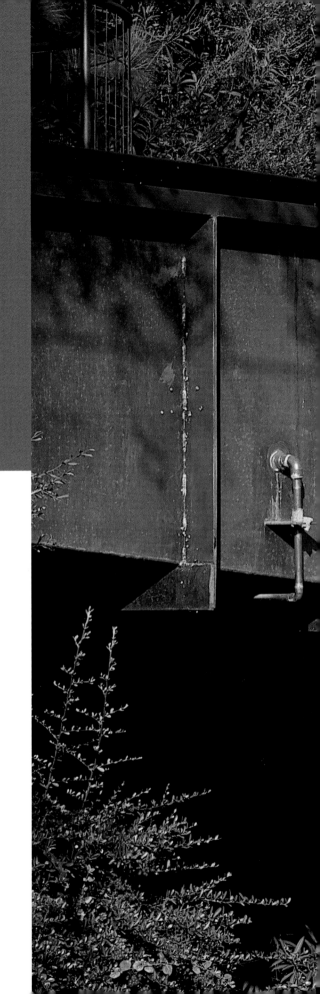

A narrow, rectangular concrete terrace was built on the top of the pool. The light furniture is ideal for sunbathing and observing the scenery.

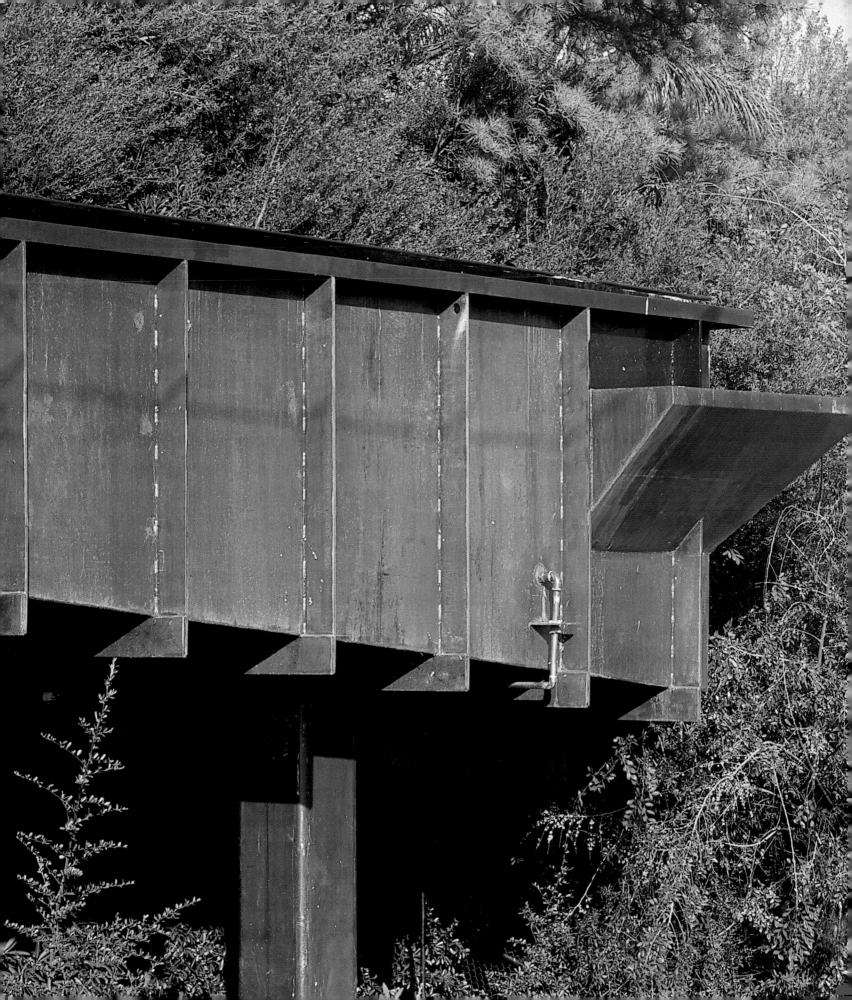

An original and practical
overflow separates the pool
from the terrace. The steps
unite the two elements.

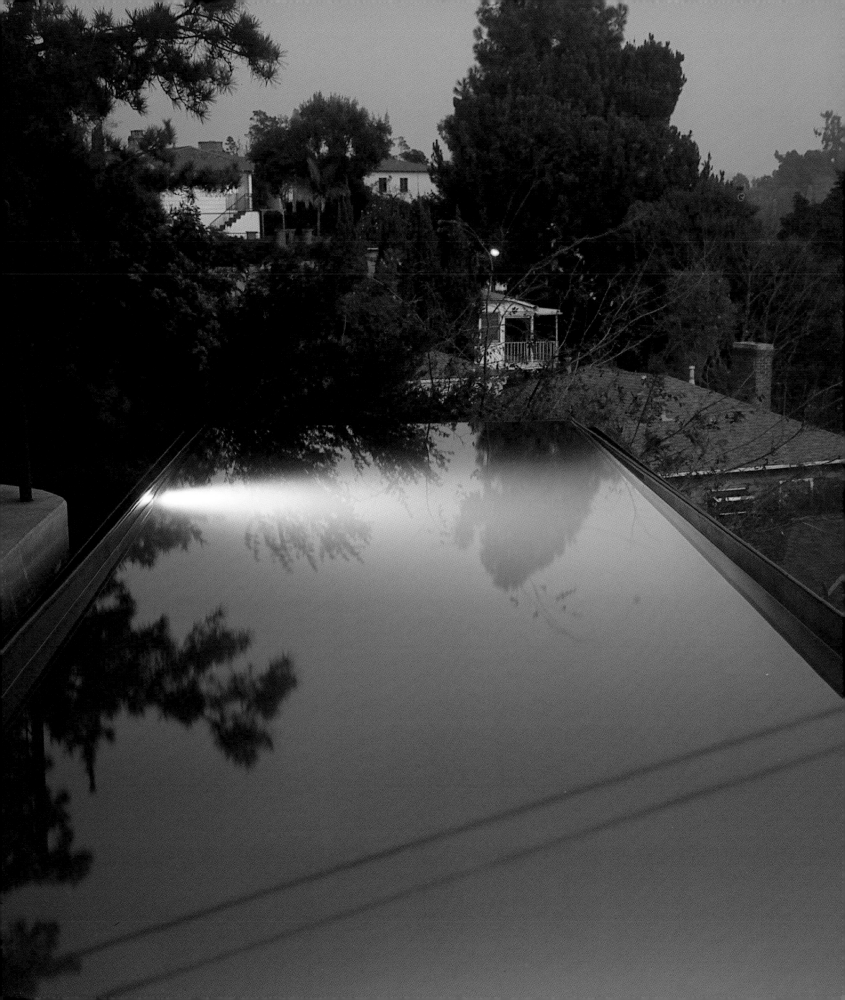

NESTLING

SWATHED IN IV

ELEGANT

RESPECTFUL

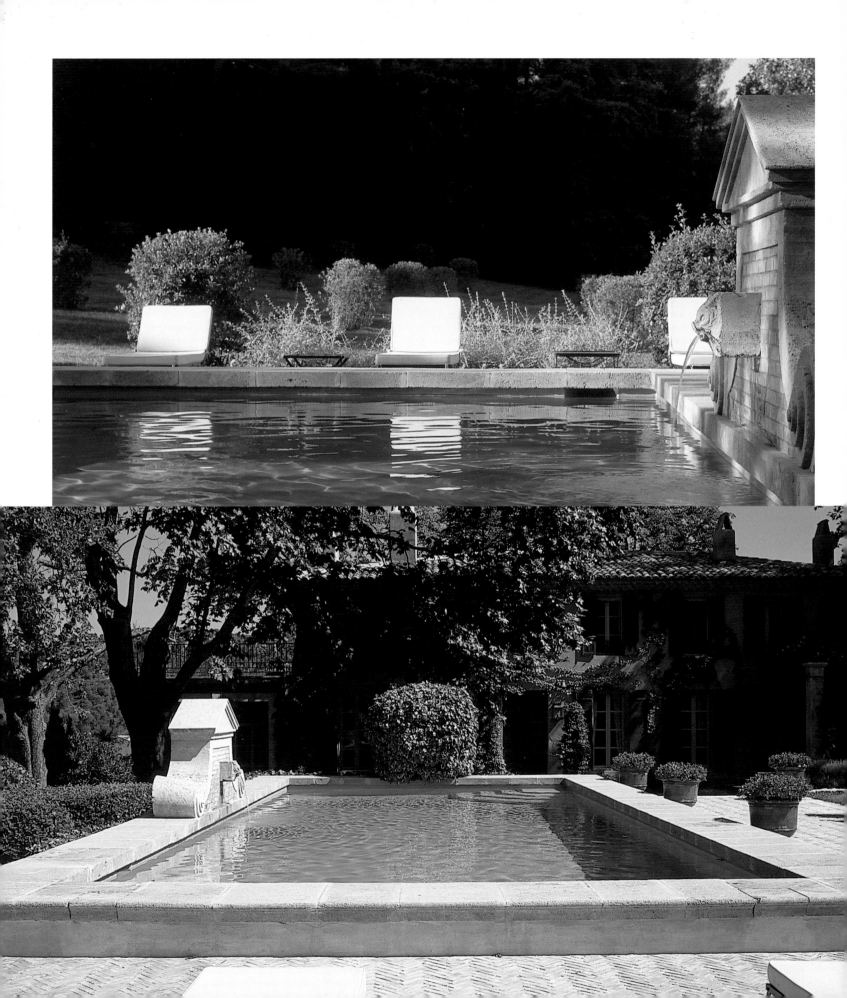

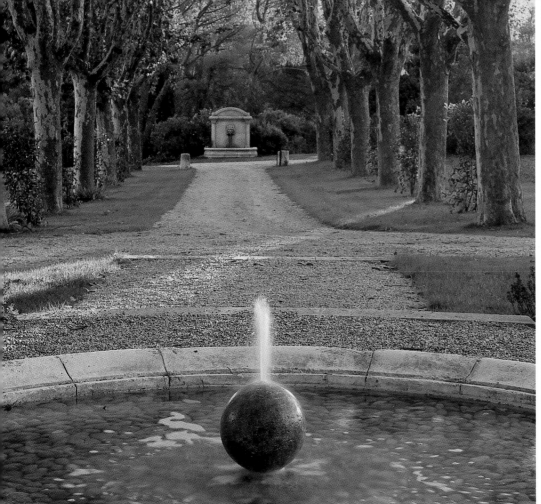

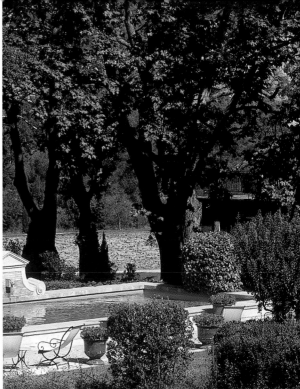

AIX-EN-PROVENCE, FRANCE

The landscapes around the city of Aix-en-Provence, the vast expanses of the vineyards in la Palette and the Sainte-Victoire mountain all inspiredTthe palette of the Impressionist painter Paul Cézanne. This part of the South of France is also home to the late eighteenth-century Château Crémade, nestled among vineyards and magnificent gardens. Its restoration has preserved the spirit of the period thanks to the painstaking work of the landscape gardener. Among the oaks, cypresses and rows of plane trees lies the swimming pool, a refurbished old reservoir with wonderful views of the green gardens. Its interior is made of concrete and its edges of natural stone, a material also found in part of the sunbathing area. A fountain designed by Bruno Lafourcade, a member of the restoration team, is a striking feature, and its water splashes directly into the pool. The team also retained another old fountain, now swathed in ivy (although the designers added the handrail, with motifs of vines covered with wisterias), and this relic of the original building summons up images of the former owners who used to stroll through these gardens. In fact, the elegant and respectful restoration almost seems to bring them alive.

The project preserved all the details that proclaim the heritage of this famous wine-making area.

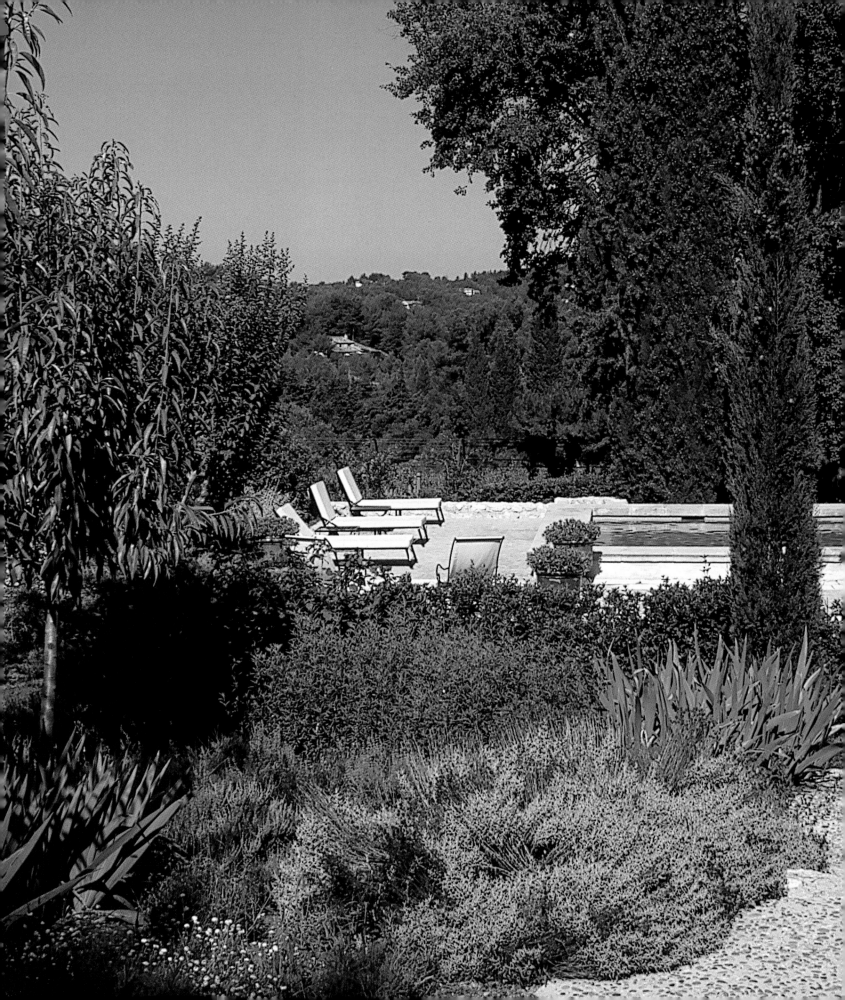

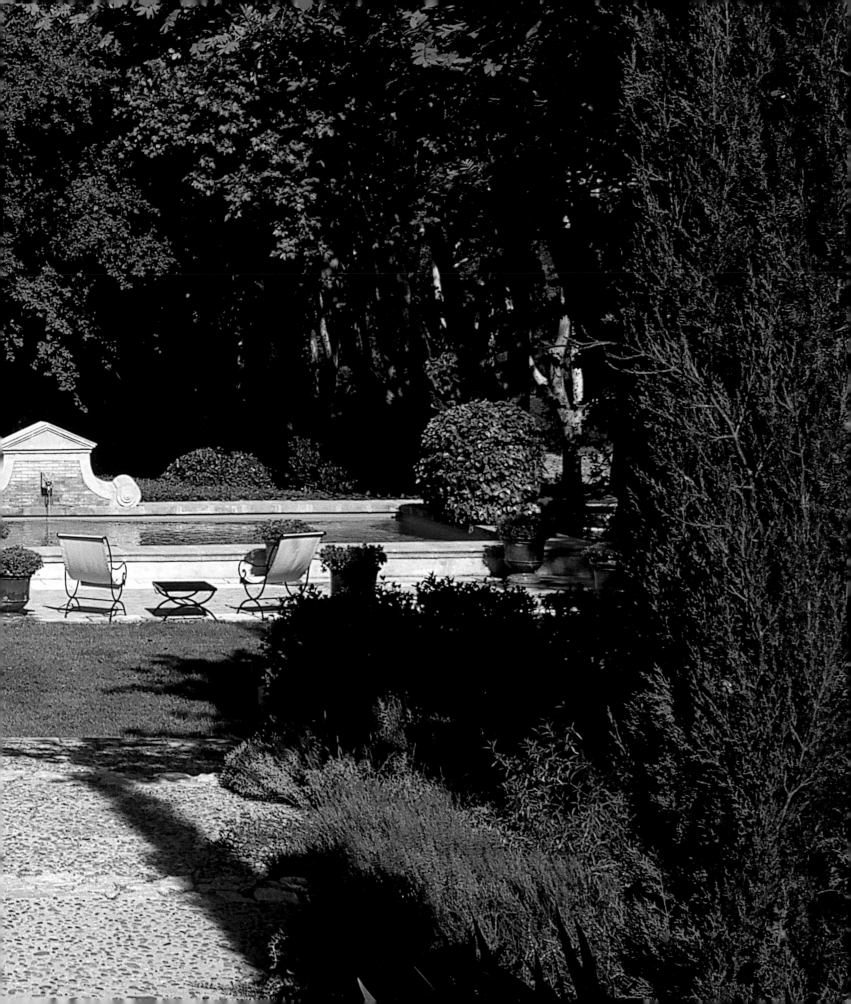

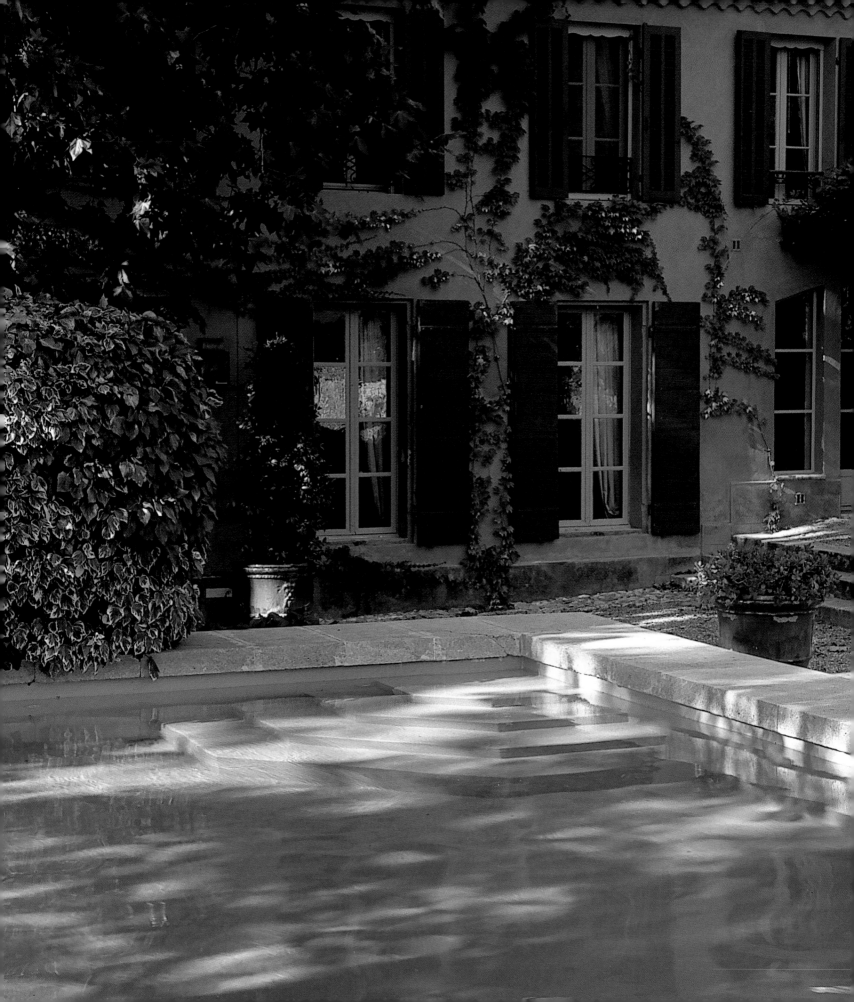

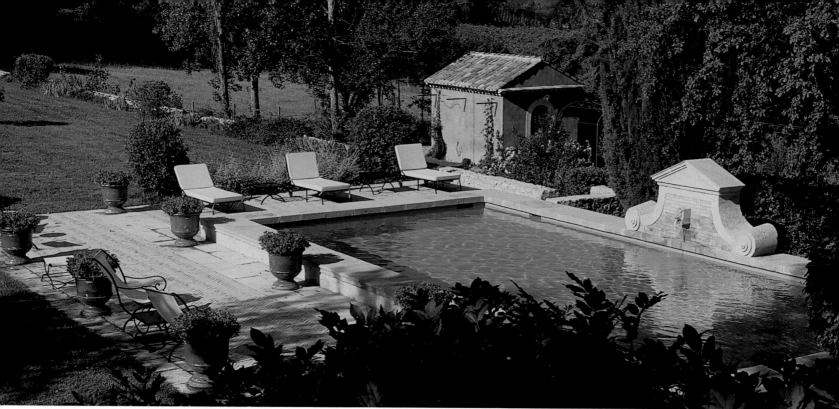

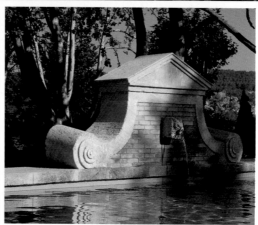

The pool is replenished
by an original fountain
that respects the spirit
of the original period.

STRIKING

PURE

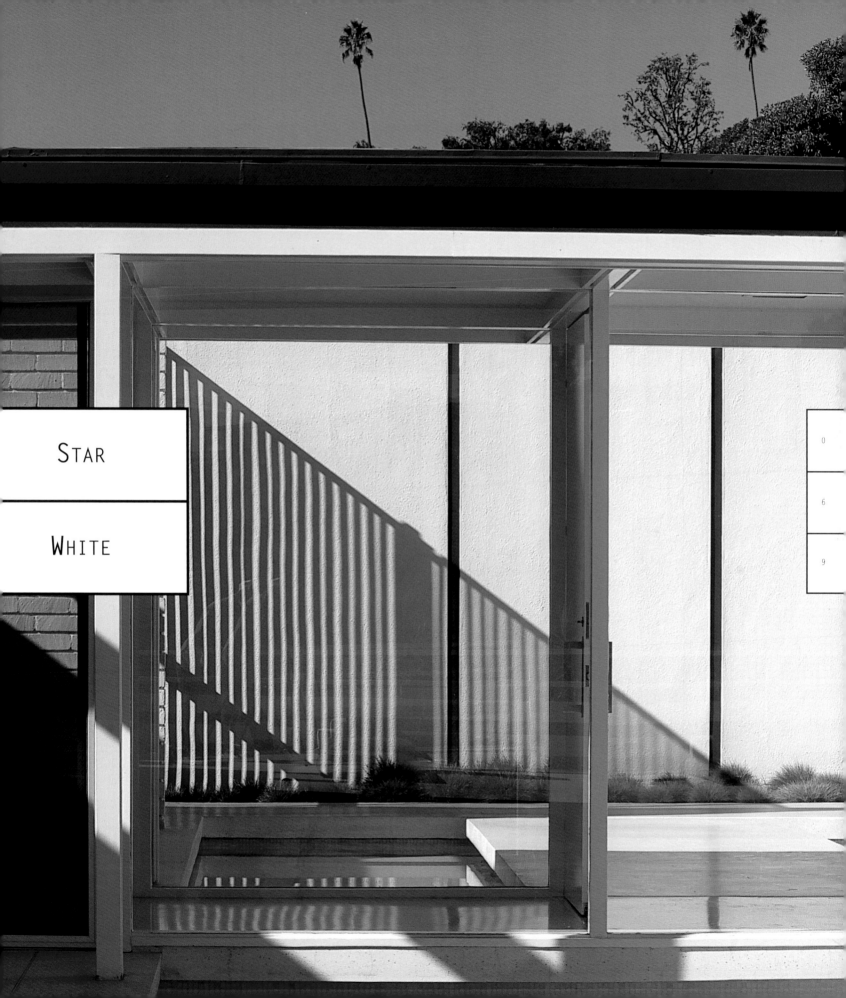

STAR

WHITE

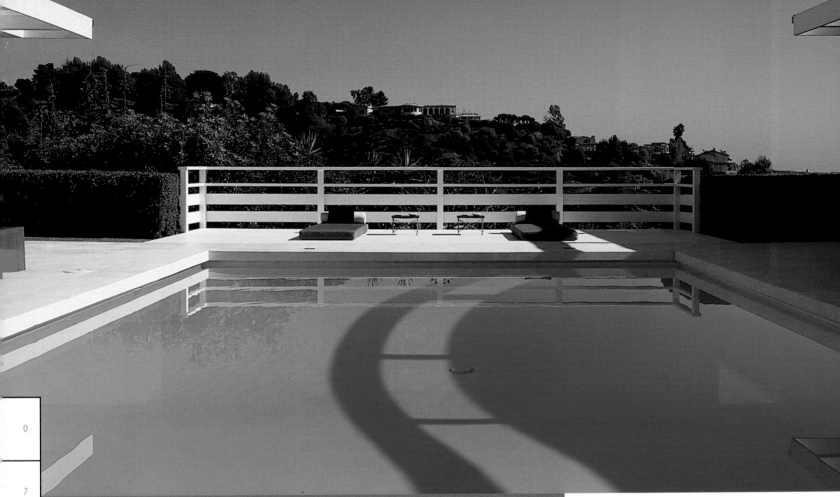

BEVERLY HILLS, CALIFORNIA. USA

The restoration of the building, originally constructed in the 1960s on a hill overlooking Los Angeles, set out to place the house between two expanses of water, with a spectacular walkway at the entrance creating a striking first impression. The walkway leads up to the building and marks off the first receptacle of transparent water. Then a glass corridor delineates the common and private areas inside the house, which is built around an interior terrace. The walkway also offers a view of the newly rebuilt swimming pool, the star of this space, opening onto the exterior. The pool's interior is made of white-stained concrete finished with small white tiles on the upper part. White terrazzo was used on the edges and around the rest of the terrace, reflecting the light and creating an impression of purity. The furniture in the sunbathing area has been set at each end of the pool, although any part of the terrace can be used to enjoy the sun after a swim. The swimming pool leads to a belvedere with views of the city and the slopes of Beverly Hills.

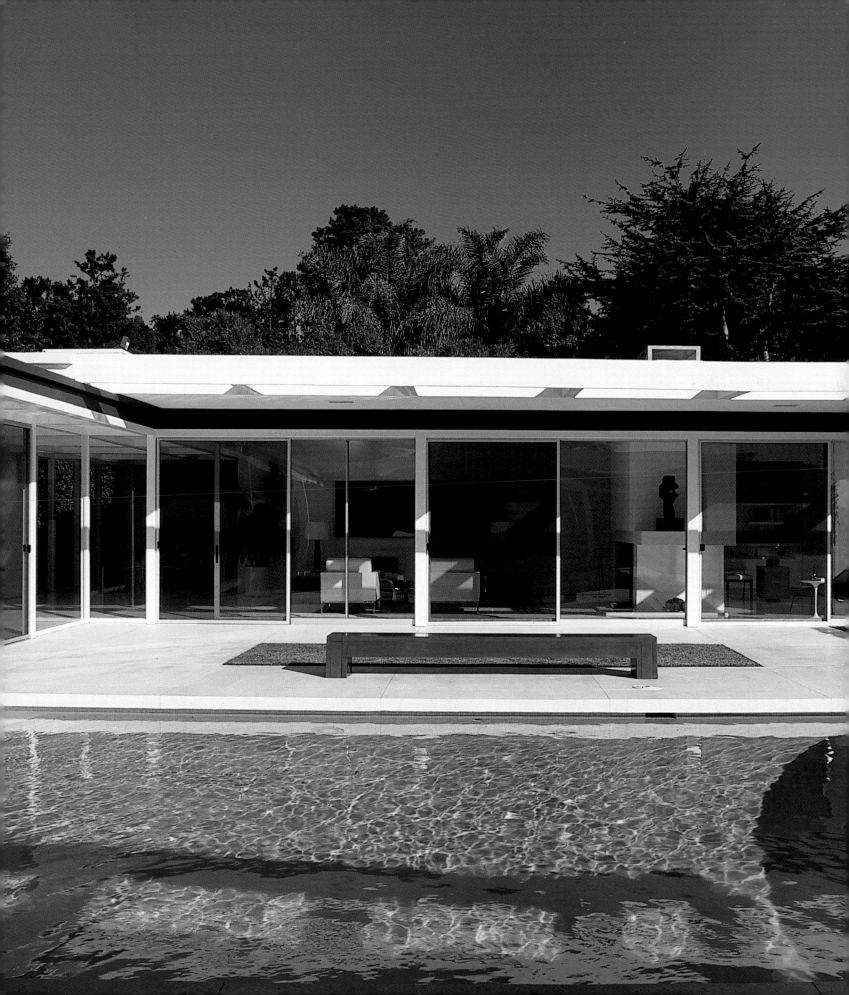

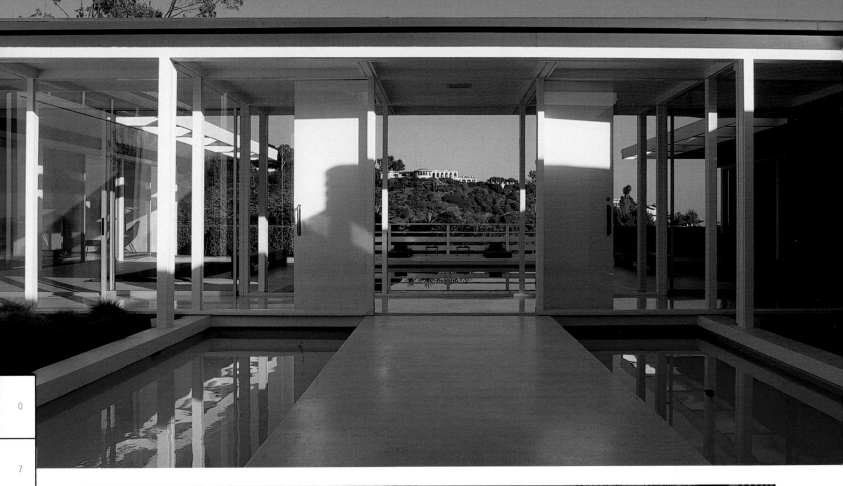

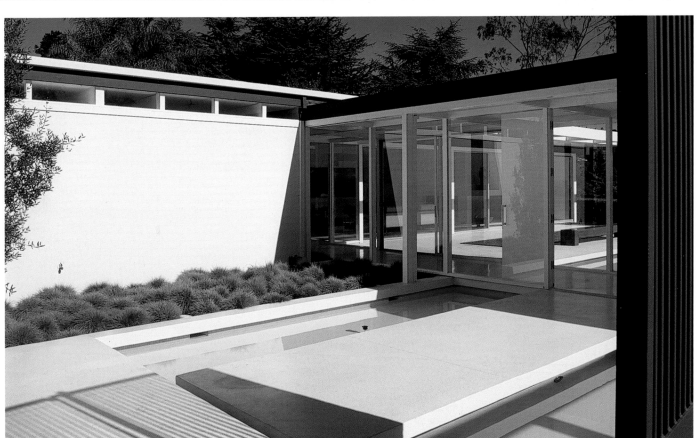

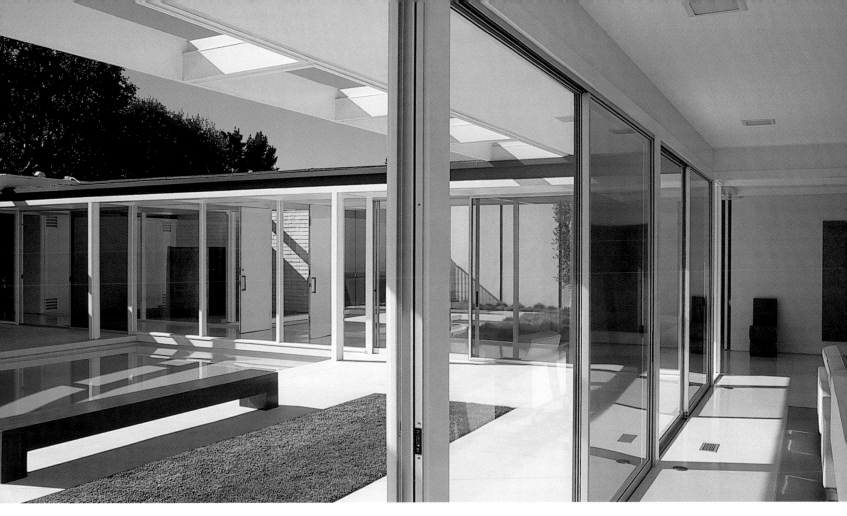

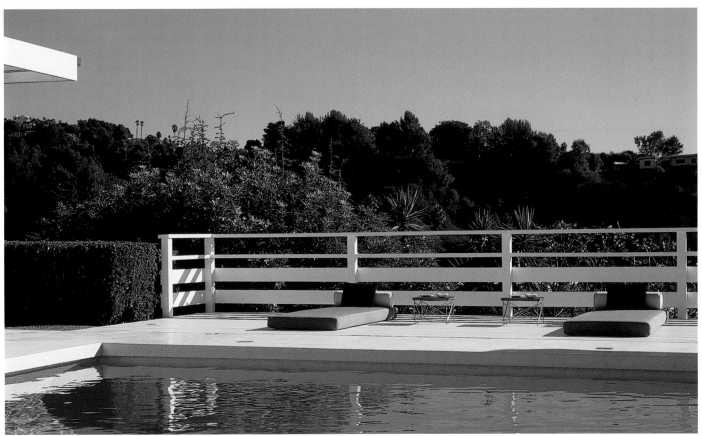

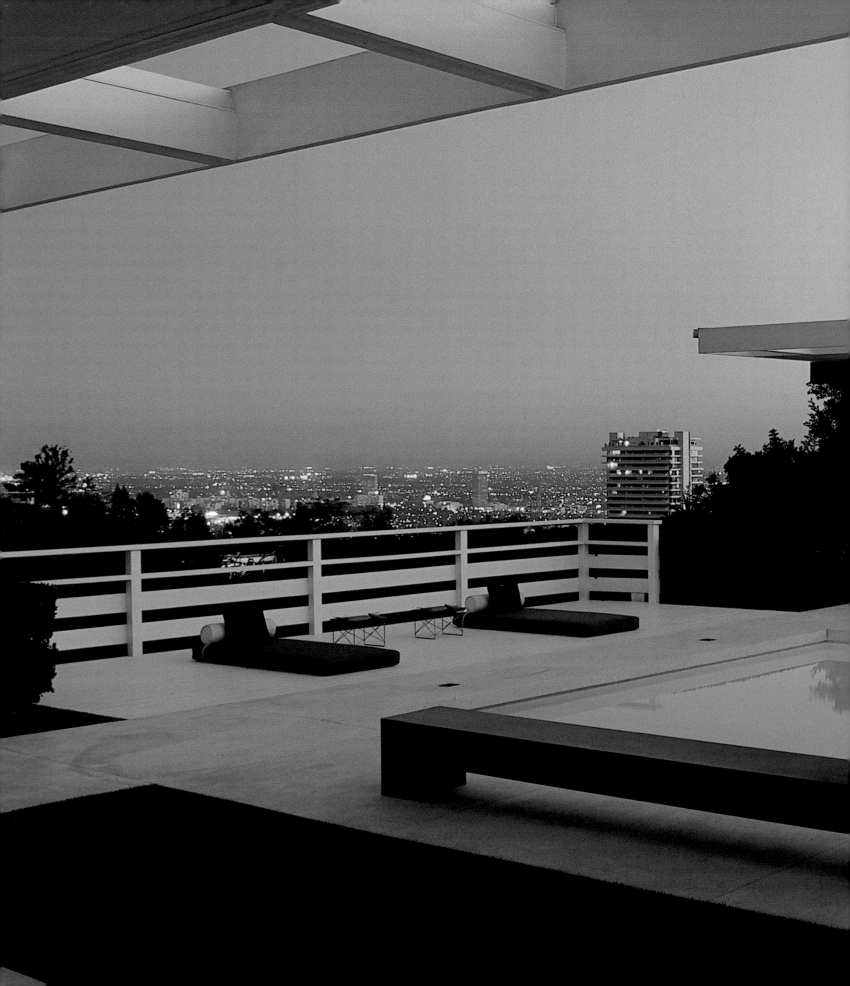

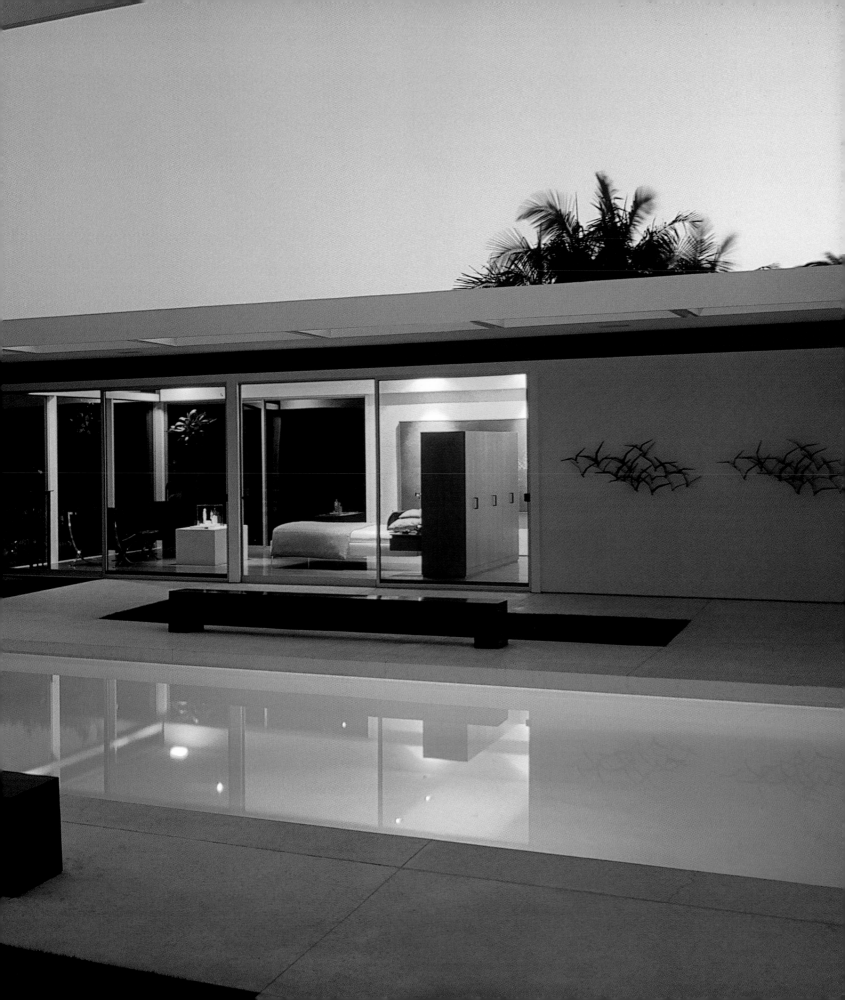

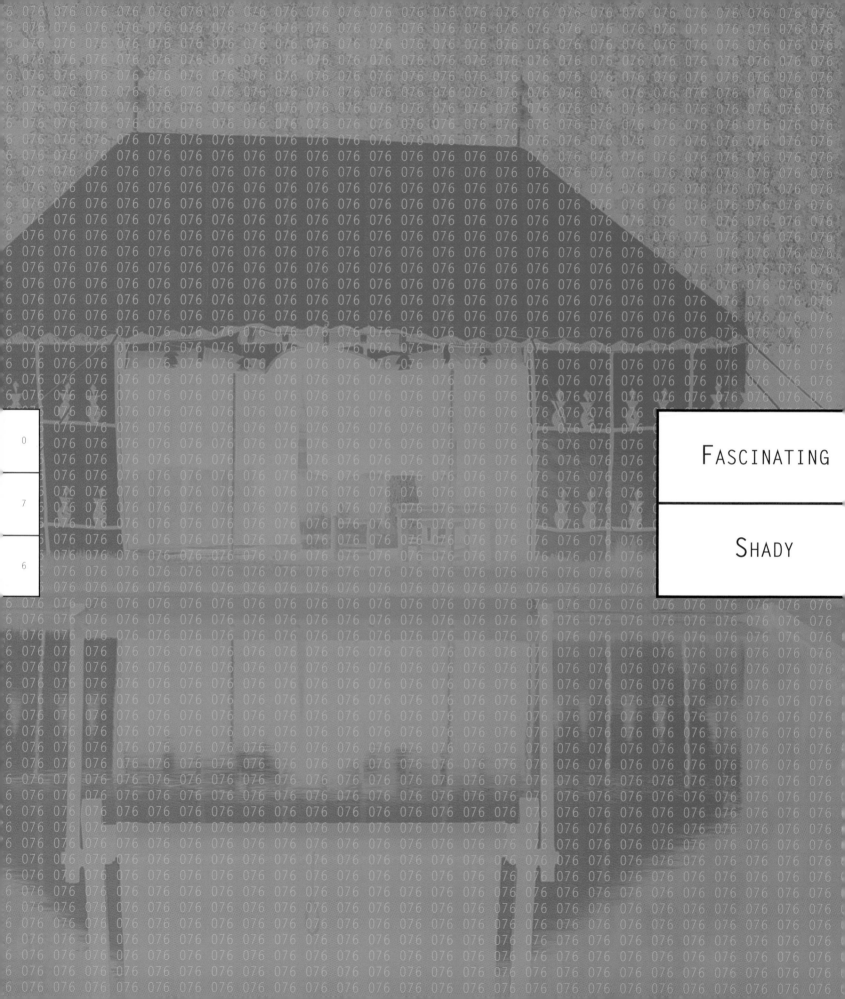

FASCINATING

SHADY

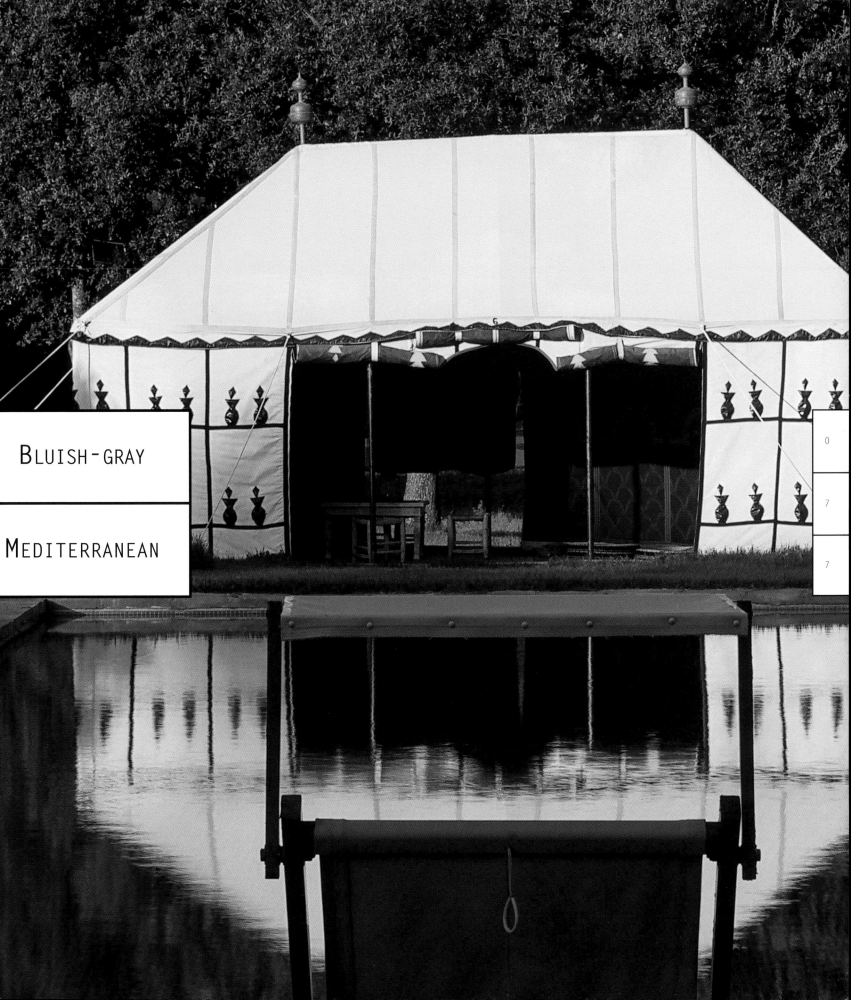

BLUISH-GRAY

MEDITERRANEAN

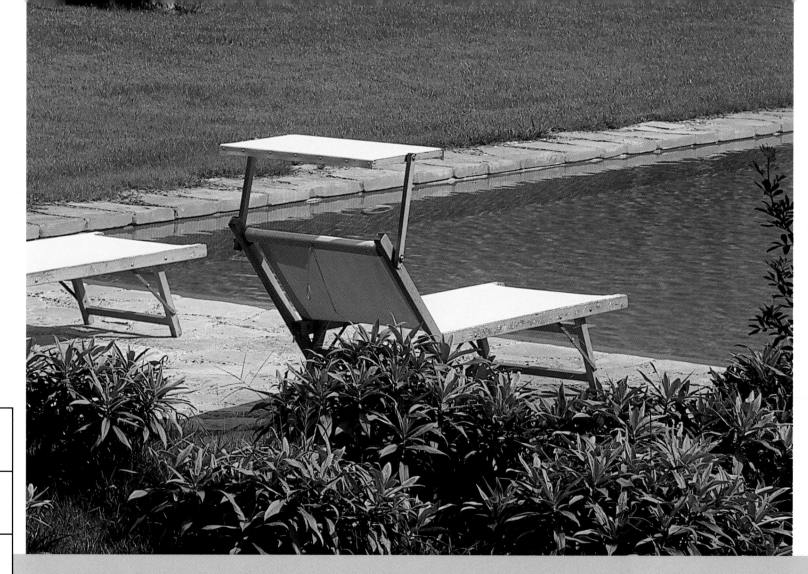

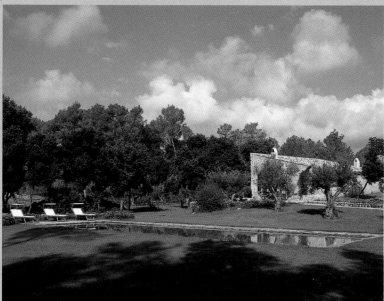

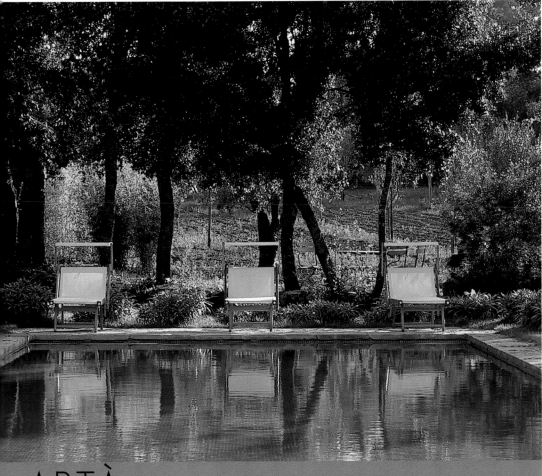

ARTÀ,
MALLORCA. SPAIN

According to Greek mythology, Athena, the goddess of wisdom and crafts, gave a cutting from an olive tree to the city of Athens, and this gift allowed olives to be grown throughout the Mediterranean. Even today this ancient tree is a symbol of peace, glory and wisdom and maintains our link with the past. This pool, with its pure Mediterranean style, is imbued with peacefulness and a reverence for the past. Two olive trees rise up from the lawn, providing shelter for the pool area. The pool itself is lined with small bluish-gray tiles and its edges are clad in natural stone. A strip of pebbles at one end soak up the water, creating a fascinating contrast of materials, while at the other end steps covered in the same bluish-gray small tiles span the entire breadth of the pool. Behind that, an authentic Arabian kaidal tent provides a shady refuge. The new buildings on this property, once owned by local farmers, also include a colorful dressing-room, complete with showers and toilets. Although this project has been realized with consummate care, it is essentially a very simple tribute to natural, wide-open spaces.

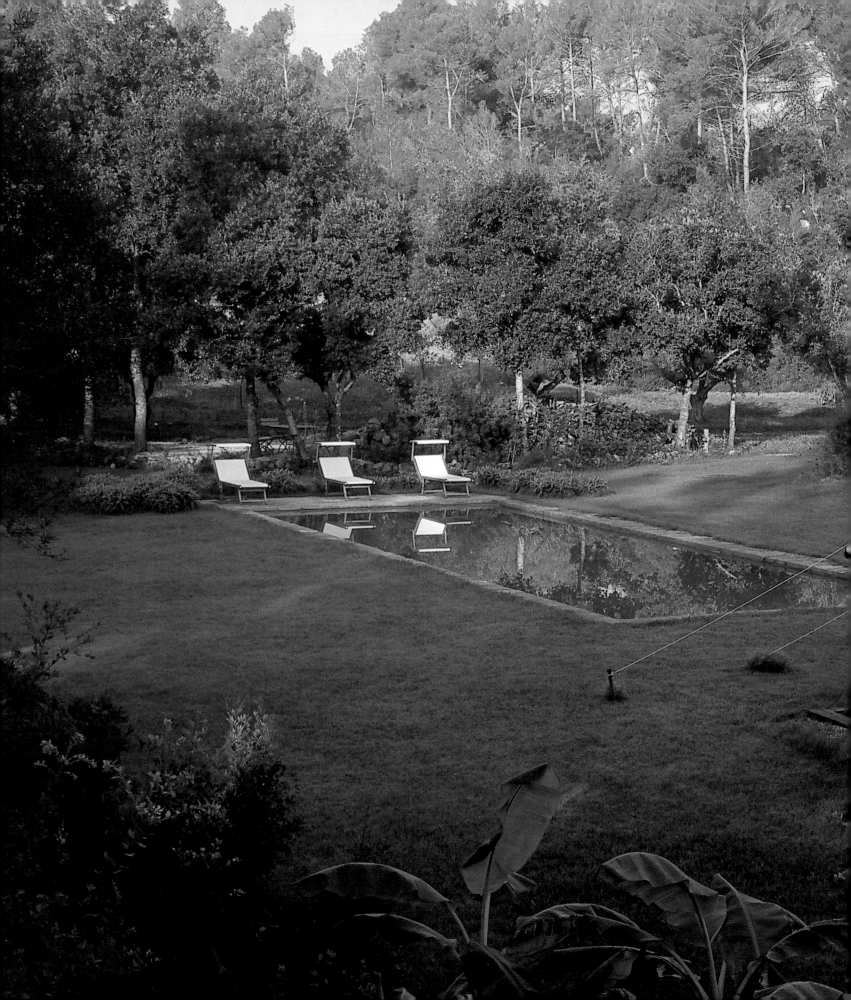

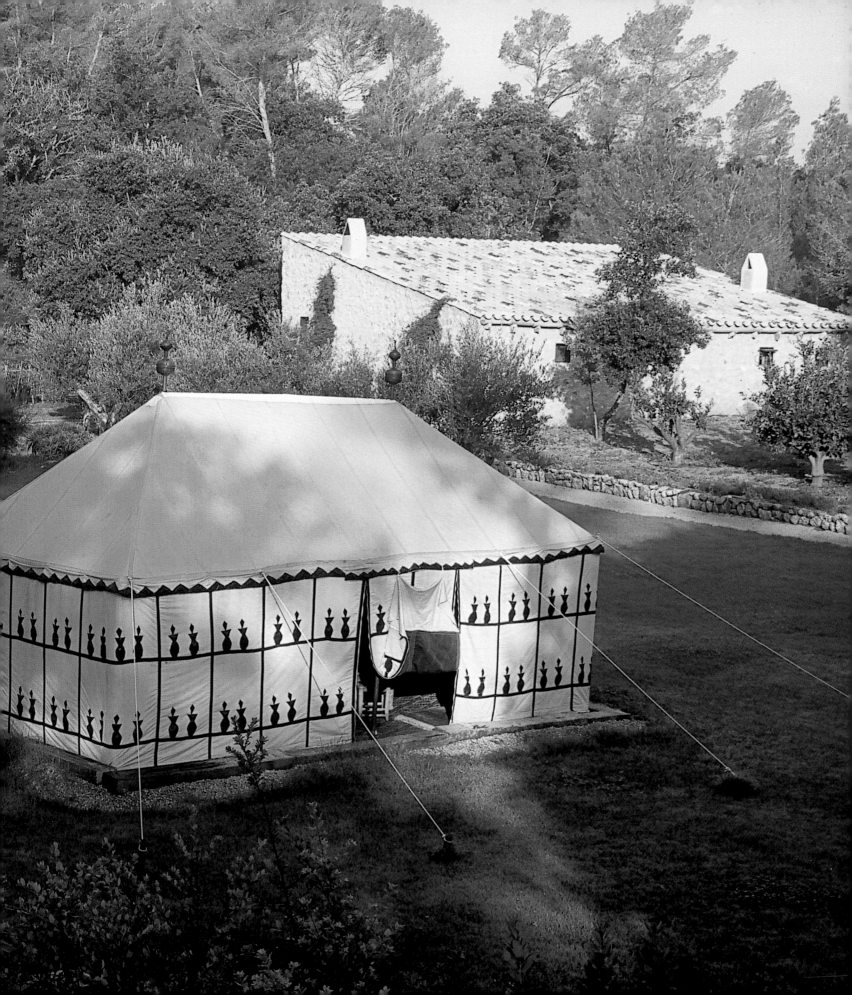

0

8

2

NATURAL

HORIZONTAL

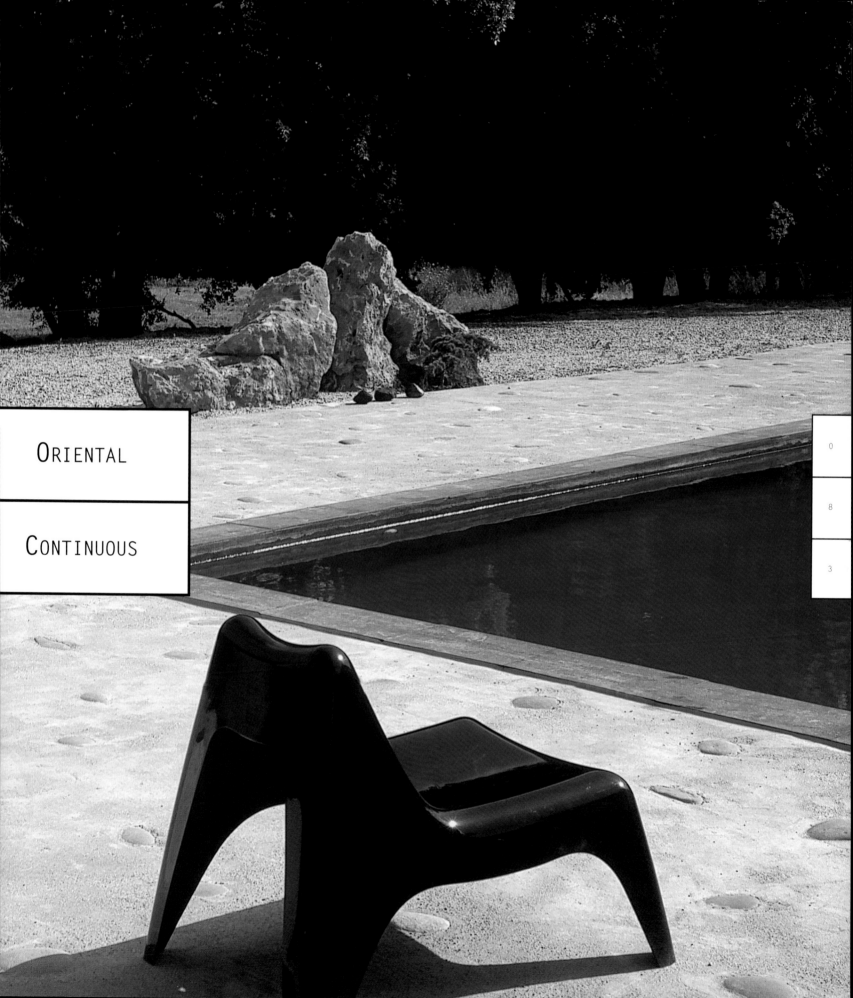

ORIENTAL

CONTINUOUS

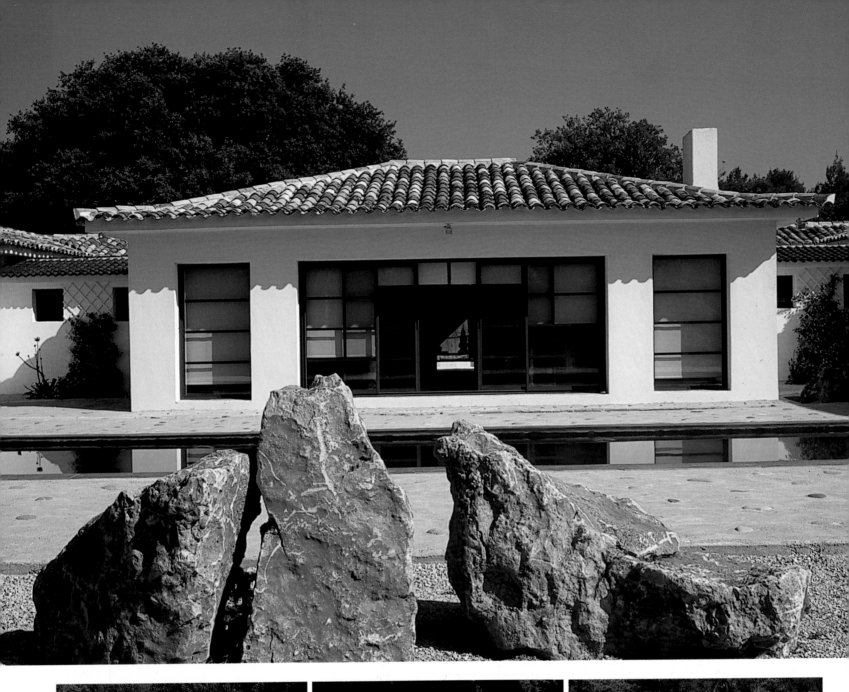

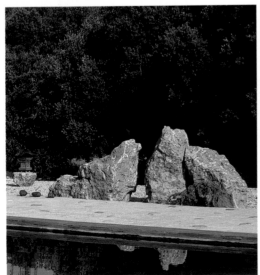
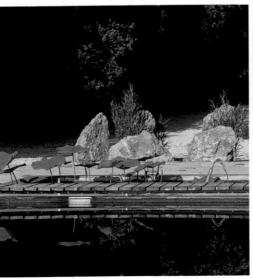
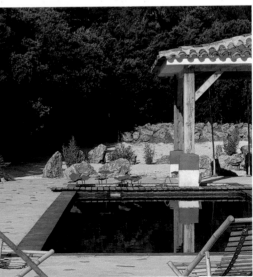

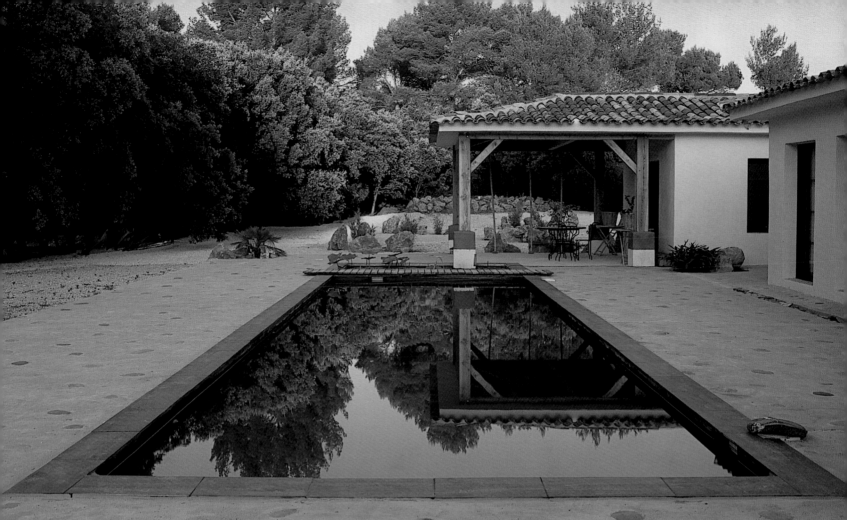

AIX-EN-PROVENCE, FRANCE

Zen beliefs maintain that water is the symbol of life and movement while plants represent growth and fertility. Water and nature combine in this project in Aix-en-Provence to create a large, almost symmetrical space inspired by centuries-old Asian traditions. The layout establishes an orderly sequence of environments, set on a horizontal plane: The house looks onto the swimming pool, which is backed by a pond with lotus plants and water lilies. The structure is flanked by two typical Japanese-style pavilions, with bamboo canes serving as vertical decorative elements, setting up a contrast with the bold horizontal lines of the other architectural forms. The pool and its surround (as well as that of the pond) are made of a combination of sand, lime and powdered marble, mixed with dark natural pigments to achieve a somber matte hue. This mixture also contains small particles of mica, a mineral that sparkles dazzlingly in the light. A treated wooden walkway marks a dividing line between the pool and the Zen garden. The pavement is made of concrete embedded with stone incrustations that echo a monumental natural sculpture made of large rocks, while the Sainte-Victoire mountain proudly rears up behind.

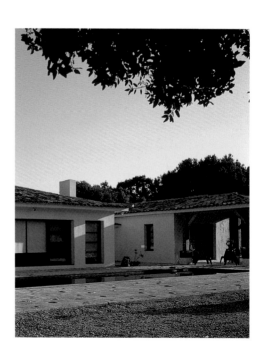

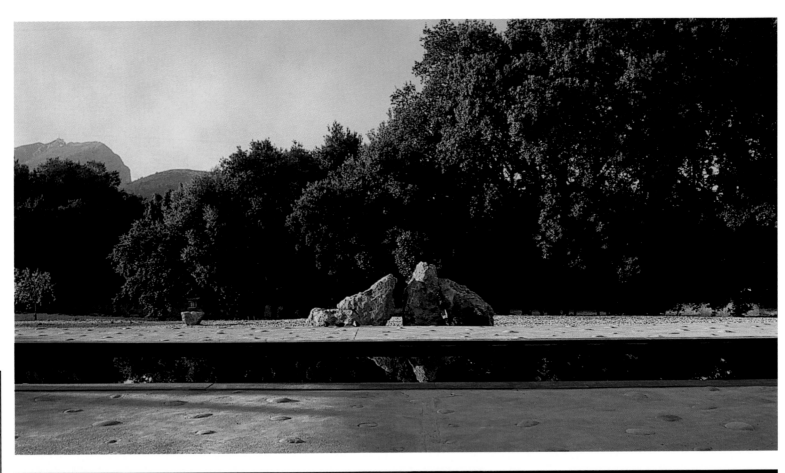

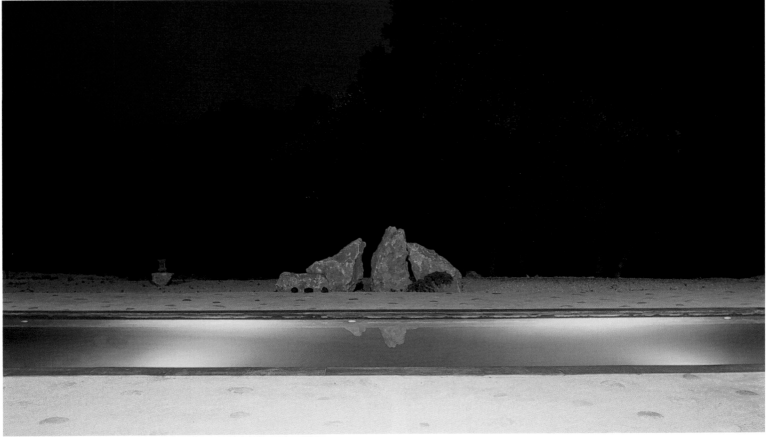

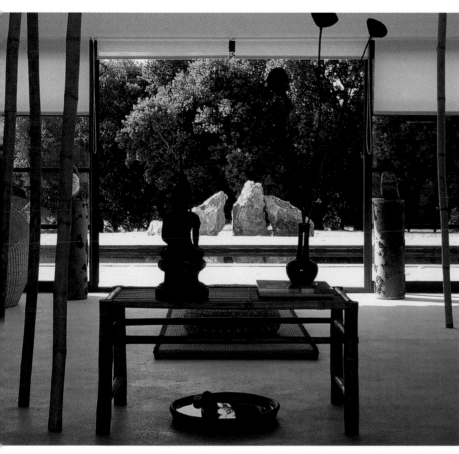

This project pays tribute to Asian culture, as well as respecting nature.

Three large boulders, arranged in a sculptural formation, vie for attention with the pool.

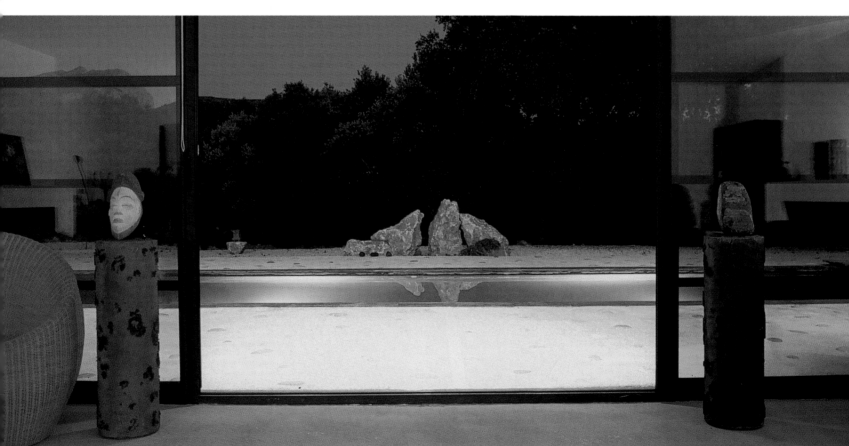

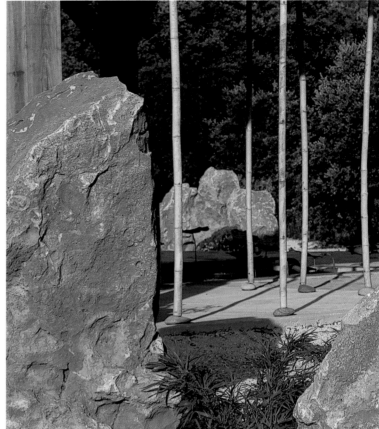

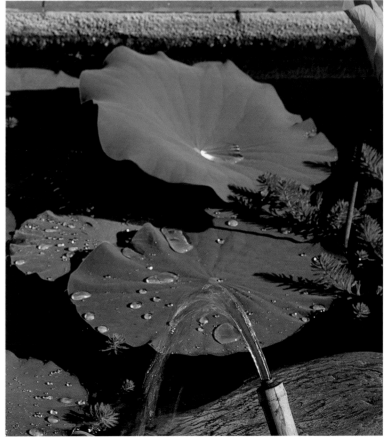

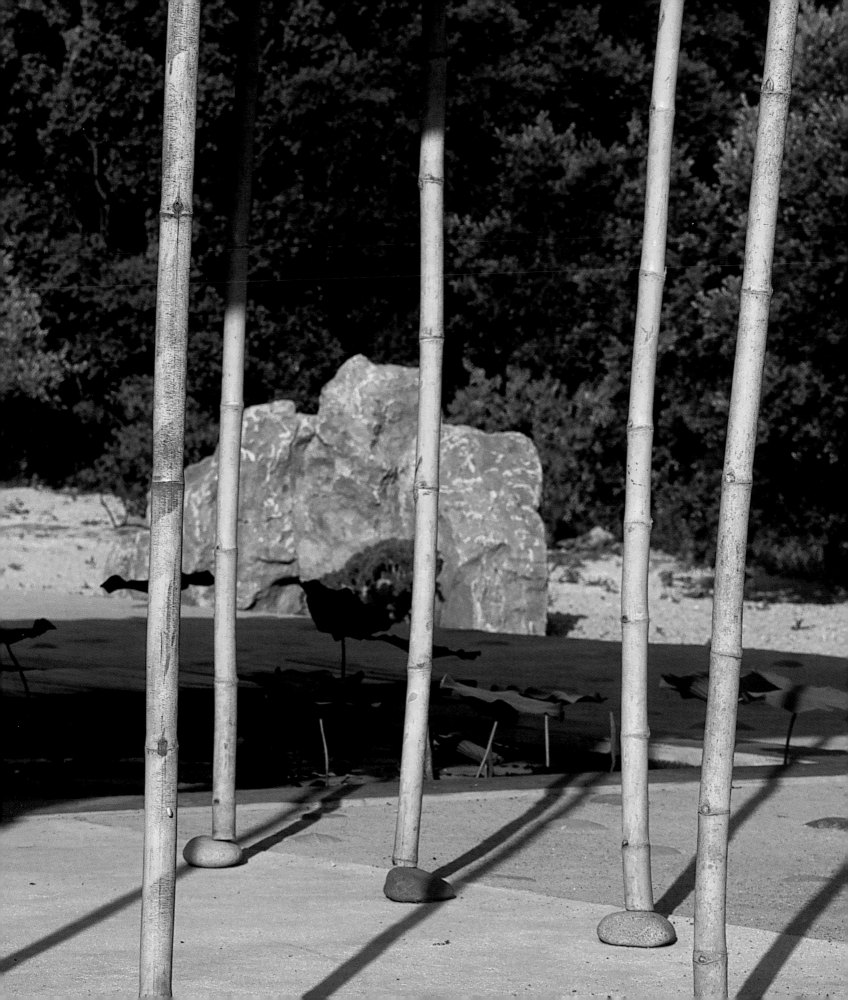

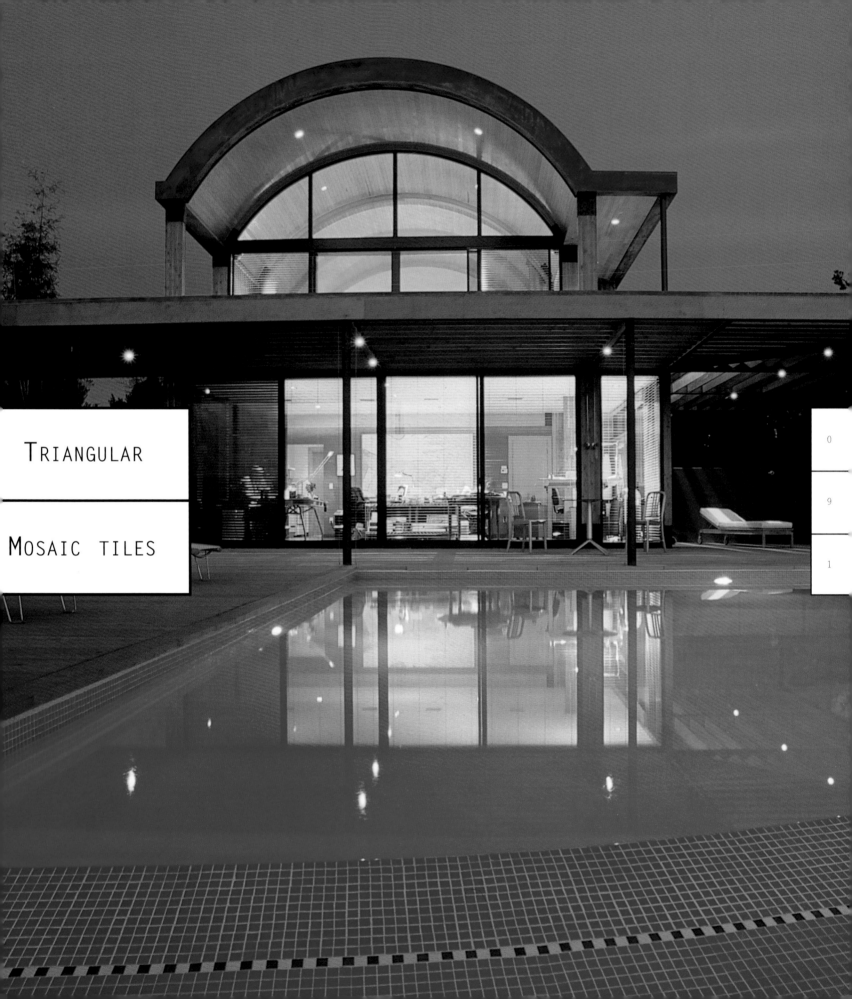

Triangular

Mosaic tiles

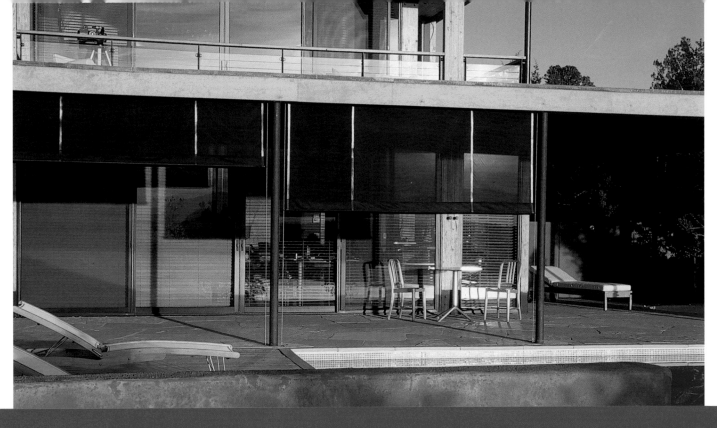

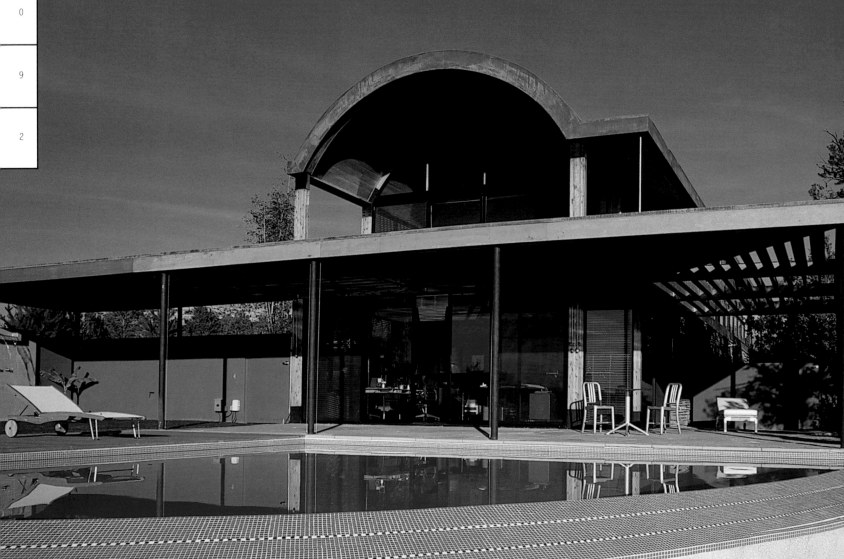

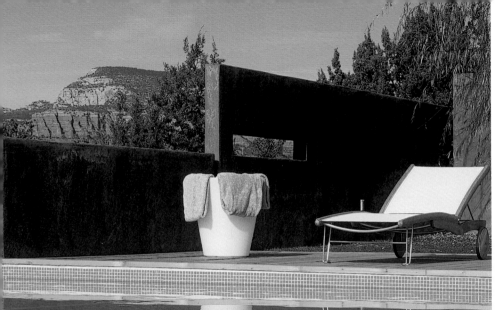

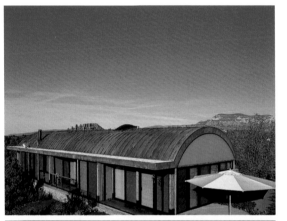

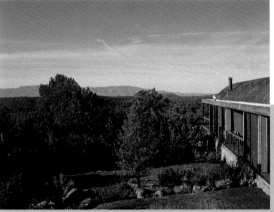

SEDONA,
ARIZONA. USA

This residence pays homage to the area in which it is situated—
the natural parks to the south of the Grand Canyon in northern
Arizona. One example of this design is in the reddish color of the
exterior walls, which imitates the natural pigments characteristic of
the soil in this region. The long-thin tunnel-like house combines
wood and glass on the facade, and its roof is clad with sheets of
oxidized copper. The swimming pool, set to the rear of the house,
takes the form of a triangle. It was built of concrete finished with
white-stained cement. The upper edges have been covered with small,
sky-blue vitrified tiles, set off by white tiles tracing two hori-
zontal lines. The sunbathing area on one side of the pool has been
floored with wooden planks, while the rest of the terrace was built
with the limestone typical of the area. The terrace is marked off by
an original and practical canopy that emerges from the house itself.
Its basic structure is made of iron, and it is completed by wooden
slats that can be adjusted as required to vary the intensity of the
light passing through them.

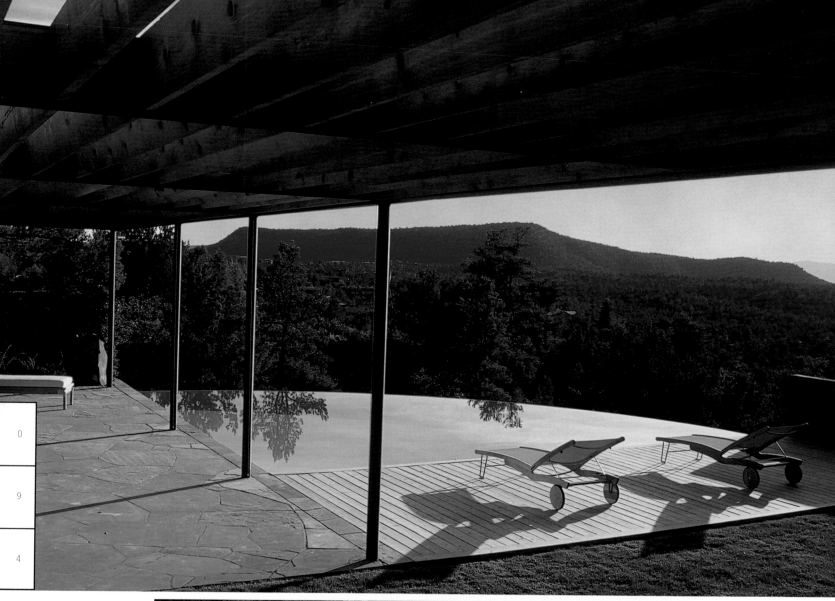

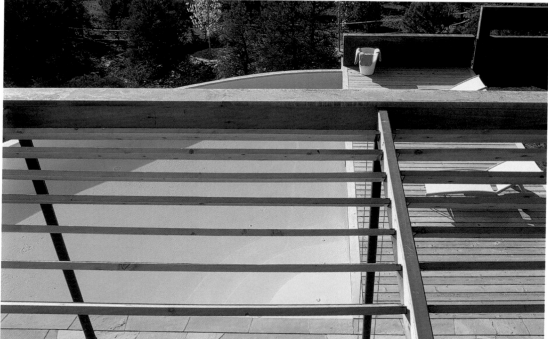

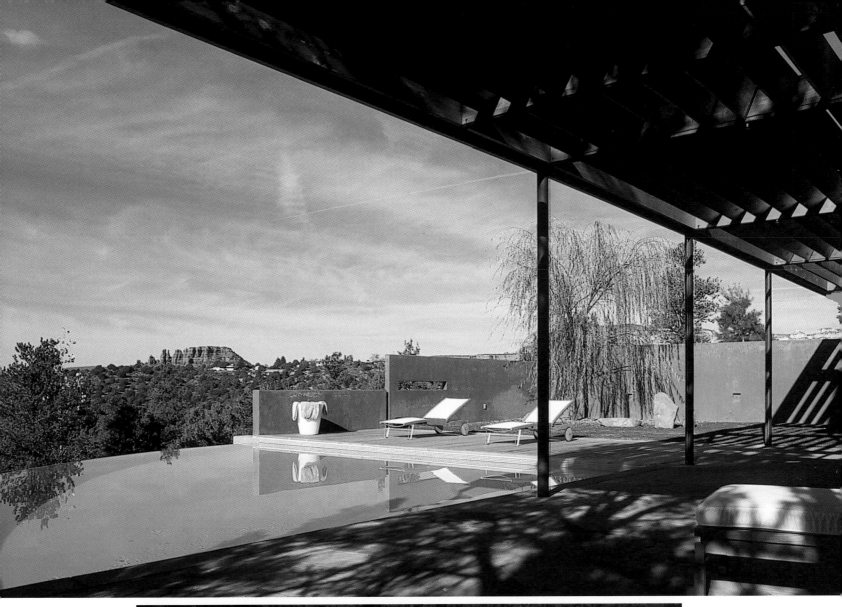

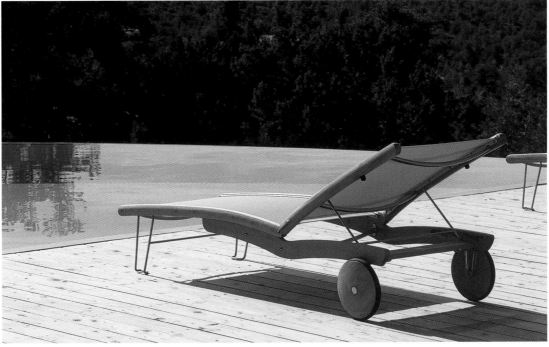

0

9

6

IMMACULATE

GEOMETRIC

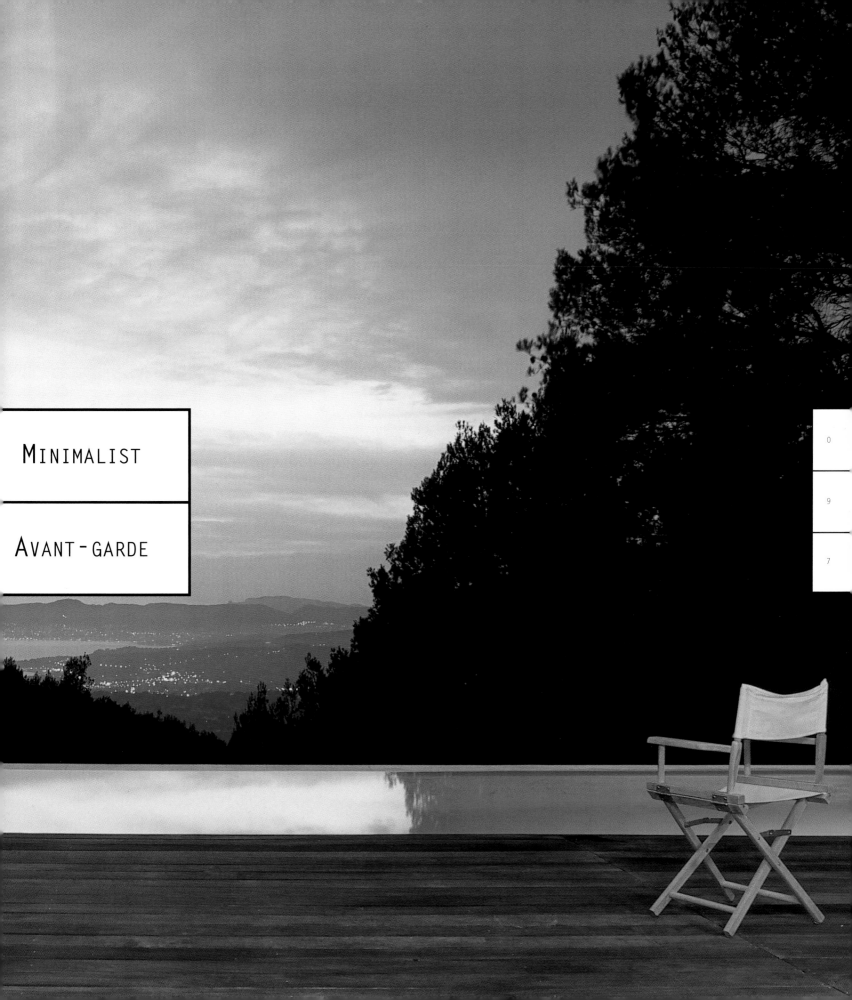

MINIMALIST

AVANT-GARDE

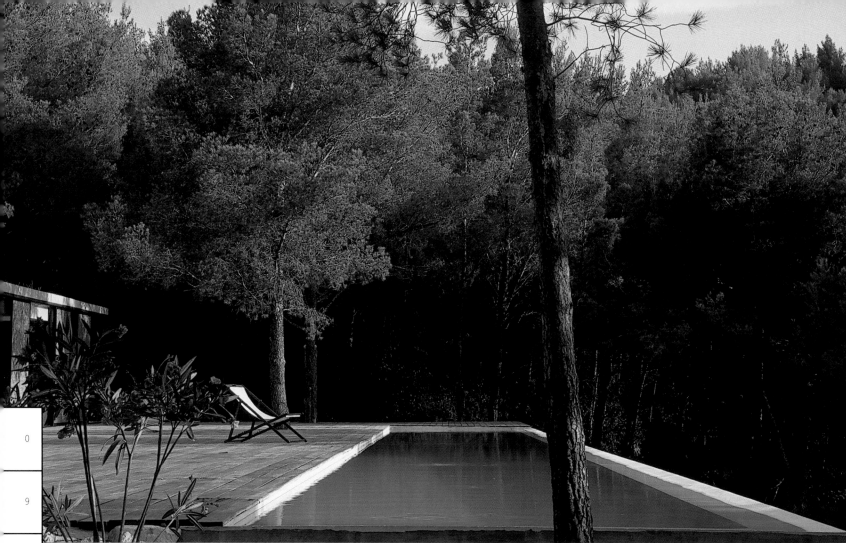

BANDOL, FRANCE

The connection that this new building establishes with the surrounding landscape is by no means easy to achieve. Creating visual continuity and providing a shared language for indoor and outdoor spaces can be a thankless task but this project brings it off. The keys to its success are the strict longitudinal geometry and pure minimalist lines of its forms. The home opens out onto the grounds by means of big, sliding glass doors, protected by striking iron structures, which effortlessly unite the two spaces. A continuous teak platform marks out the ample terrace and links the building to the pool, a strip of water that stretches towards the lush vegetation of pines and vineyards. A mixture of marble powder, cement, lime and pale-colored natural pigments was used for the casing of the pool, setting up a powerful interplay of blues and whites that seem to merge into the sea on the horizon. Despite its uncompromising avant-garde approach, this project shows the utmost respect for the landscape. One example of this is the attention that has been given to the trees growing on the property: the design of the wooden platform has been adapted to their forms. This detail encapsulates the essence of the project.

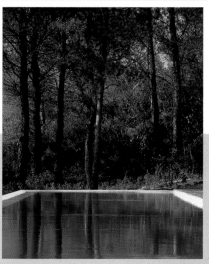

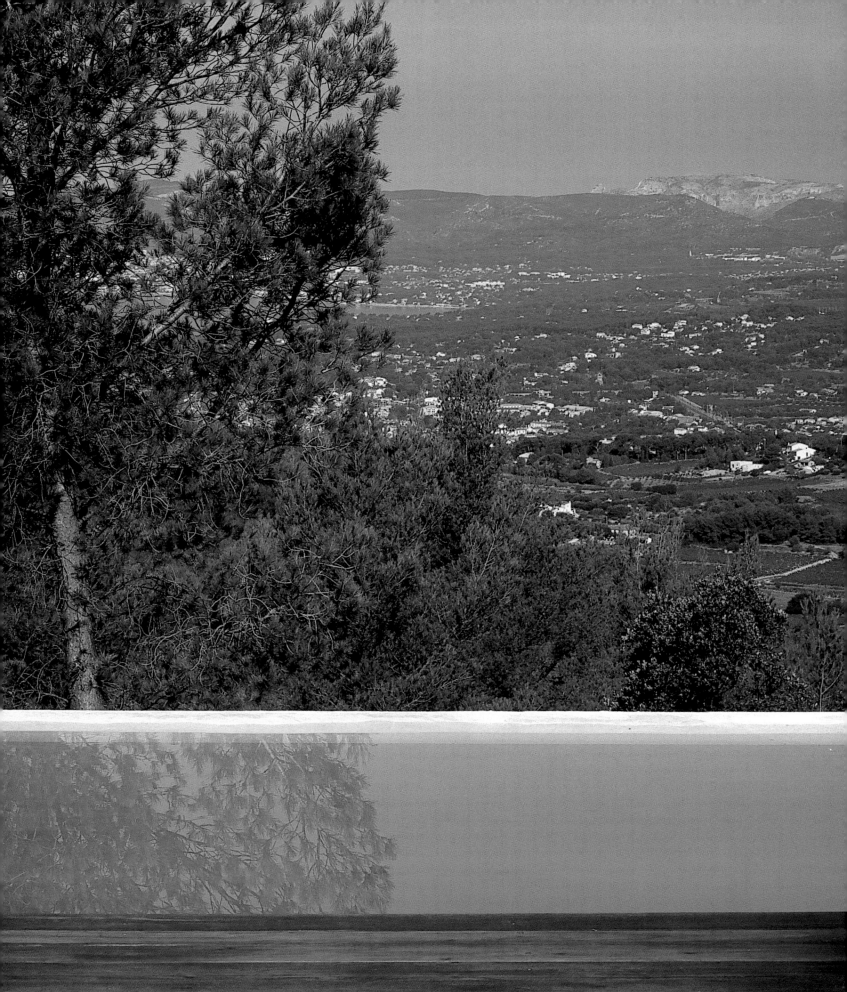

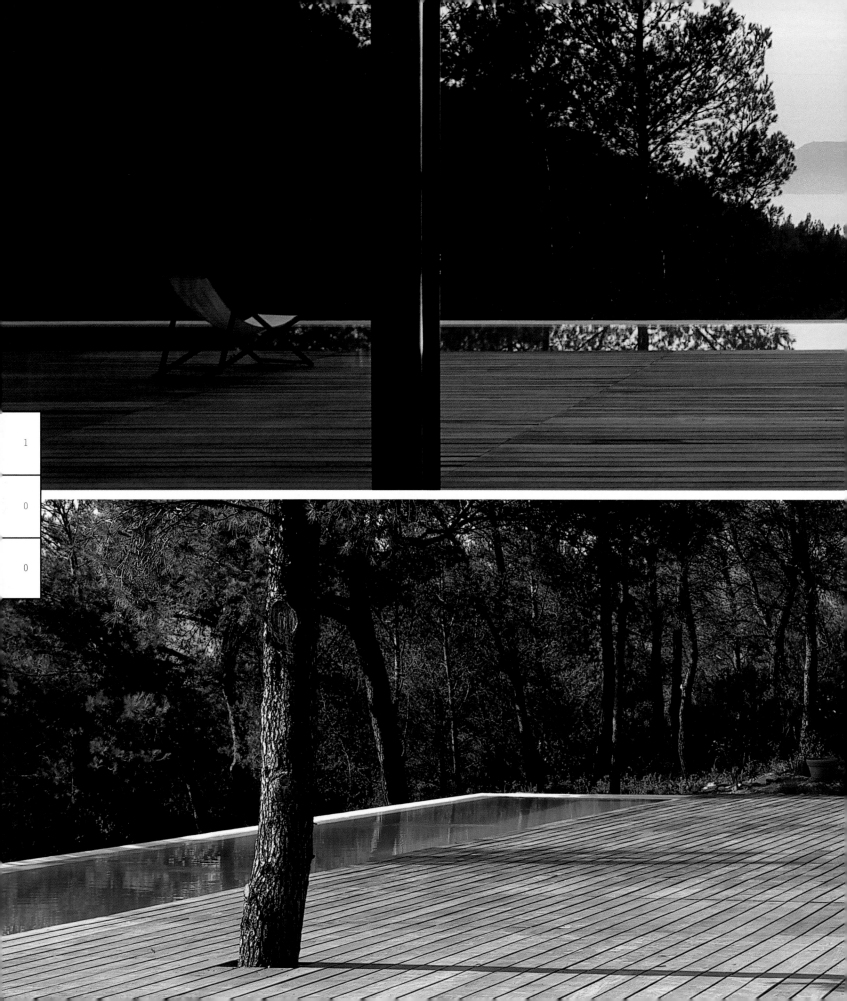

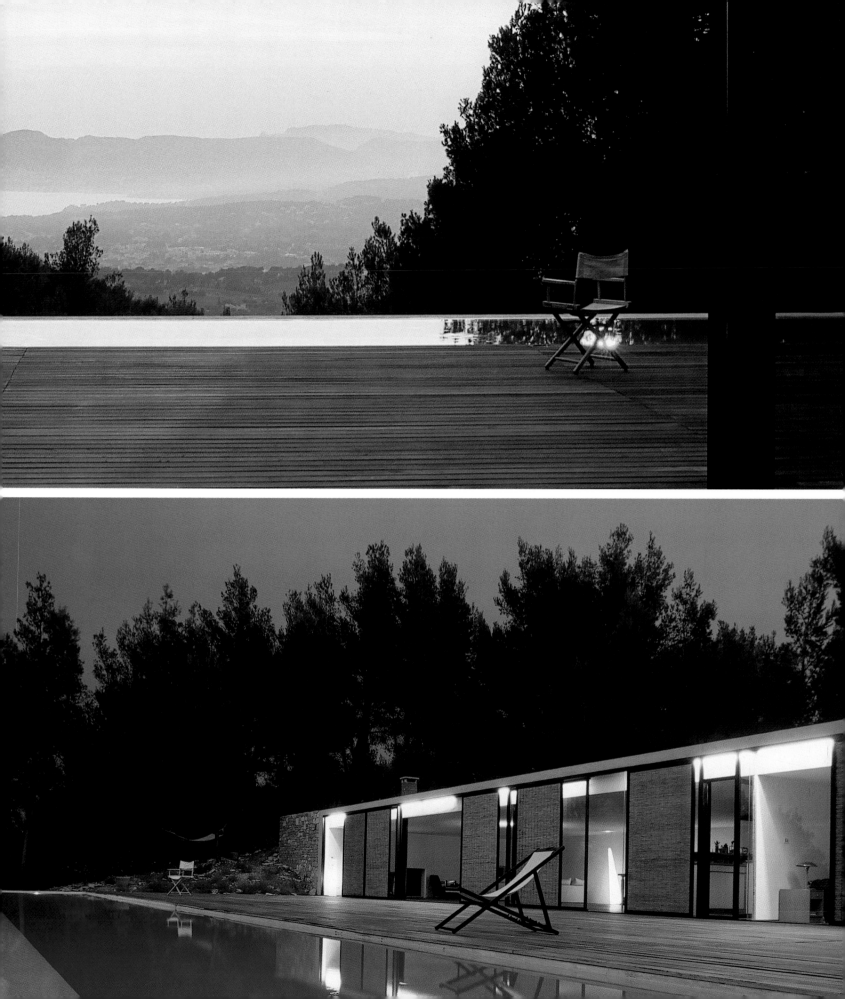

1
0
2

SECLUDED

GRAY AND BEIG

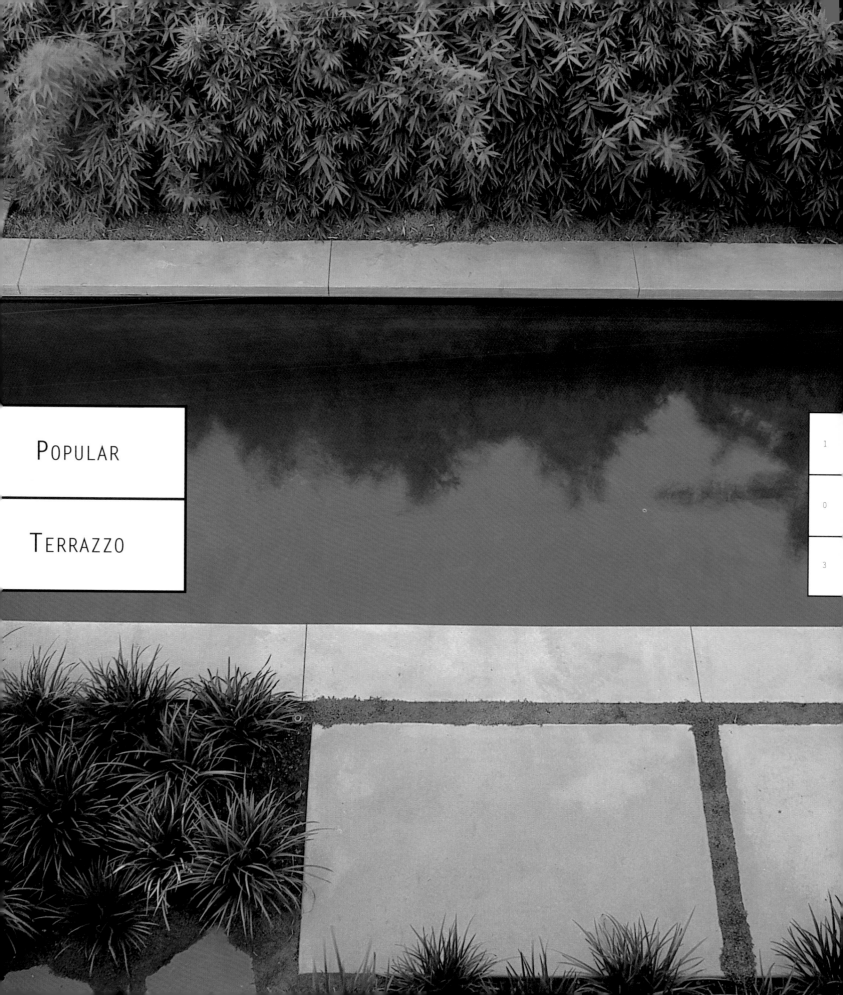

POPULAR

TERRAZZO

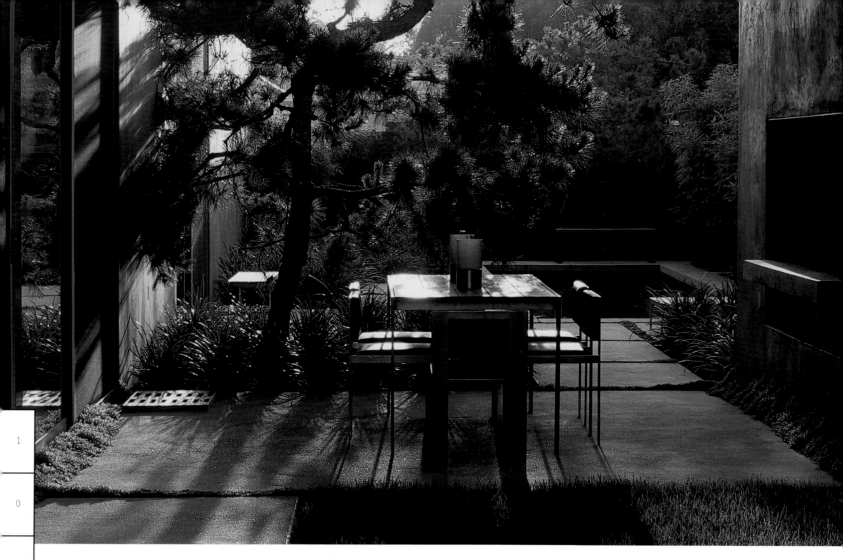

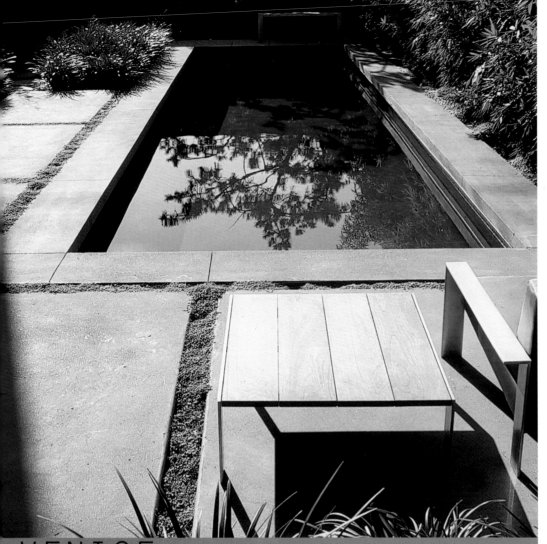

VENICE,
CALIFORNIA. USA

Although this pool is a modern construction, its rectangular design and total integration into the environment inevitably take us back to the old country reservoirs of the past. It is situated on a secluded property in the highly popular Venice neighborhood. Gray concrete was used for its interior, while the same material was applied in beige to the edges of the pool and the rest of the deck. The tops of the pool's walls are set off by a strip of small black tiles. The materials used seem to paint the water in shades of gray and green that match the natural surroundings. The curved forms of the steps are striking—they may not be symmetrical but they are nevertheless extremely elegant. The terrazzo slabs are laid with slight spaces between them, and these are planted with grass to extend the lush vegetation of the bamboos and pines. One end of the pool is designed to be a sunbathing area, decorated with a style of furniture that emphasizes the modern spirit of the project; at the far end, a stylized bench surveys the water and marks the boundaries of the property with an original flourish.

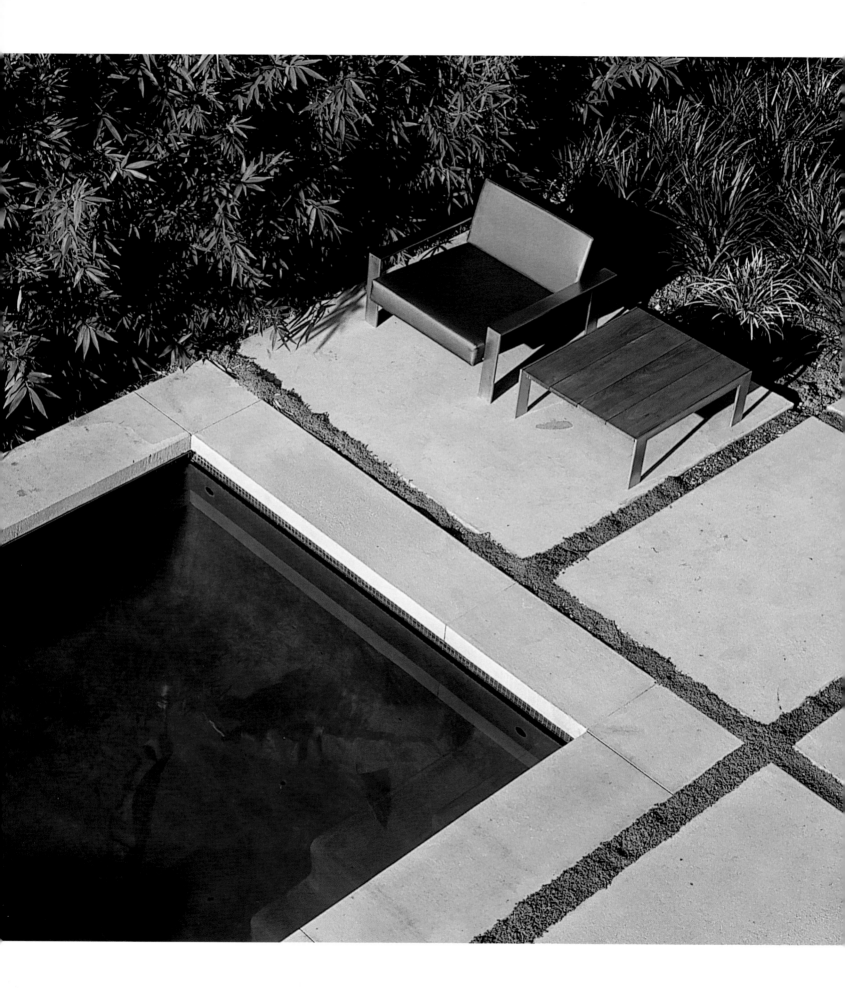

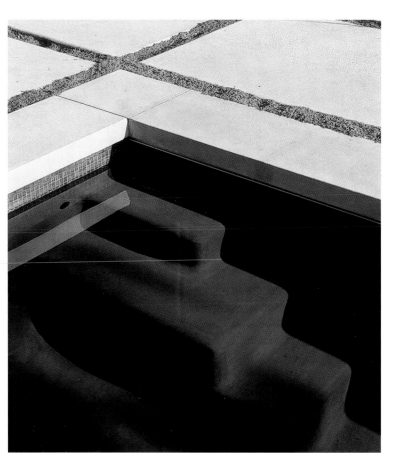
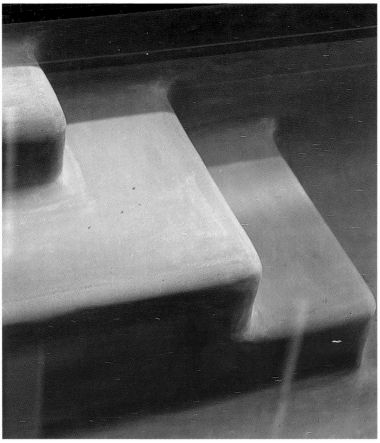

108

INFINITE

EXPANSIVE

SPACIOUS

SCRUBBY

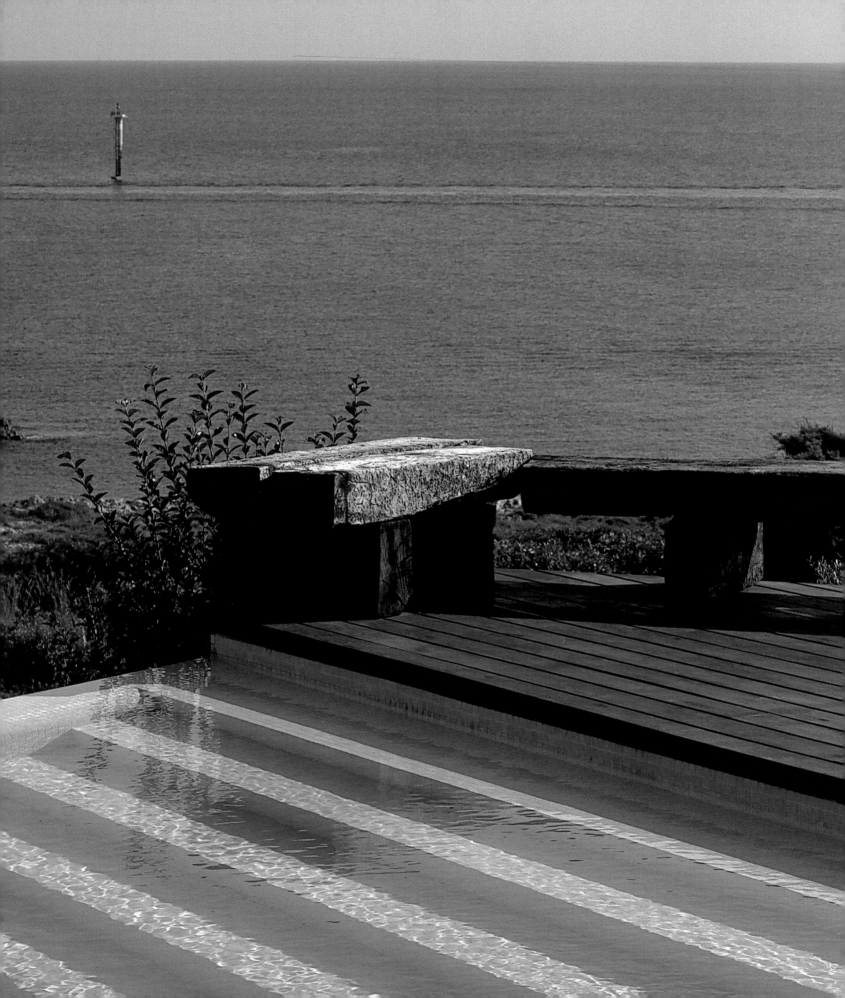

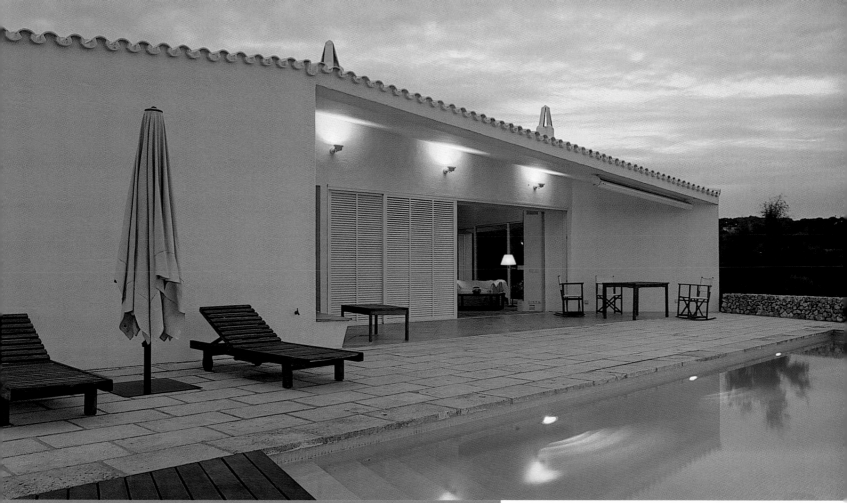

EAST COAST, MENORCA. SPAIN

The trapezoidal form of this pool on the coast of Menorca provide a logical link between the land and the vastness of the sea, blurring the edges of the two settings. The pool was set in front of the infinite Mediterranean seascape, creating an interesting contrast of blues, broken up by the scrubby beach. The overall construction of the property was inspired by the old rural houses on the island, with their tiled roofs, traditional white-painted chimneys and stone walls, although they have all acquired updated forms. Mirroring the natural setting, local marés stone was used on the terrace, which provides a spacious sunbathing area. The steps to the pool are unobtrusively set into one side, ensuring that nothing impinges on the expansive view of the sea and leading elegantly onto the sharp rectangular lines of a walkway made of tropical wood. The space is marked off by a bench made out of old railway ties, cutting across the display of blues offered by both the water and the sky.

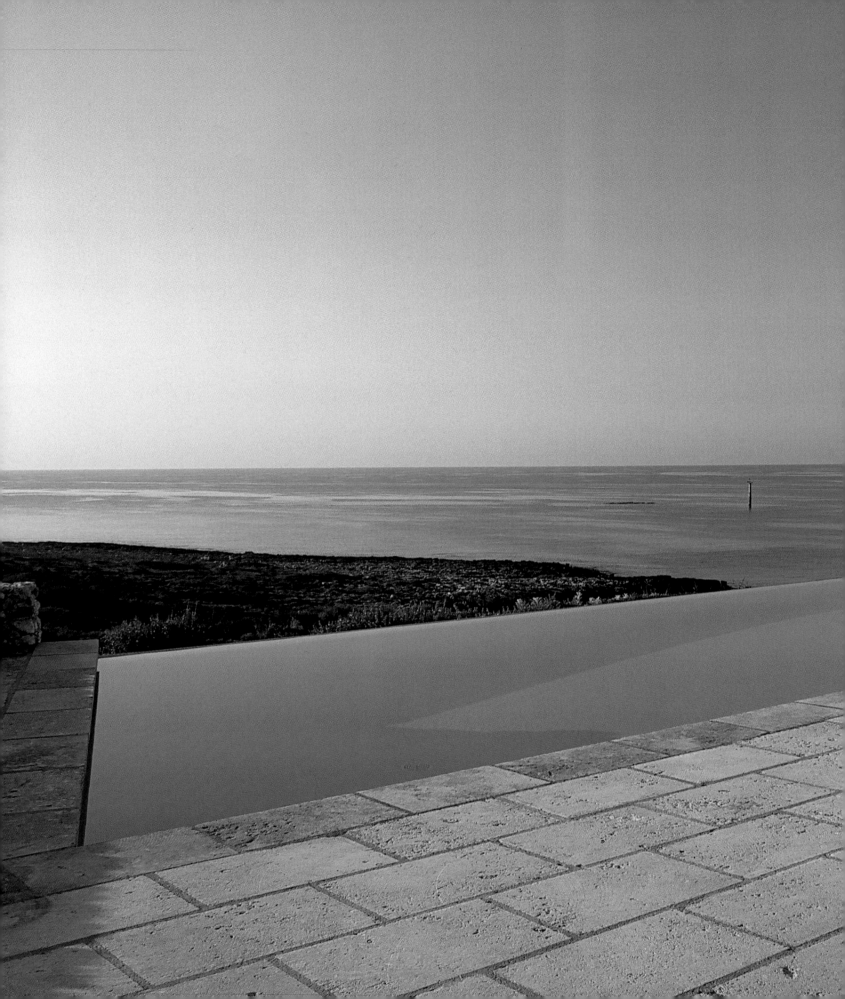

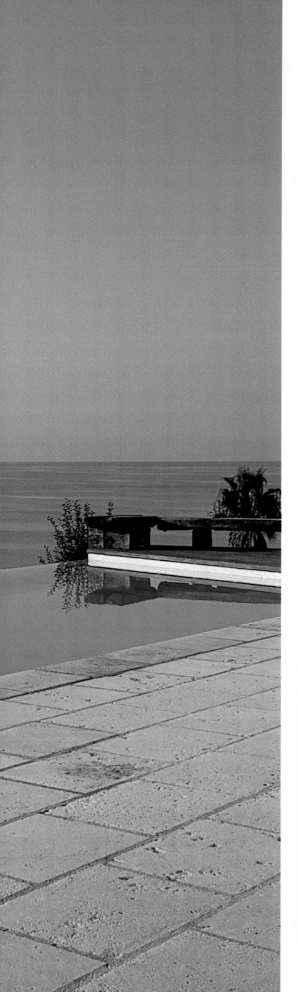

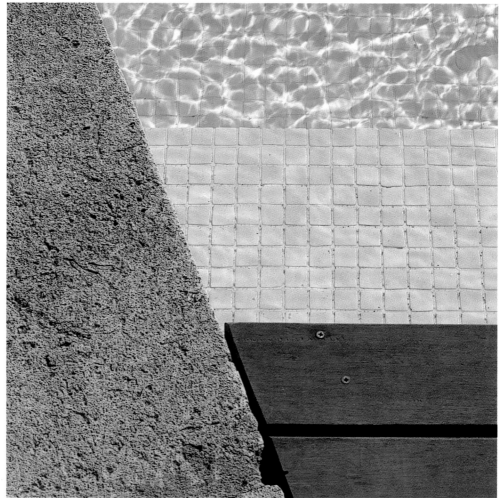

1

1

3

DISTINGUISHED

EXQUISITE

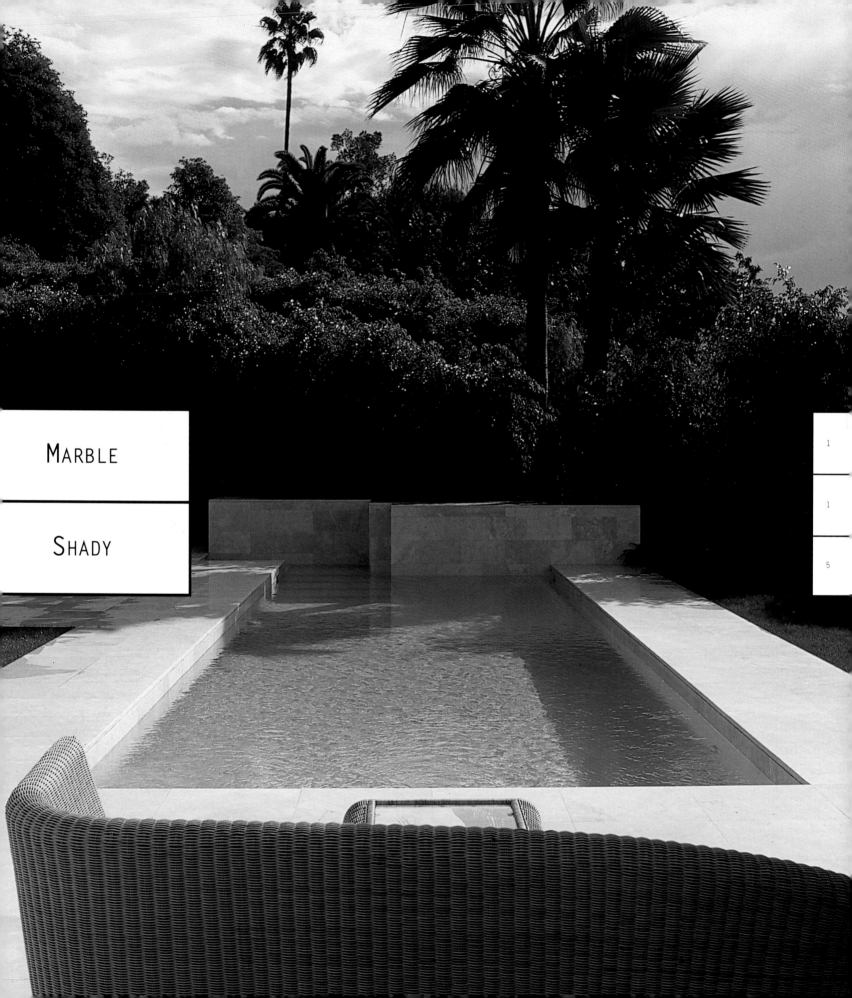

MARBLE

SHADY

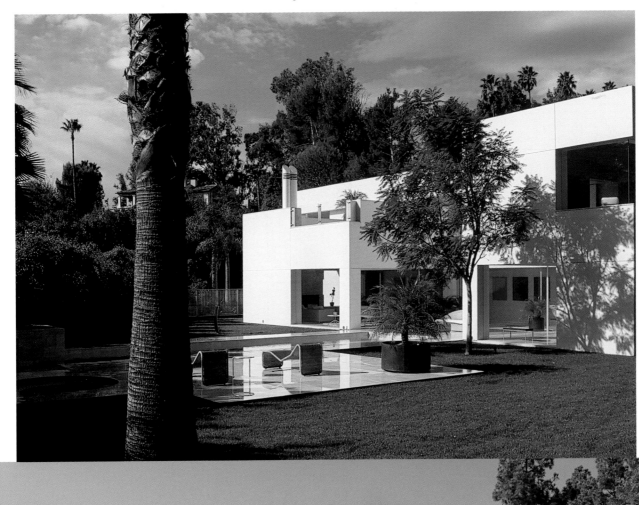

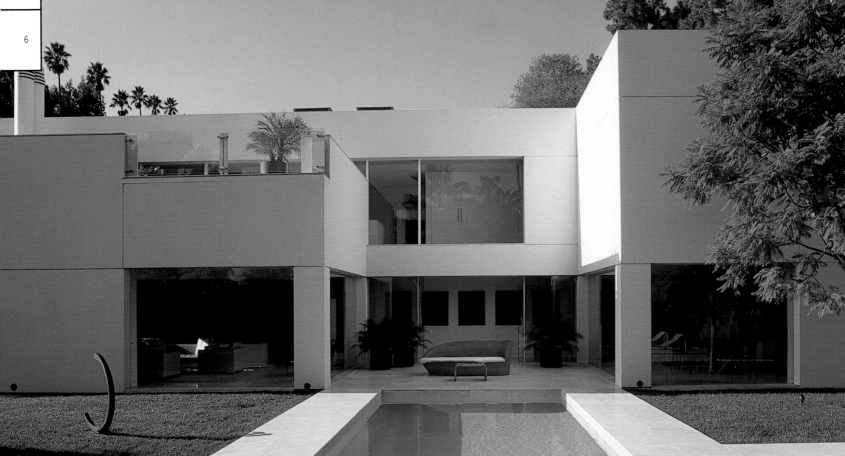

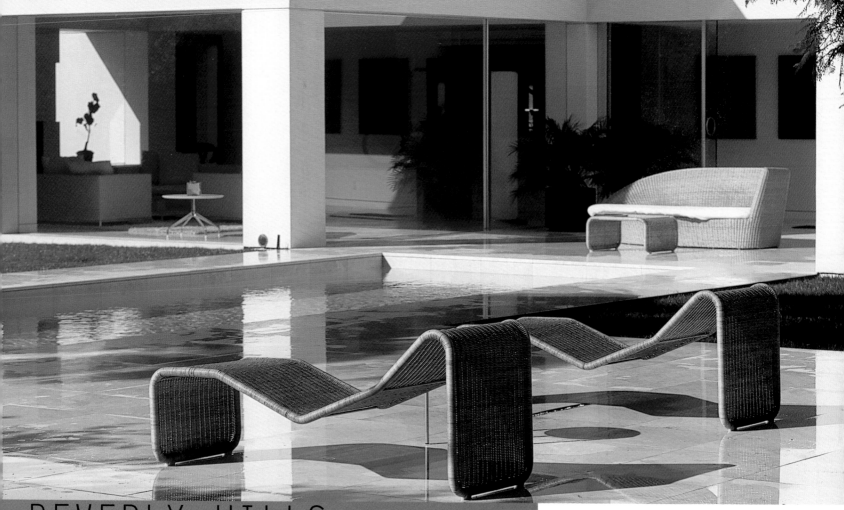

BEVERLY HILLS, CALIFORNIA. USA

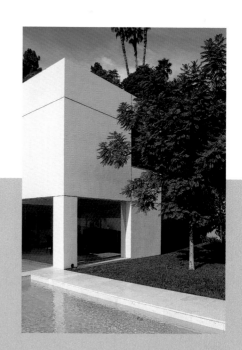

This is a very modern project, with exquisite lines and perfect finishing. Water is the dominant element in this large terrace, which gradually gives way—via imposing steps made of Travertine marble from Nabona set into an access area—to a round jacuzzi. While the interior of the pool is built with white-painted concrete, the distinguished and elegant Travertine marble integrates it into its surroundings, as this material is also used on the edges and in a large part of the terrace-garden. Marble and grass alternate in the area around the pool, and the grass serves as a natural marker of the areas given over to vegetation and sunbathing. This alternation of bright white with the green shades of grass and palm trees creates an attractive natural mosaic, as well as making the space extremely luminous and bestowing elegance and order on it. The sinuous forms of the sparse furniture, made of natural fibers (two sun beds and a small table in the sunbathing area, and a couch with a side table facing the pool) add the warmth that this almost pristine space requires.

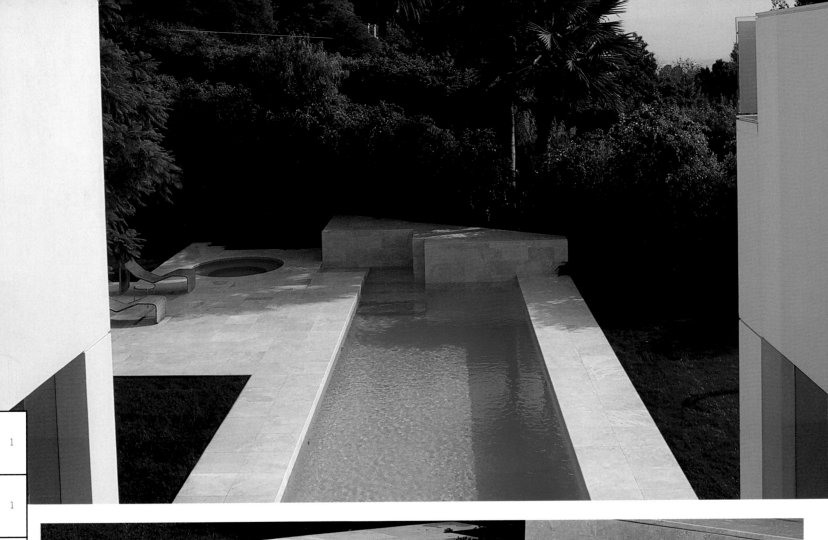

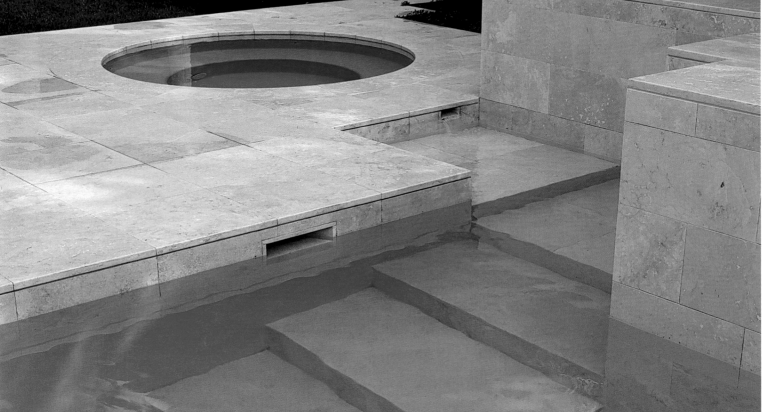

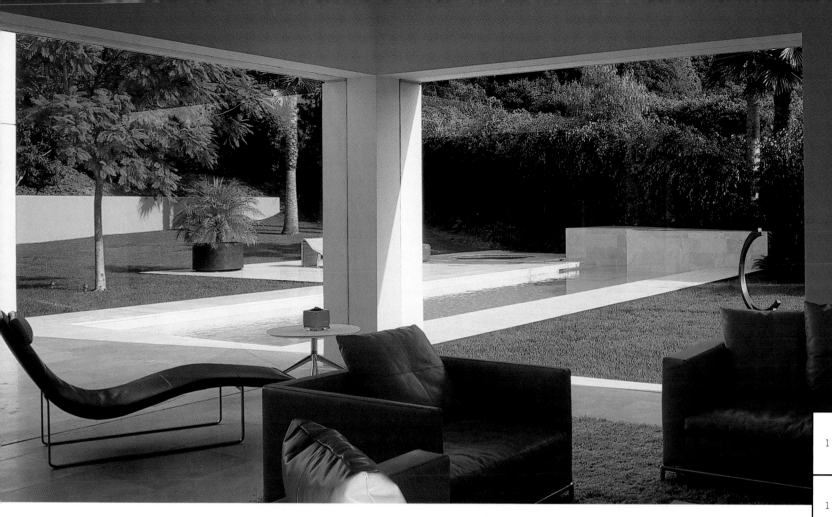

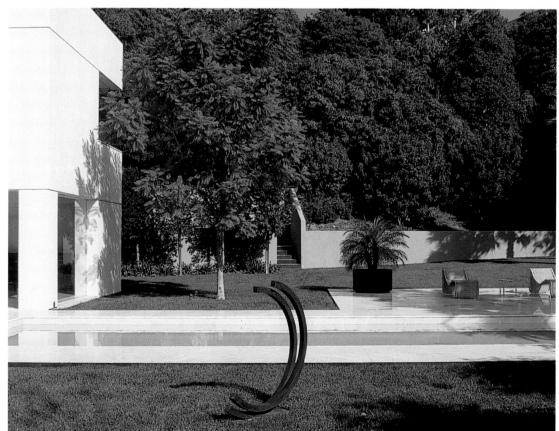

1
2
0

CLASSICAL

FAITHFUL

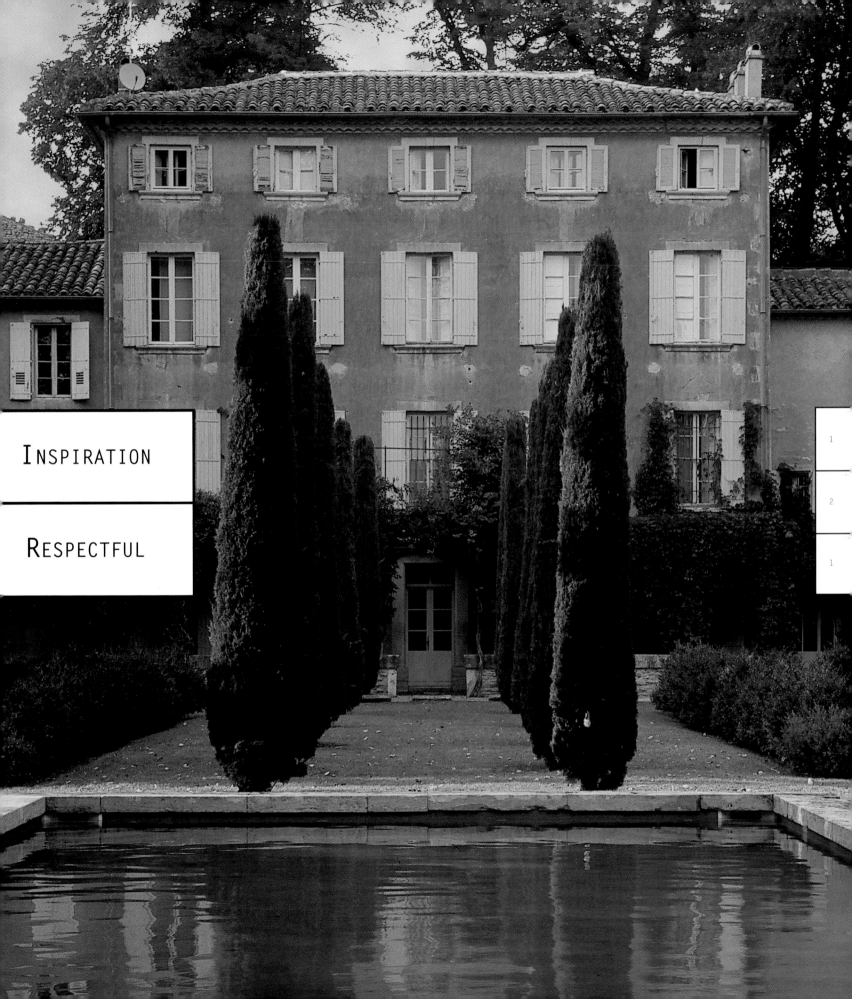

INSPIRATION

RESPECTFUL

All homes have a story to tell and the fact is that it is often the space that chooses the owner and not the other way round. This was the case with the owner of the Château de l'Ange in Luberon Natural Park in France, who is also responsible for its refurbishment—a process that involved recreating every detail while faithfully reflecting the classical values prevalent when the building was originally built in the eighteenth century. Peace and inspiration are the touchstones of this château, as the owner has divided the space into a living area and a studio devoted to work. A reservoir that was once used to irrigate the garden has been converted into a swimming pool, which is linked to the house by a row of cypress trees. The interior of the pool is clad with sand, cement and lime, and the casing is made of the sandstone native to the area. The extensive lawn stretches out before giving way to lush natural vegetation, studded with plane trees and black poplars, which also mark out the boundaries of the property. In a more intimate area, designed for relaxation, a pergola made of plant fibers protects an old fountain left over from the original construction, illustrating how respect for the past imbues every nook and cranny.

LUBERON, FRANCE

1
2
2

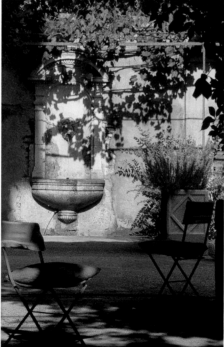

The owner of the house
has preserved many period
elements, such as this old
fountain, which looks onto
a shady resting area.

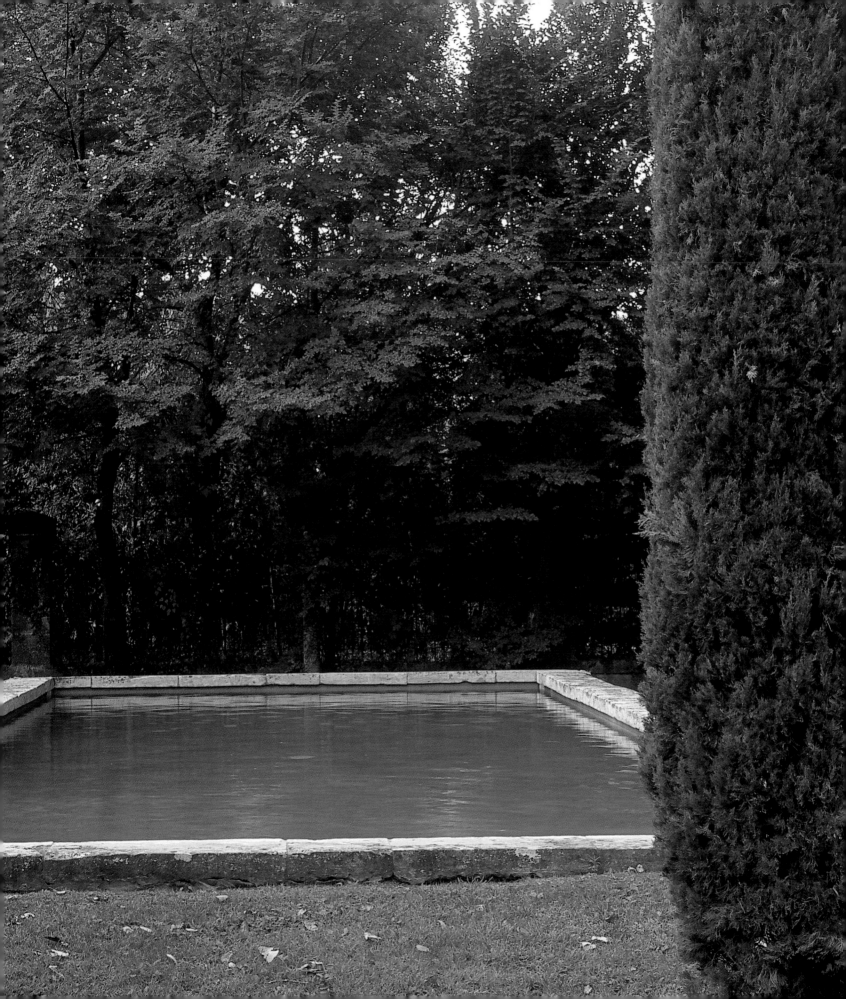

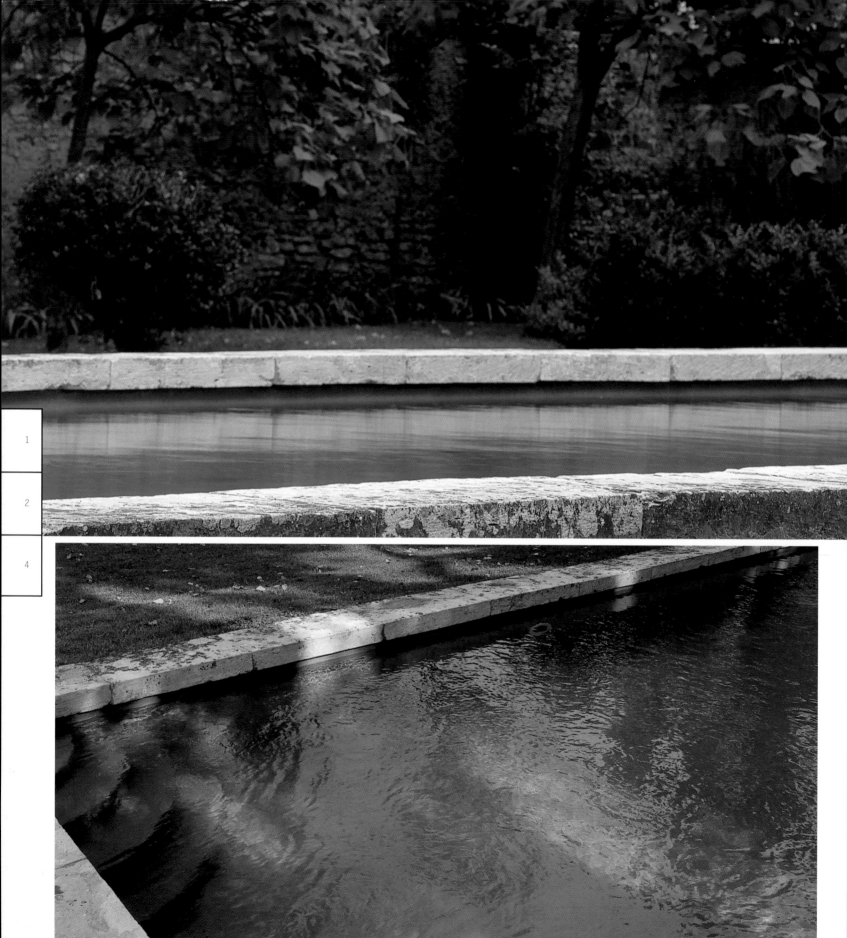

1

2

4

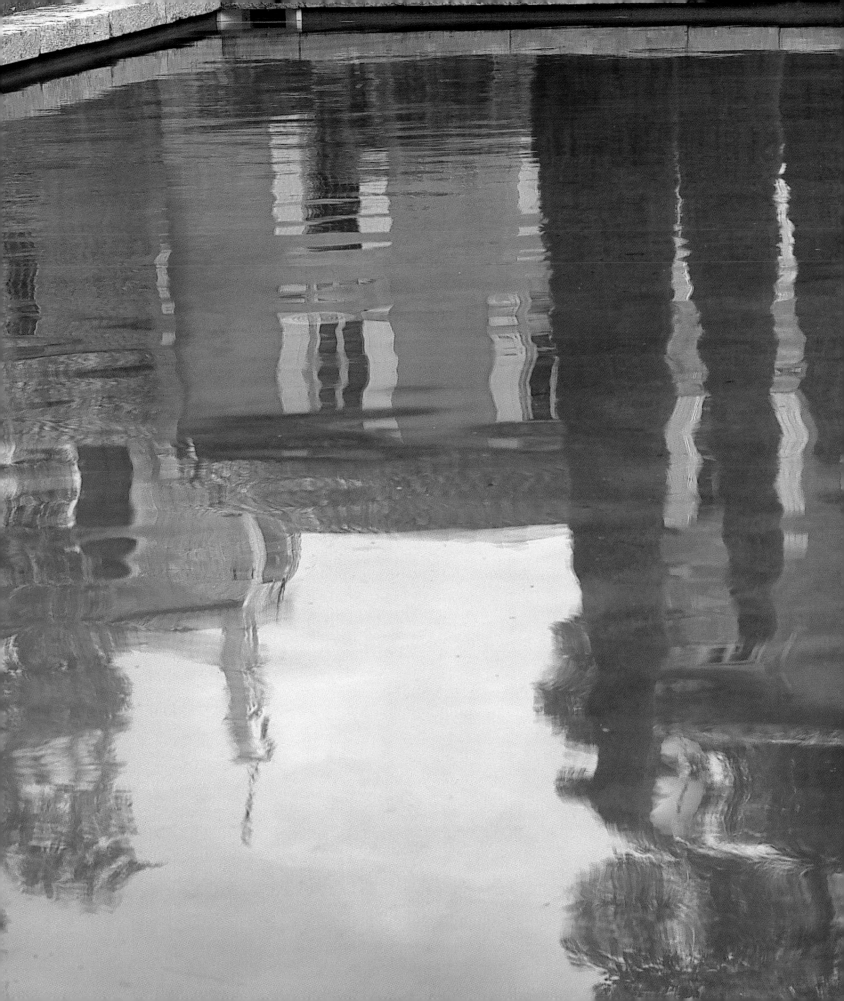

UNDULATING

ROUNDED

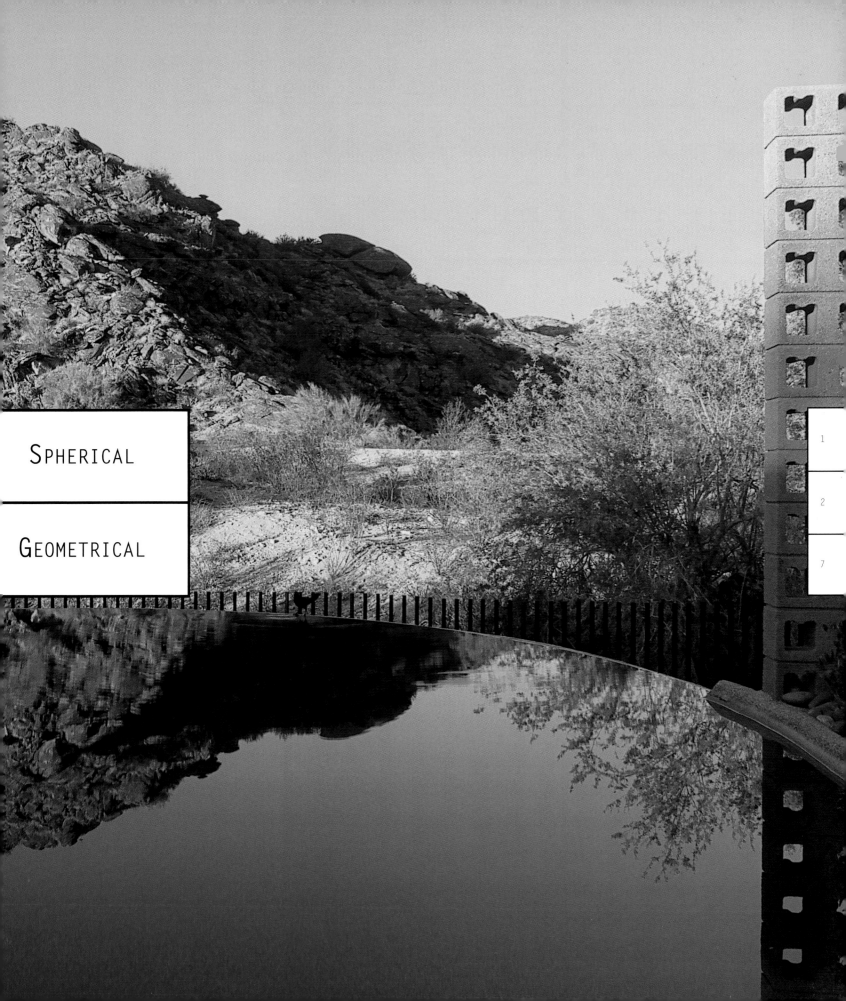

SPHERICAL

GEOMETRICAL

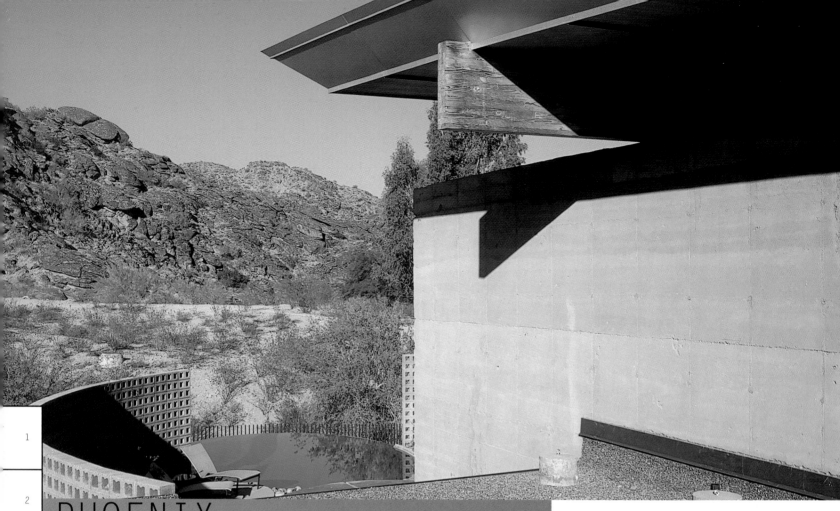

PHOENIX, ARIZONA. USA

This pool opens out onto the landscape to blend into the rough vegetation of southern Arizona. The whole project shows great respect for its natural surroundings. The terrain is slightly undulating, and the terrace area seems to have been designed to imitate it. The spherical forms are bounded by distinctive iron railings that discreetly mark off the pool. The circle is the dominant element in the outdoor construction: In the shape of the pool, in the stairs, in the floor of the sunbathing area (which couples rounded edges with circular pieces of concrete), and in the summer-house (with spherical tables). Even the concrete border shielding the pool from the other houses is a semicircular block; it serves as protection from prying eyes but does not block out all the light as it is dotted with openings. Overall, the project comprises an interplay of geometrical forms, as the rounded edges of the exterior set off the rectangular shapes of the house, with its projecting roof. The materials used are concrete, rammed earth and iron; the vegetation basically consists of acacias.

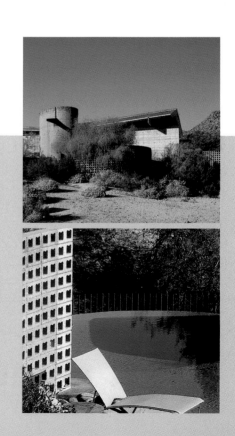

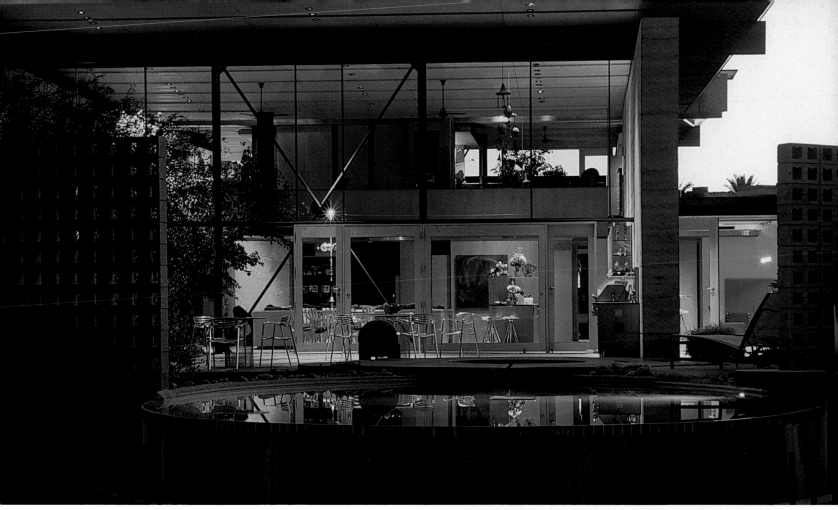

The rounded paving
stones and the
pebbles contrast with
the rectangular forms
of the furniture.

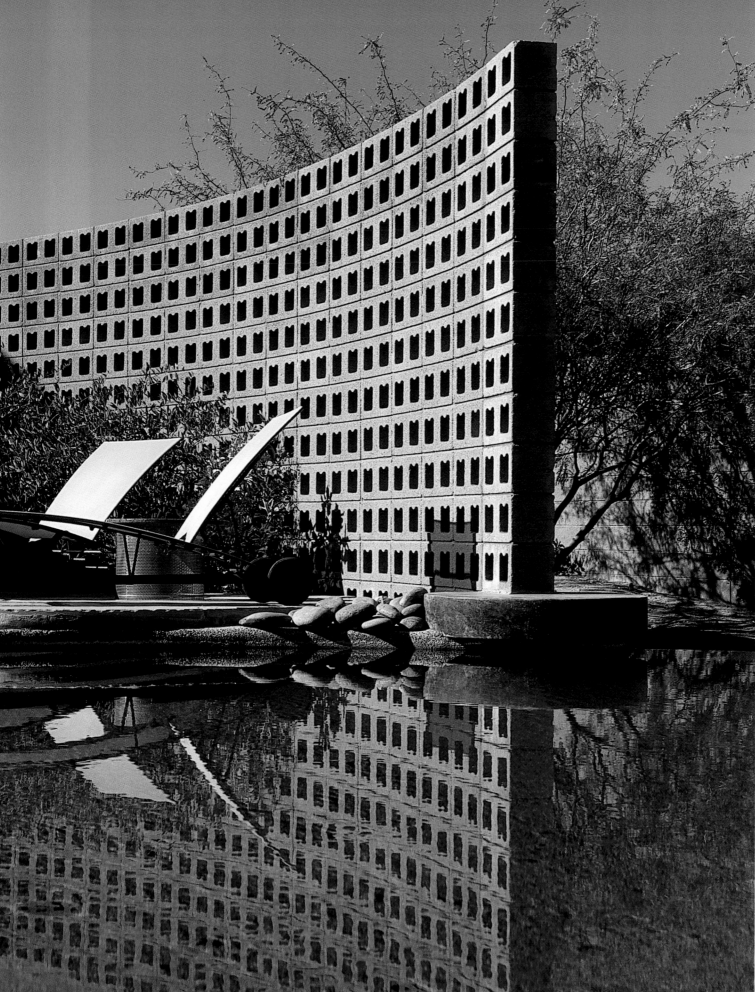

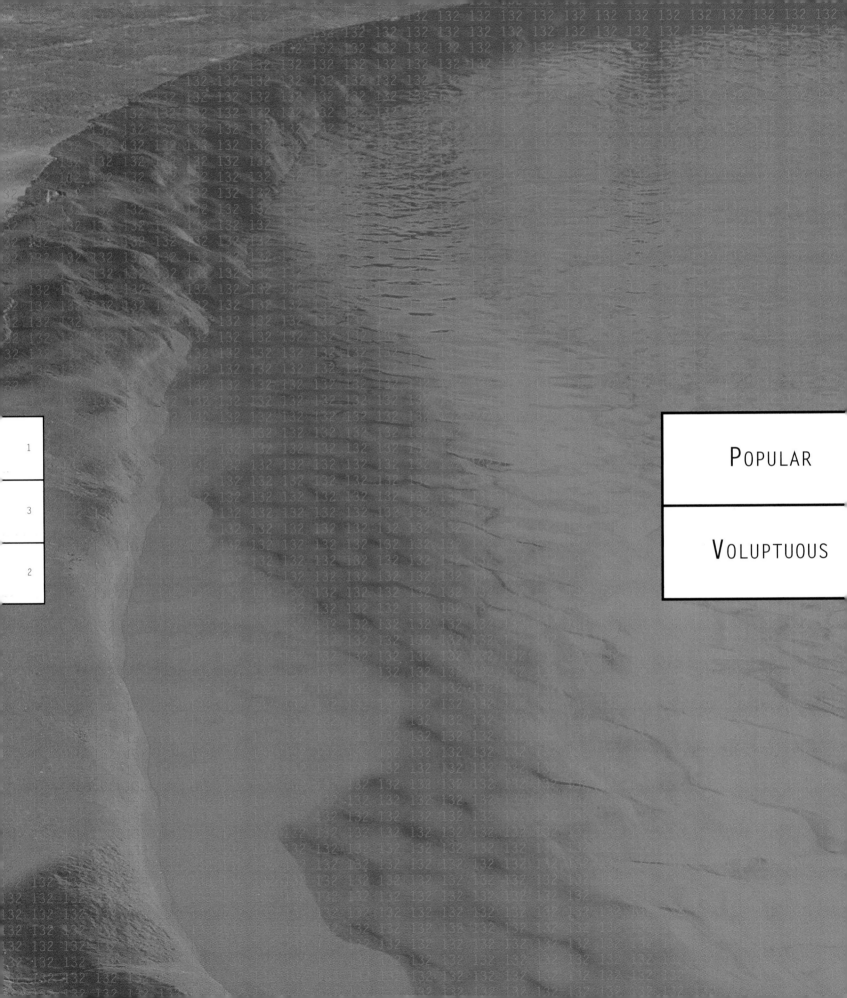

1

3

2

POPULAR

VOLUPTUOUS

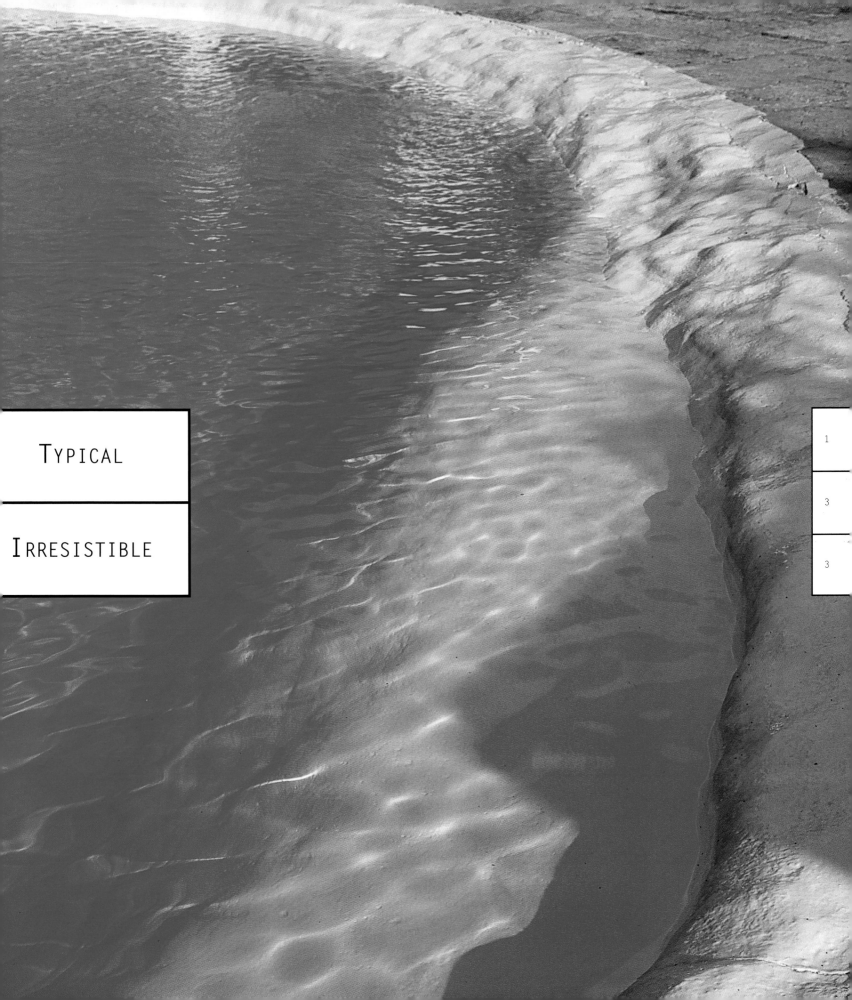

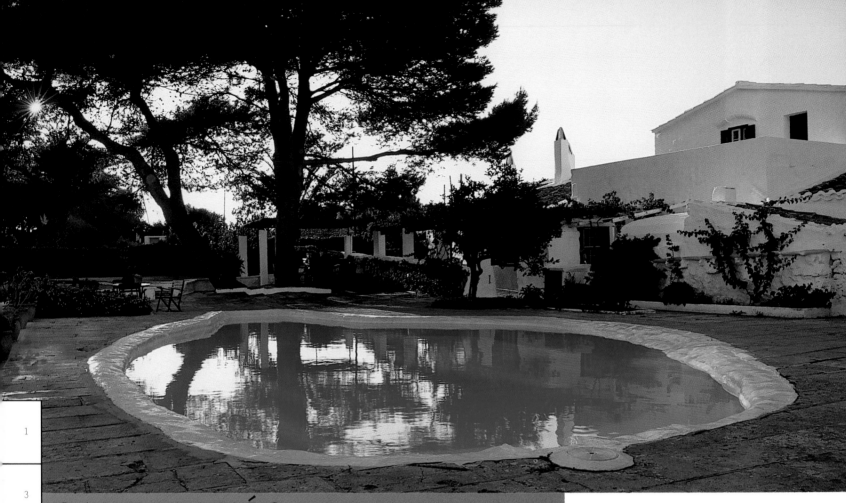

1

3

4

SANT LLUÍS,
MENORCA. SPAIN

Tradition is not incompatible with originality, especially if a new construction respects the voluptuous forms of the landscape. In this typical Menorca-style house, with its stone walls (some covered in white lime), the swimming pool is a mixture of tradition and originality. It is designed in the shape of an egg to adhere to the contours of the terrain: At one end the bottom rises to almost meet the edge of the pool. The owners wanted not only to respect these natural forms but also to exploit them to take a rest from swimming or enjoy the sunshine. The end result is an irregularly shaped pool with a striking personality. It is at its most geometrically structured in the area containing the steps. The pool's cladding echoes the style of popular architecture displayed in the house by using the marés sandstone that is so typical of Menorca, along with concrete daubed with white plastic paint to ensure that it is watertight. A canopy covered with climbing plants shelters the arbor and sunbathing area by the steps, while the unassuming iron furniture by the pool offer an irresistible invitation to make the most of the sunlight.

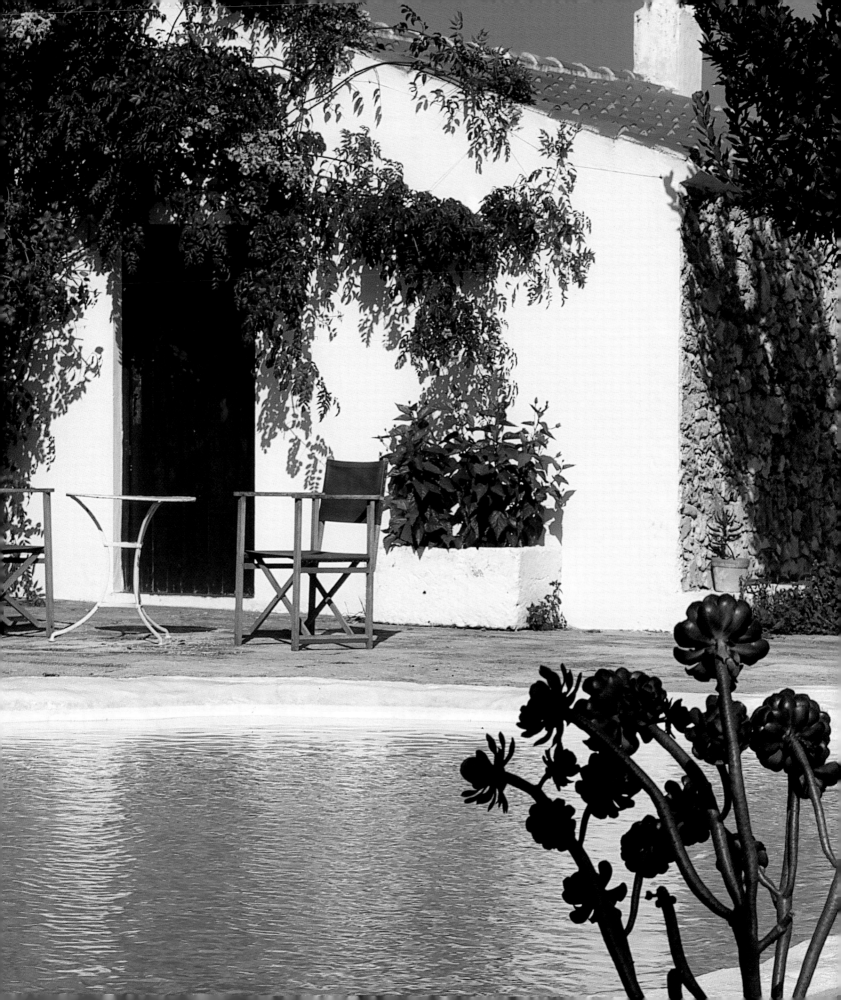

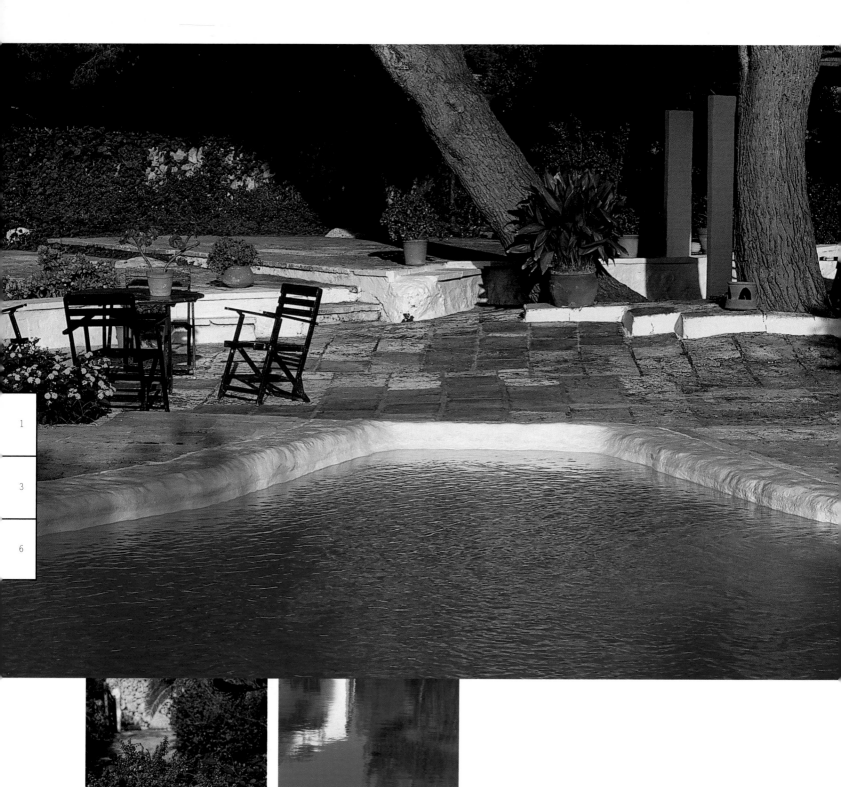

1

3

6

The entrance to the pool
is by one of the resting
areas, ideally placed to
bask in the sun.

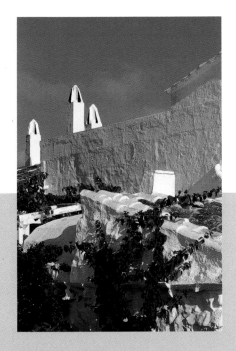

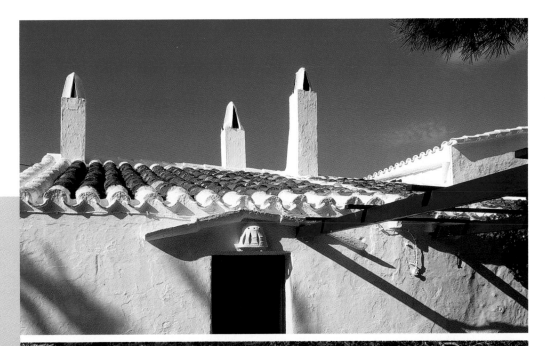

The house reproduces the architecture typical of the island of Menorca, with stylized chimneys and walls clad with white lime.

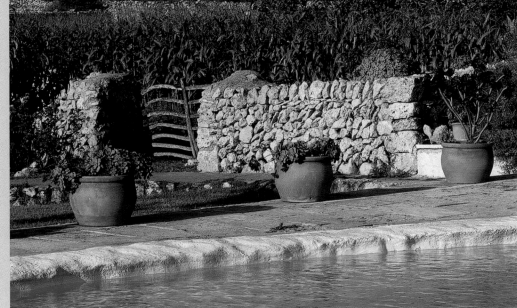

1

3

7

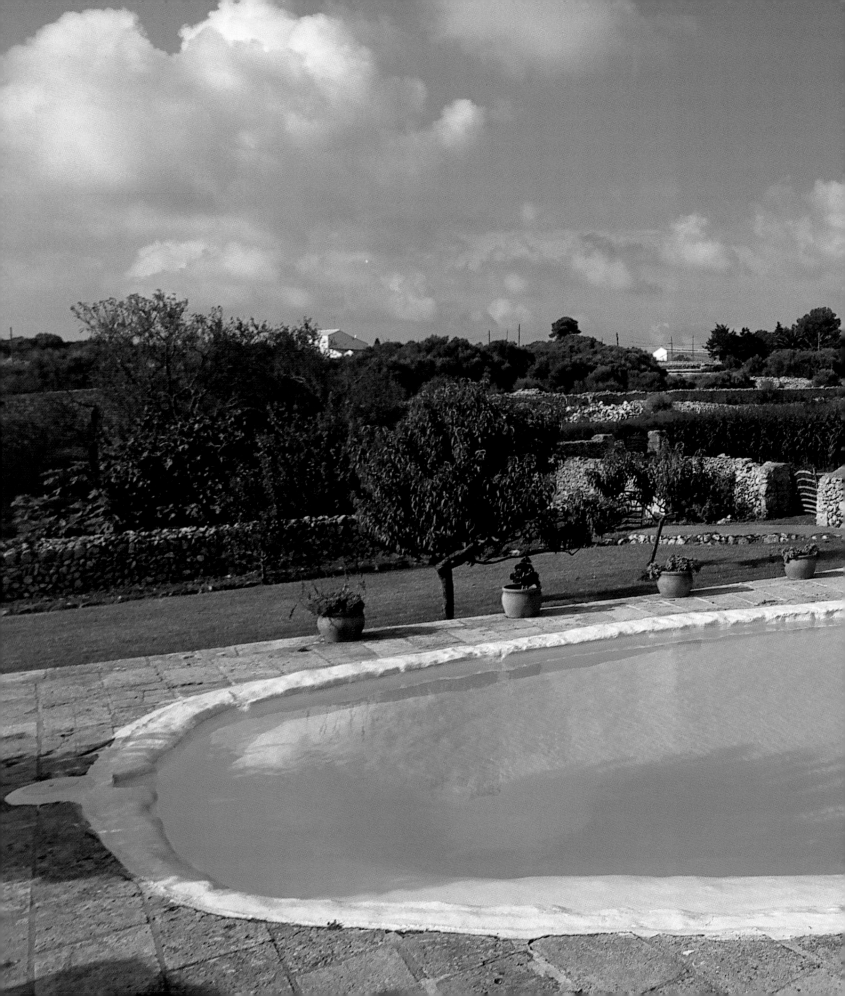

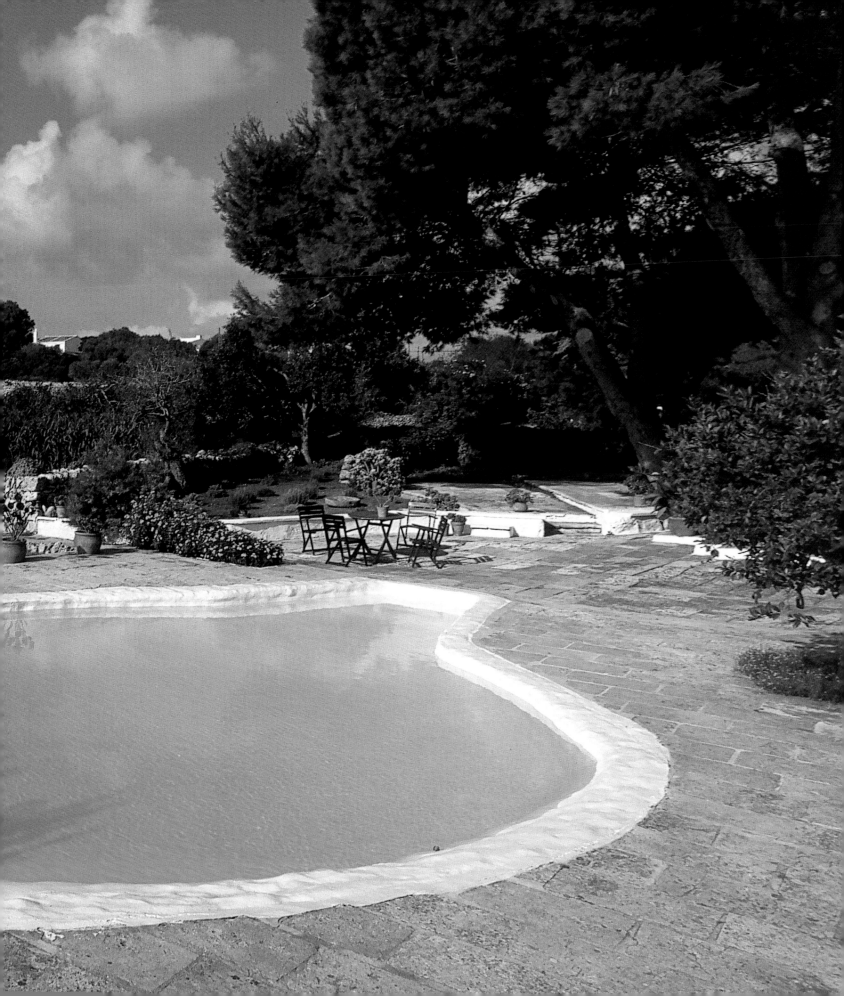

EXPRESSIONIST

SPECTACULAR

CHANGING

UNMISTAKABLE

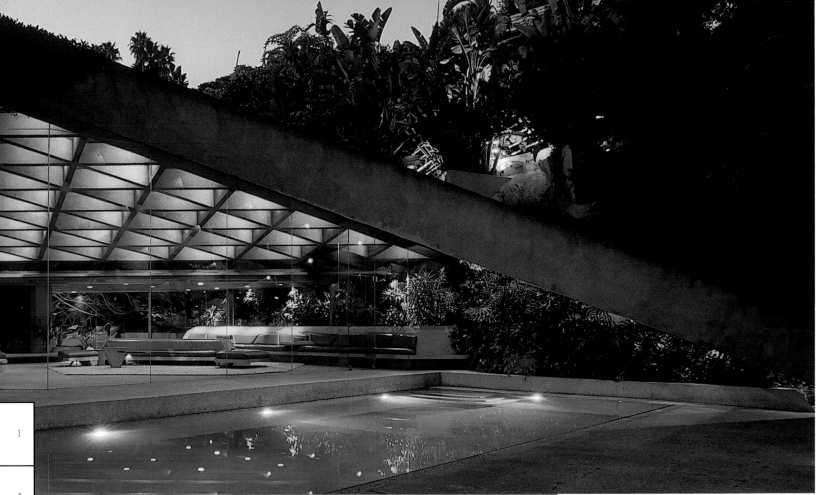

BEVERLY HILLS, CALIFORNIA. USA

The Sheats house, built in 1963 for Paul Sheats and his family and subsequently refurbished for James Goldstein in 1989, was one of the key works of John Lautner's mature period. His houses, which have been described as "technovisionary" and expressionist, made him one of the most significant architectural representatives of the southern Californian spirit. The most striking aspect here is the geometrical design of the roof covering the living room and the pool area. This is a concrete slab made of triangular pieces studded with 750 glasses. This distinctive detail enables the glasses to act as small skylights and create a special kind of light which, according to Lautner, evokes a forest. The roof represents a natural space and imitates, in the architect's unmistakable style, a cave or grotto depending on the light, as the space is modified in accordance with the light that falls onto it. Every nook in this house is spectacular, especially the entrance area, with a stone walkway that leads into the distinctive living room, which is connected to the pool and offers stunning views of the city.

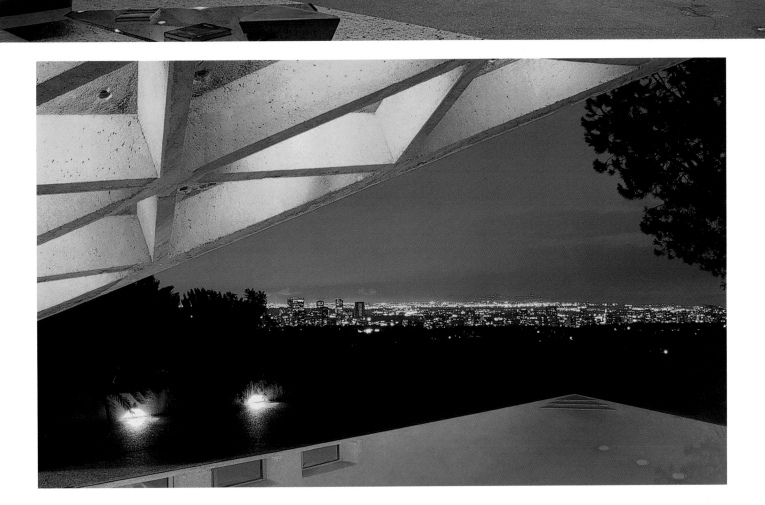

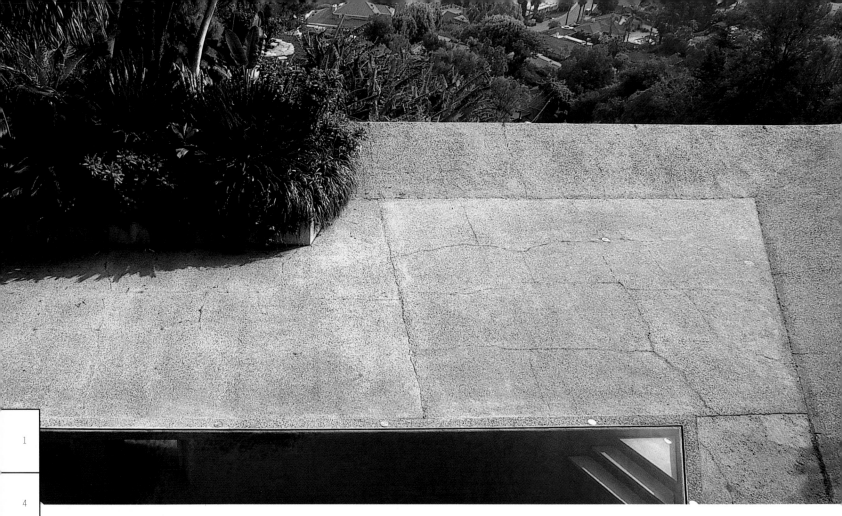

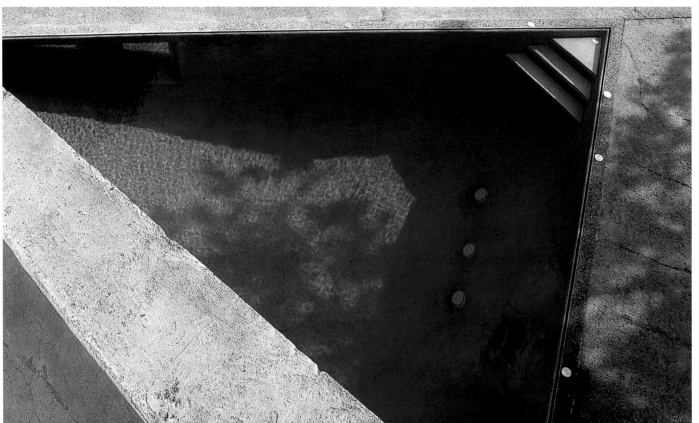

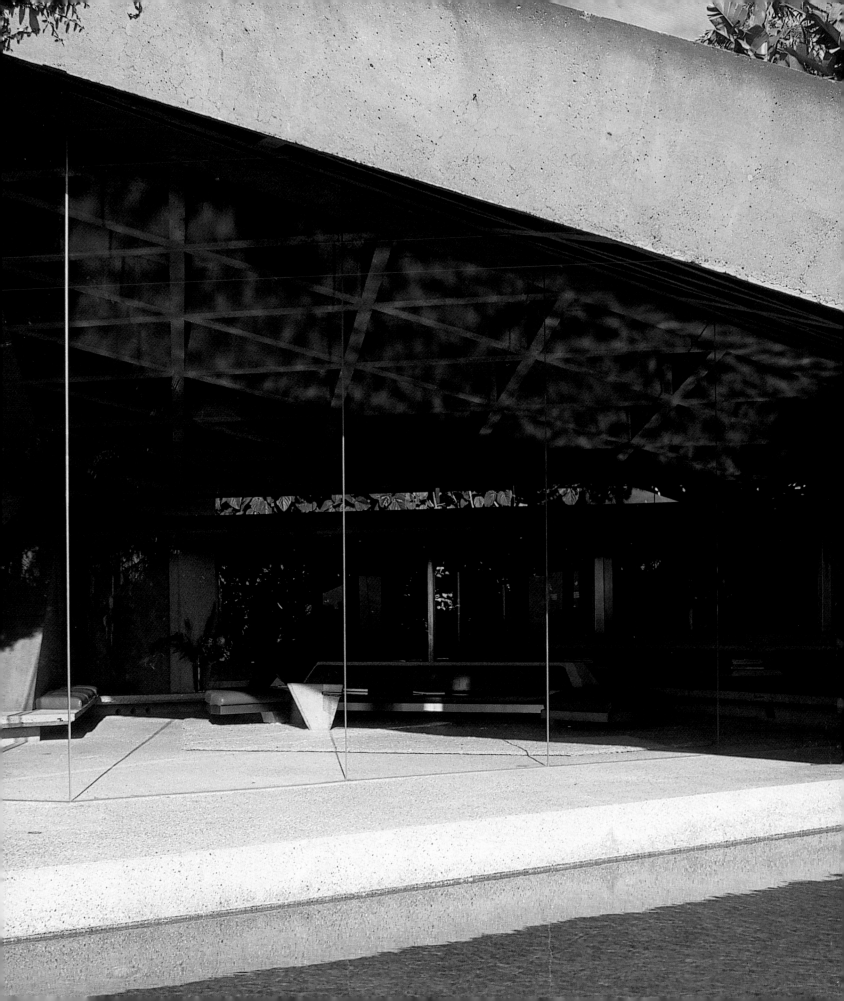

146

1
4
6

TRADITIONAL

ANCESTRAL

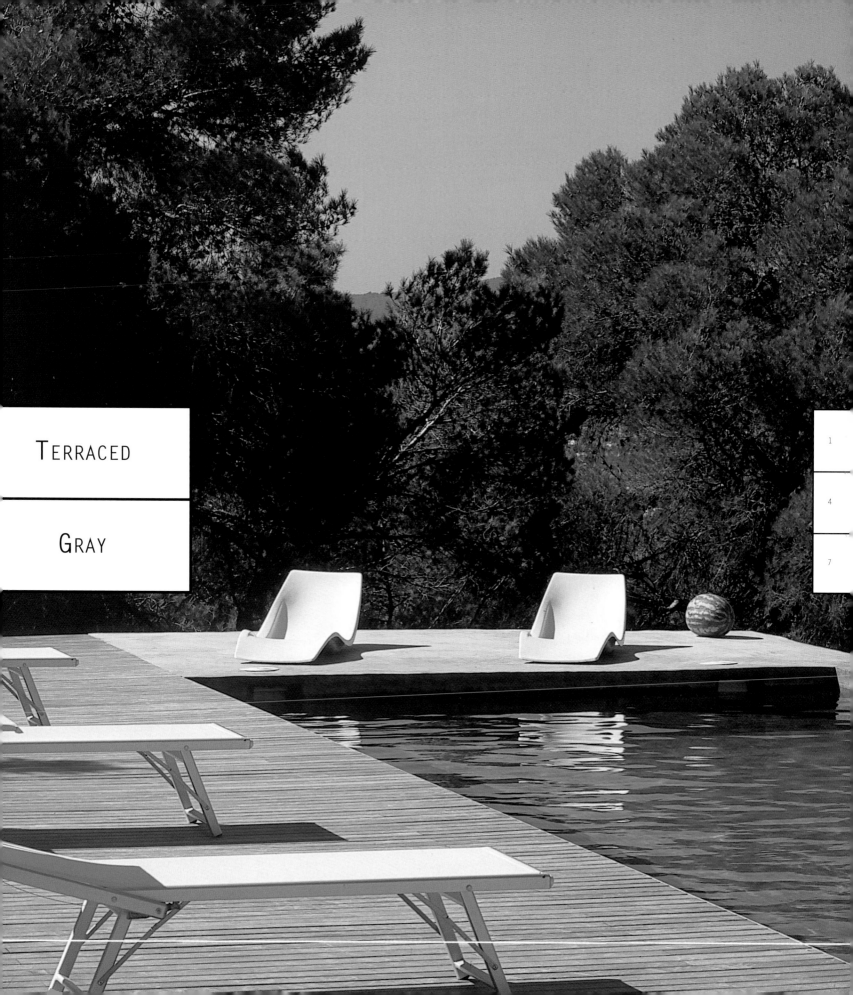

TERRACED

GRAY

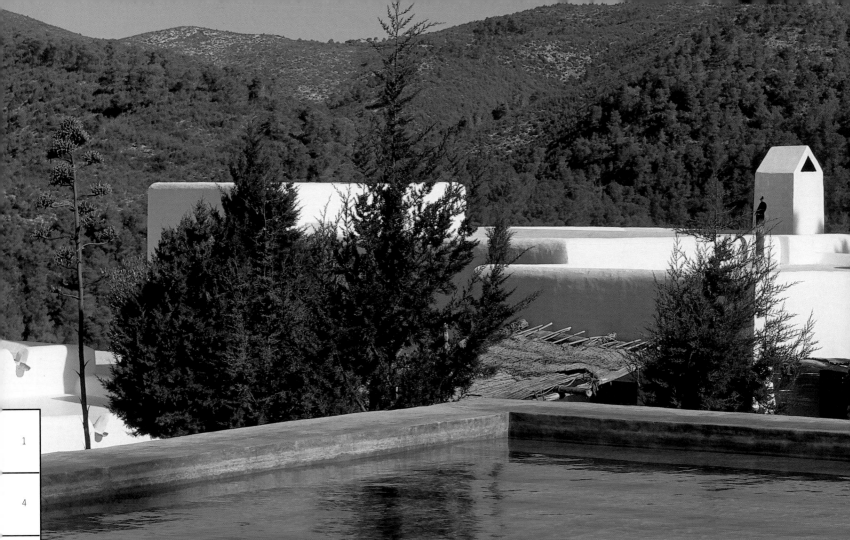

IBIZA, SPAIN

This project is situated on the upper slopes of a valley with extremely uneven terrain that not long ago was irrigated by ditches that served all the different plots in the area. This old irrigation system was the starting point for this new pool, the construction of which draws on the ancestral knowledge of the island's peasants and farmers. The construction is based on a traditional reservoir, although the form has been adapted to create a highly contemporary pool area. Reinforced concrete was used for the base, which takes advantage of the pre-existing terraced land formation. Inside, a layer of cement tinted with natural dark gray pigments creates the illusion of the constant movement of the sea in the pool's still water. This same cement is also used to clad the edges of the pool, although the part furthest from the house is backed by a platform made of tropical wood. Natural stone has been used on the exterior, echoing the terracing typical of the area. Pines, carobs and junipers have been planted around the pool in keeping with the vegetation native to the region.

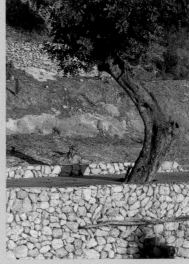

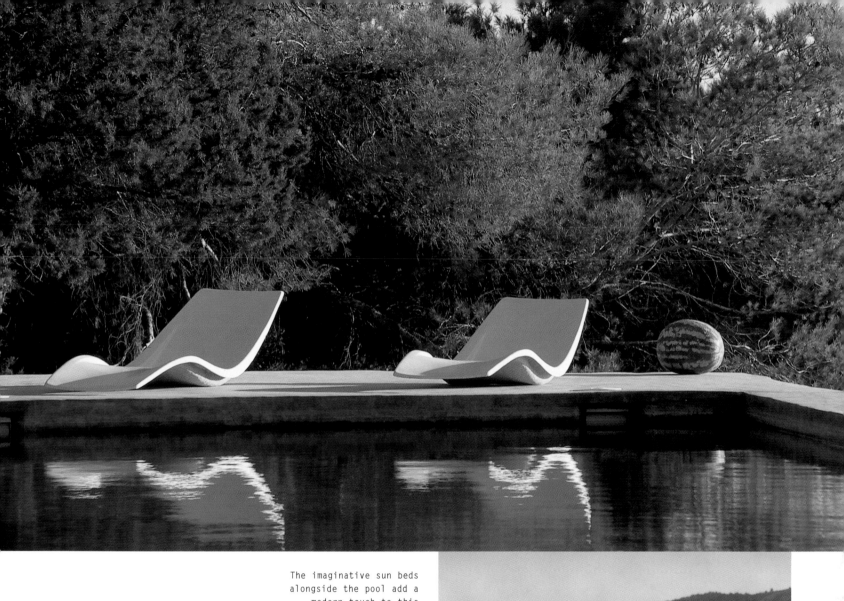

The imaginative sun beds alongside the pool add a modern touch to this refurbished property.

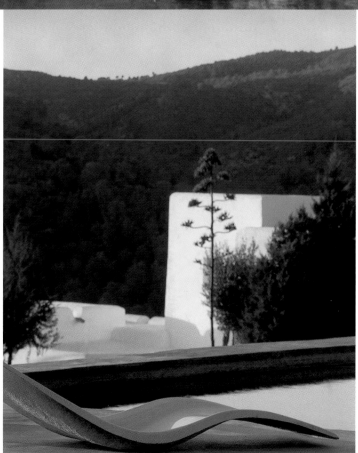

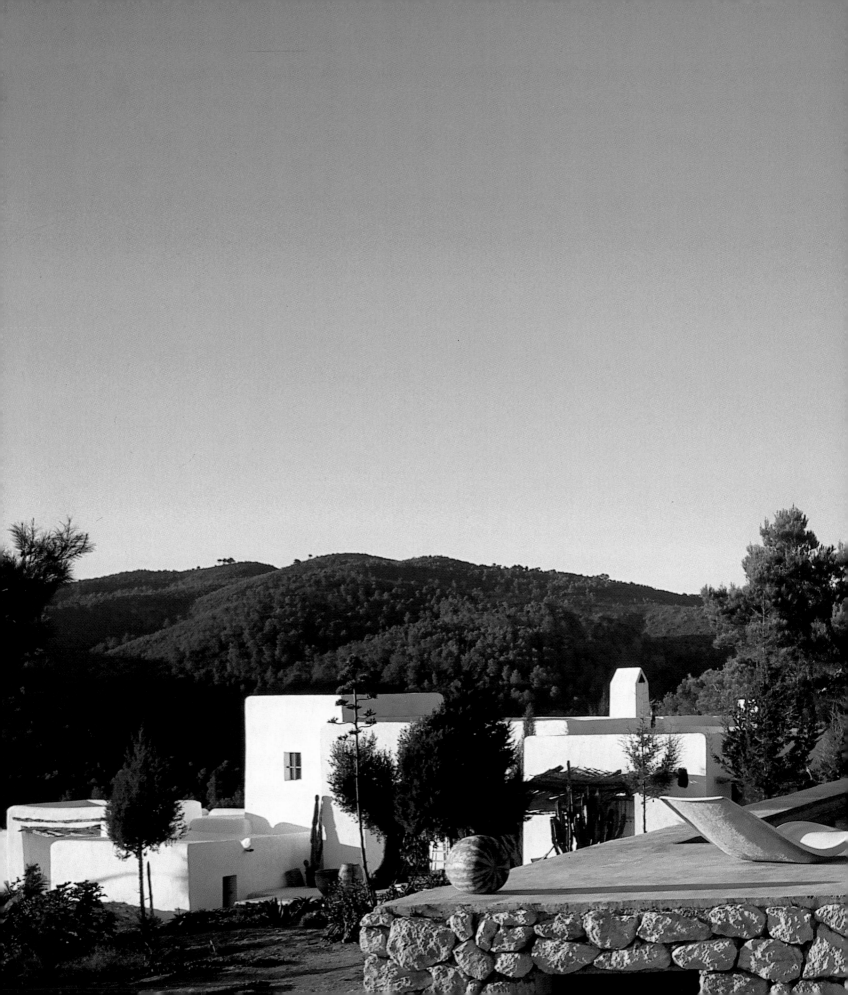

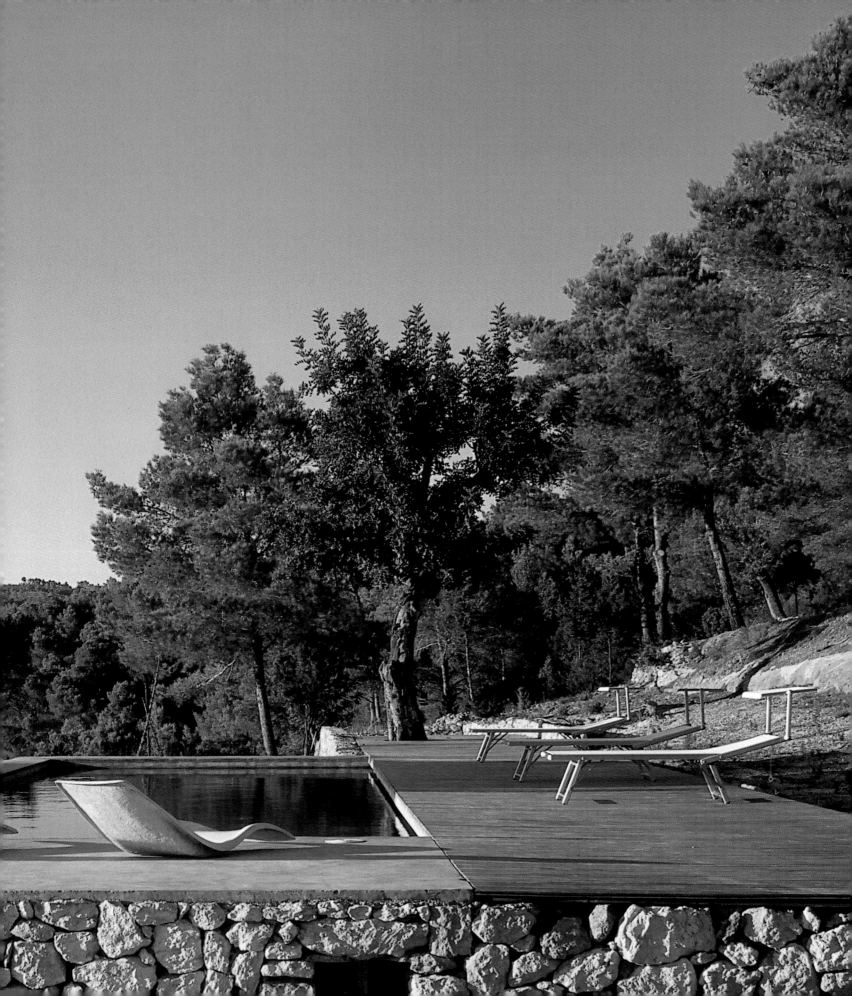

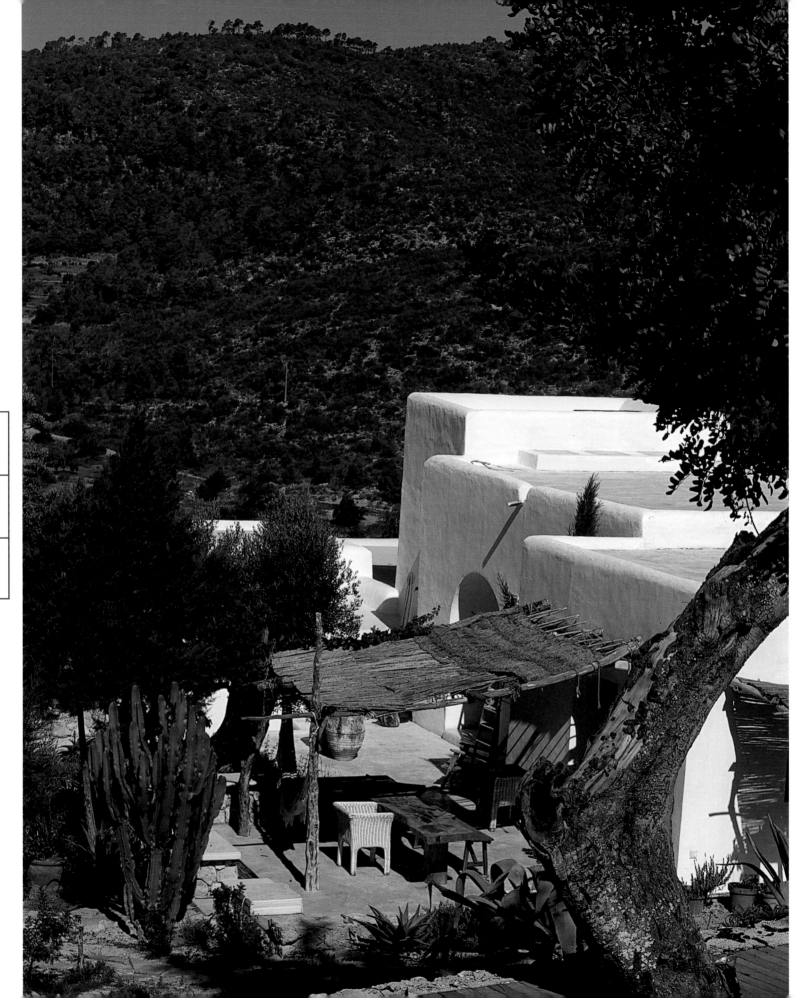

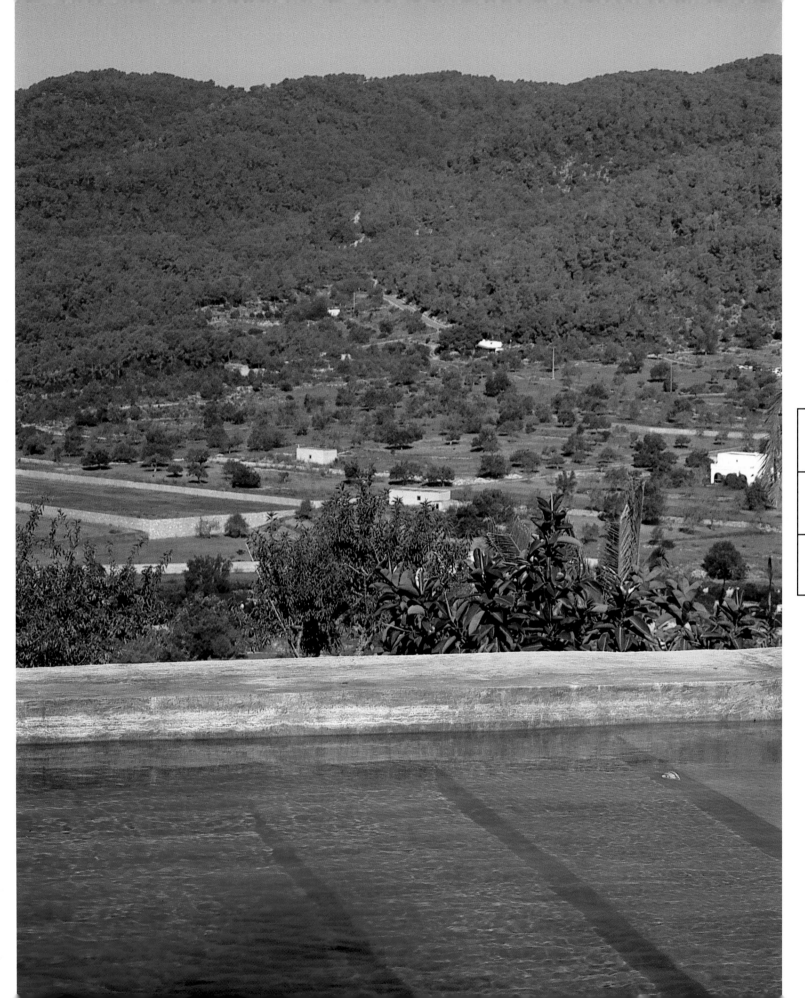

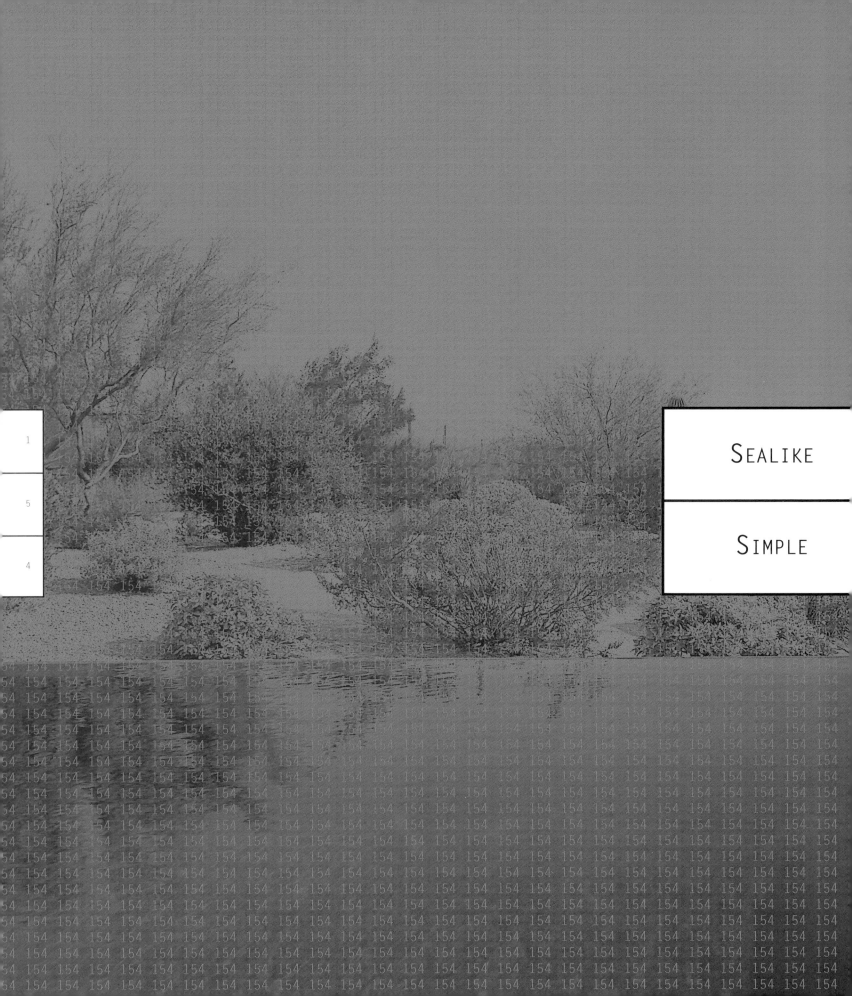

SEALIKE

SIMPLE

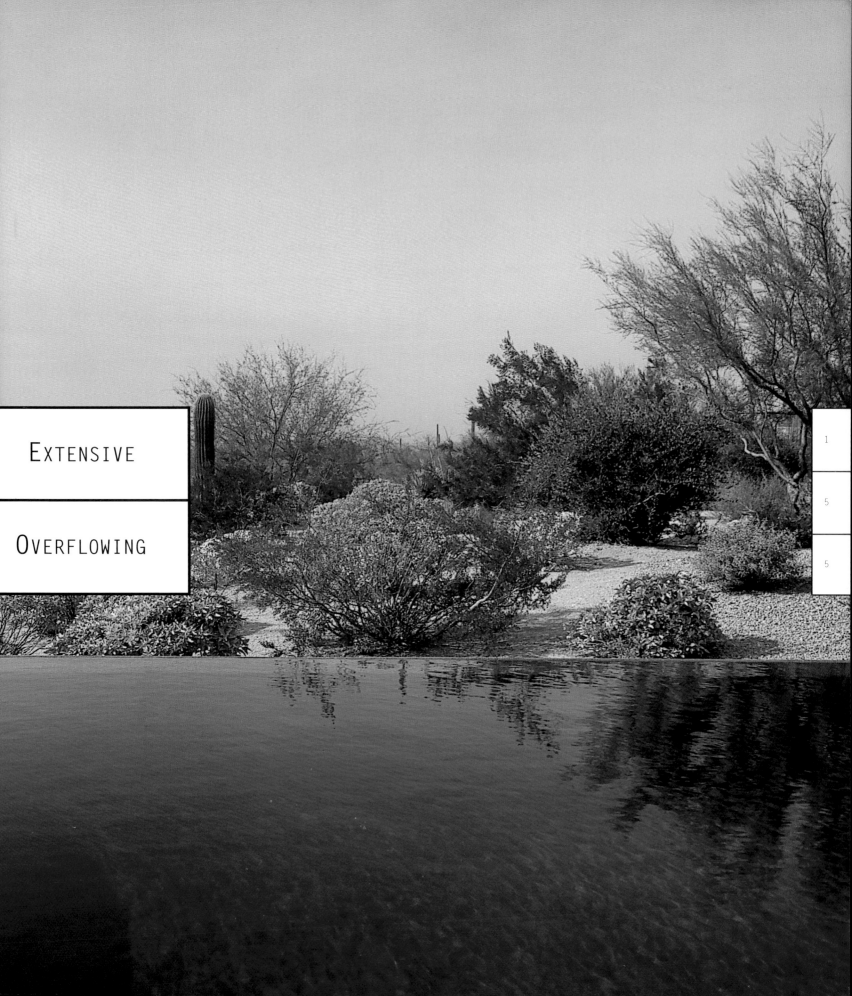

EXTENSIVE

OVERFLOWING

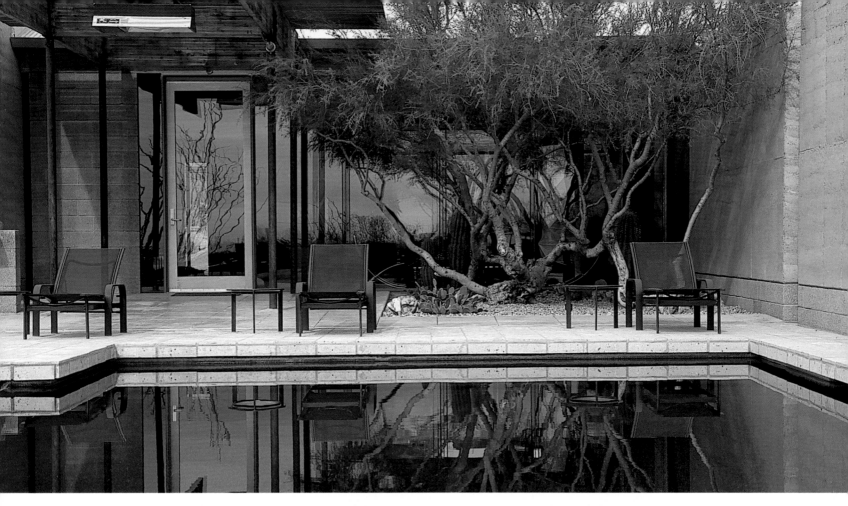

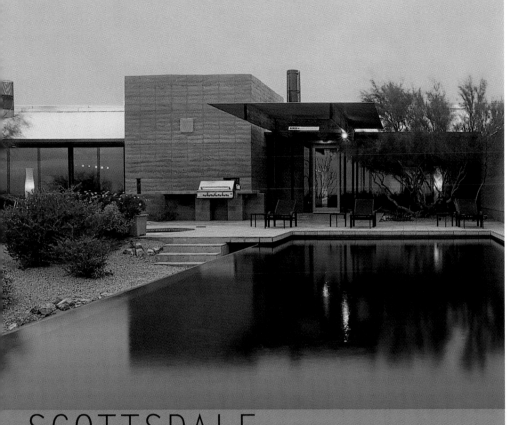

SCOTTSDALE, ARIZONA. USA

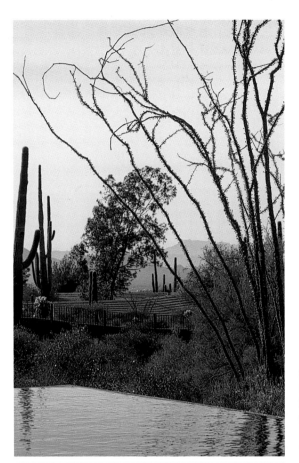

This swimming pool seems almost like a sea watering the Arizona desert, creating a beautiful contrast with the stark arid vegetation around it. With its rectangular form and water spilling over two sides, it makes a highly spectacular visual impact. The project uses both very modern techniques and traditional materials like concrete and iron, although in terms of construction it is relatively simple. The edges of the pool and the terrace area have both been covered with tiles made of the sandstone typical of the region, while the walls of the pool have been coated in a somber color. A rammed earth wall, echoing parts of the house, separates the pool and the communal garden area from the bedrooms. A delicate light metal fence, with iron shafts set in the ground, extends the line of the wall to the end of the pool. The steps that separate the terrace from the pool's access area sweep down through the vegetation before merging into the water. The gardens feature several local plant species, and so they blend into the surrounding landscape.

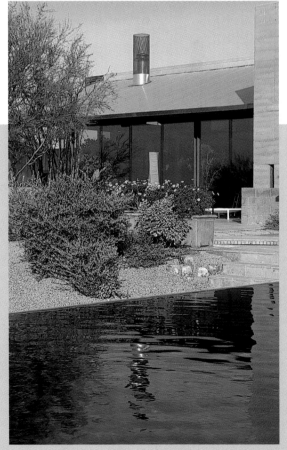

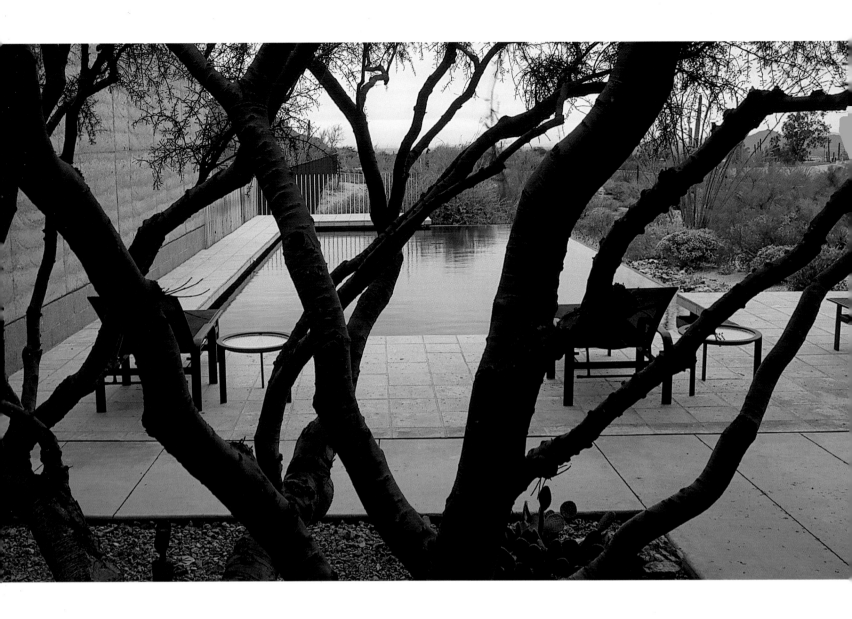

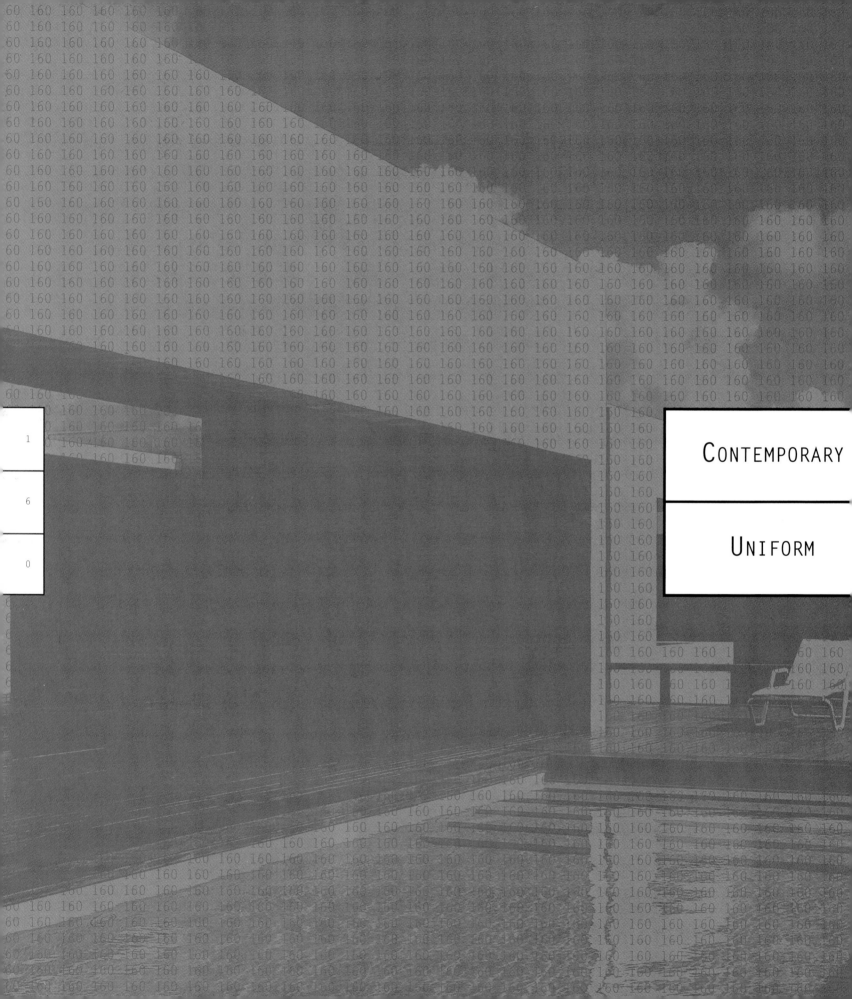

CONTEMPORARY

UNIFORM

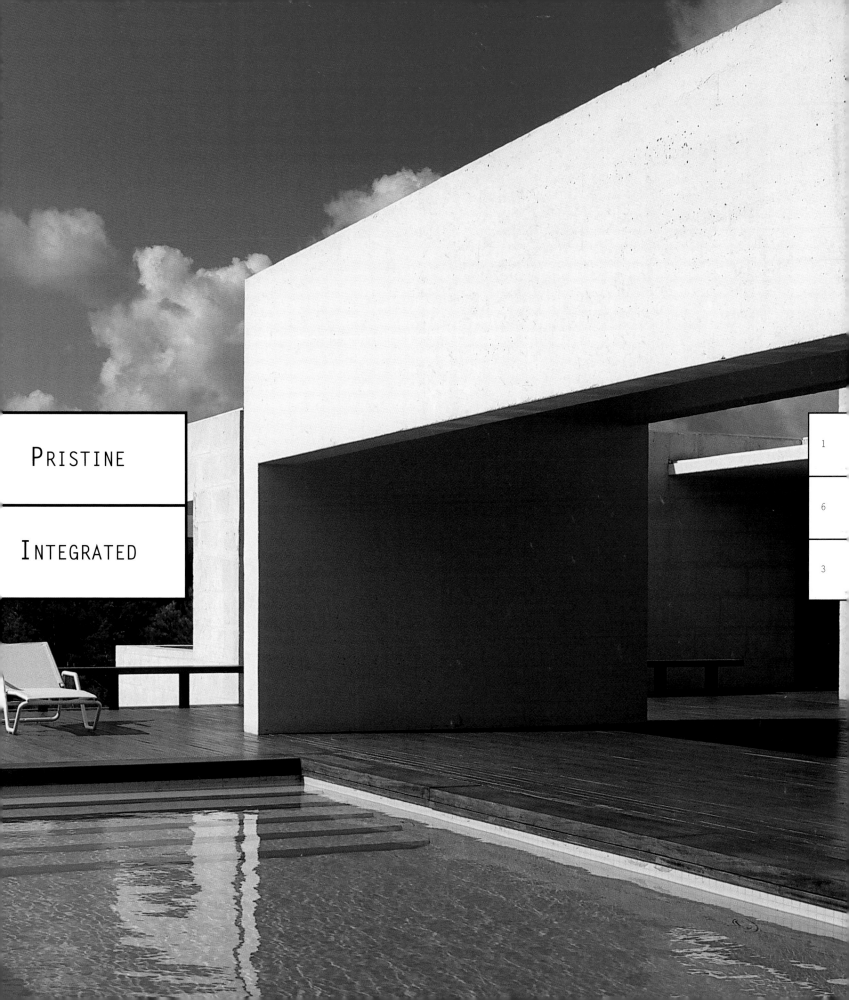

PRISTINE

INTEGRATED

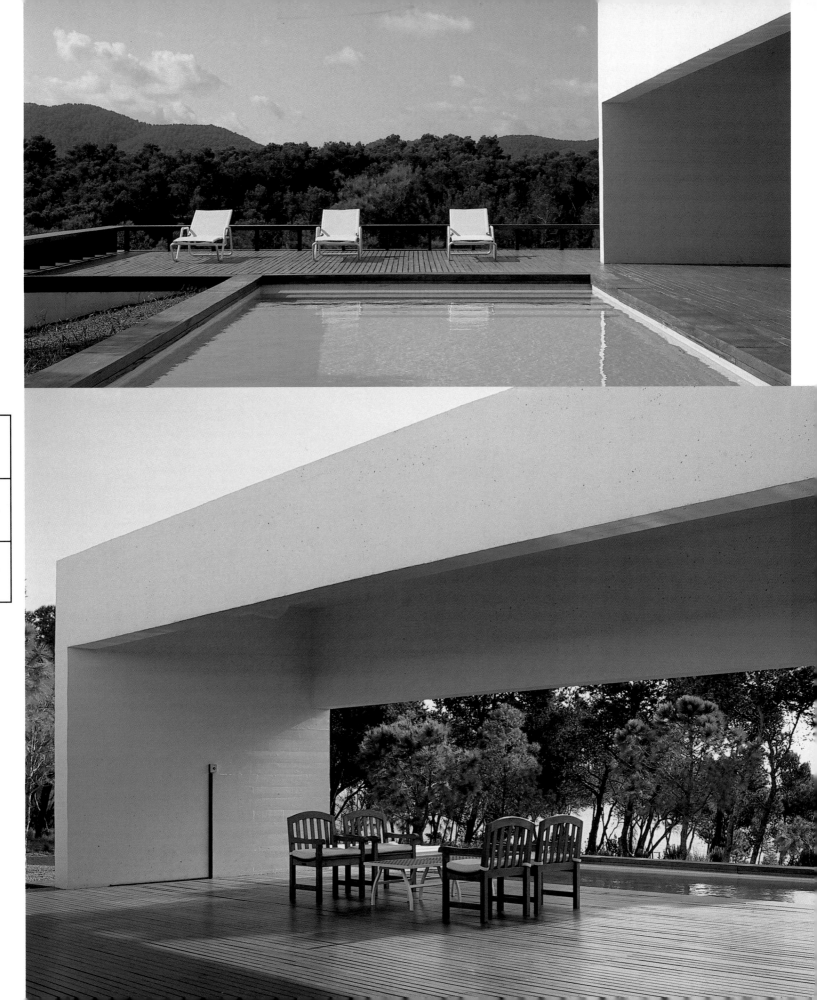

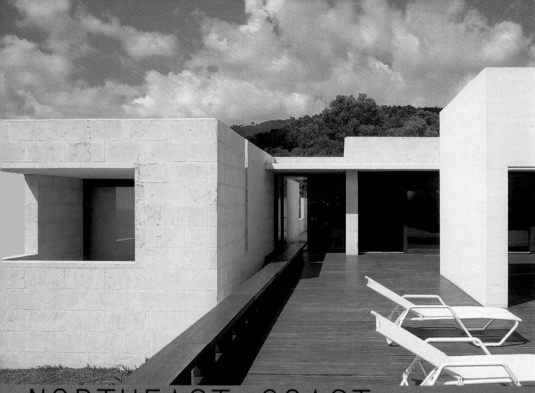

The large terrace is divided
into clearly delineated
sections. The sunbathing
areas are located at each
end of the pool.

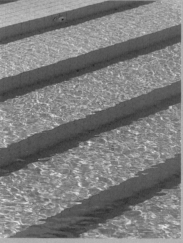

1

6

3

NORTHEAST COAST, IBIZA. SPAIN

This project in Ibiza pays homage to the island's traditional architecture, although the approach is strictly contemporary. Cubes and rectangular figures in pristine white are skillfully coordinated to create a visual language that respects the natural surroundings. This interplay of geometric forms gives way to a spacious terrace with a platform made of tropical wood and a large structure in the center that serves as a shady arbor. Beyond this, at the rear of the property, lies an ample swimming pool of uniform depth, with access at one end from the sunbathing area on the terrace. The pool is a concrete box clad with small white tiles that echo the exterior of the house, while the strips of wood along the edge contrast with the ceramic tesseras and the steps spanning the breadth of the water. This minimalist project reflects the essence of the Mediterranean, and the pool has been sensitively integrated into the overall design.

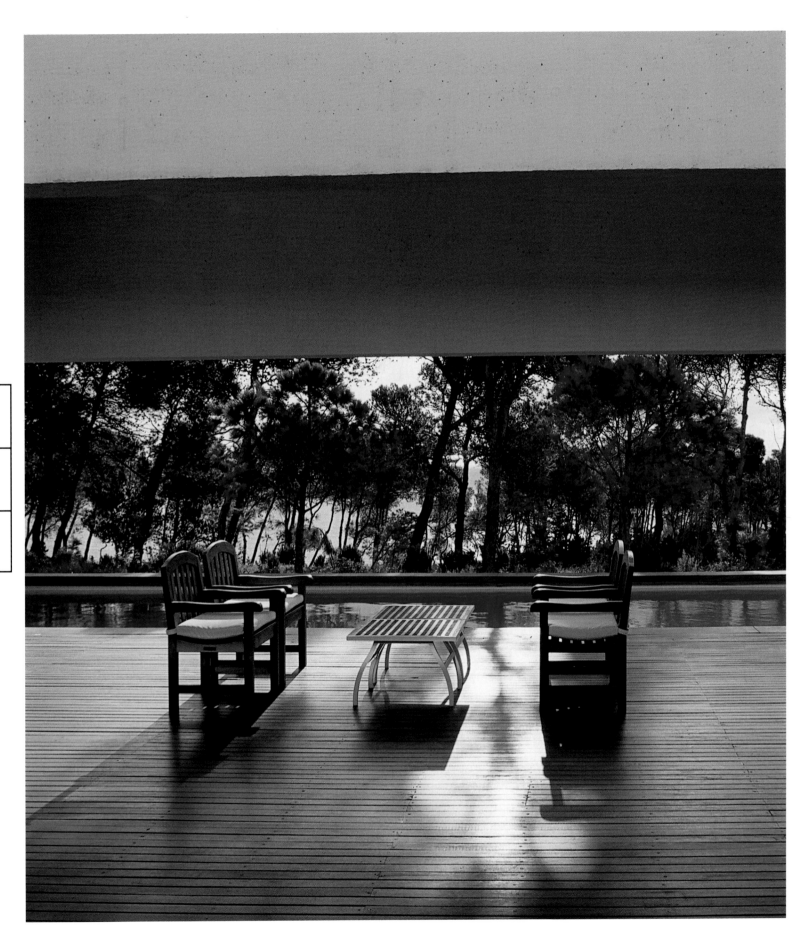

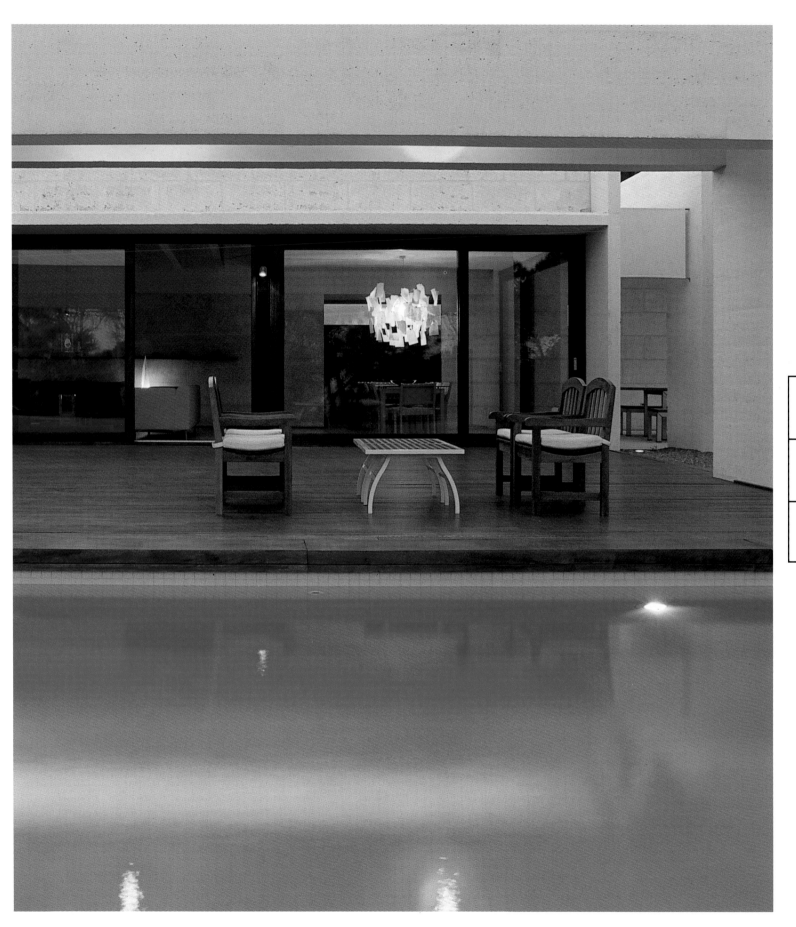

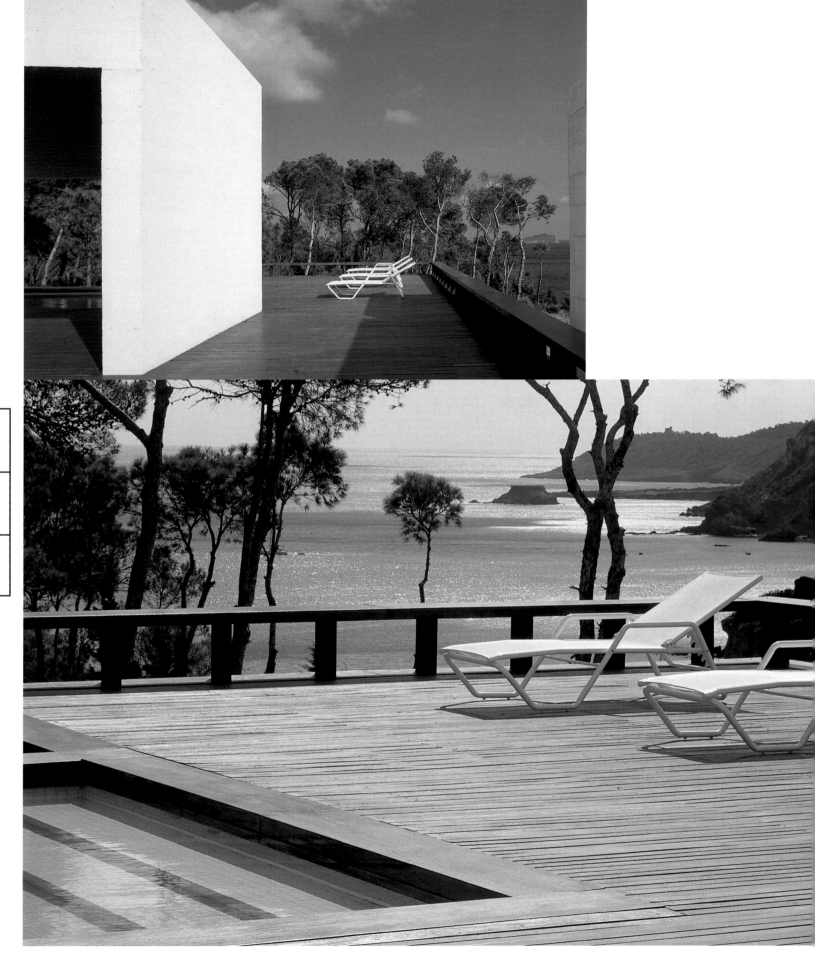

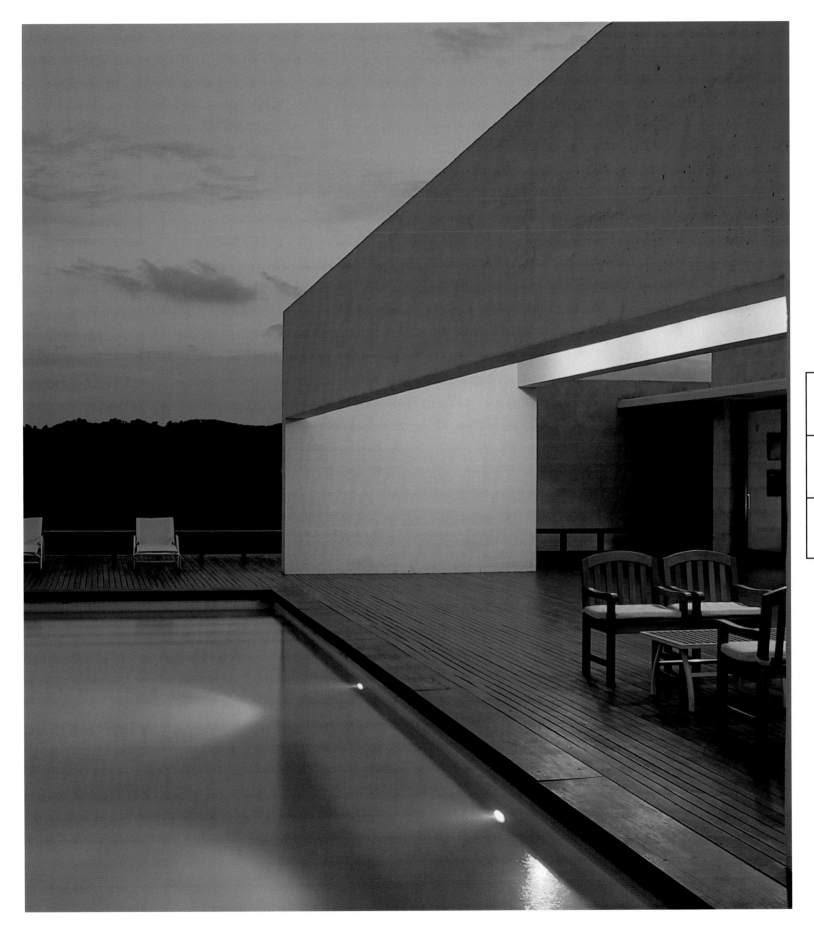

UNTAMED

EXTENDING

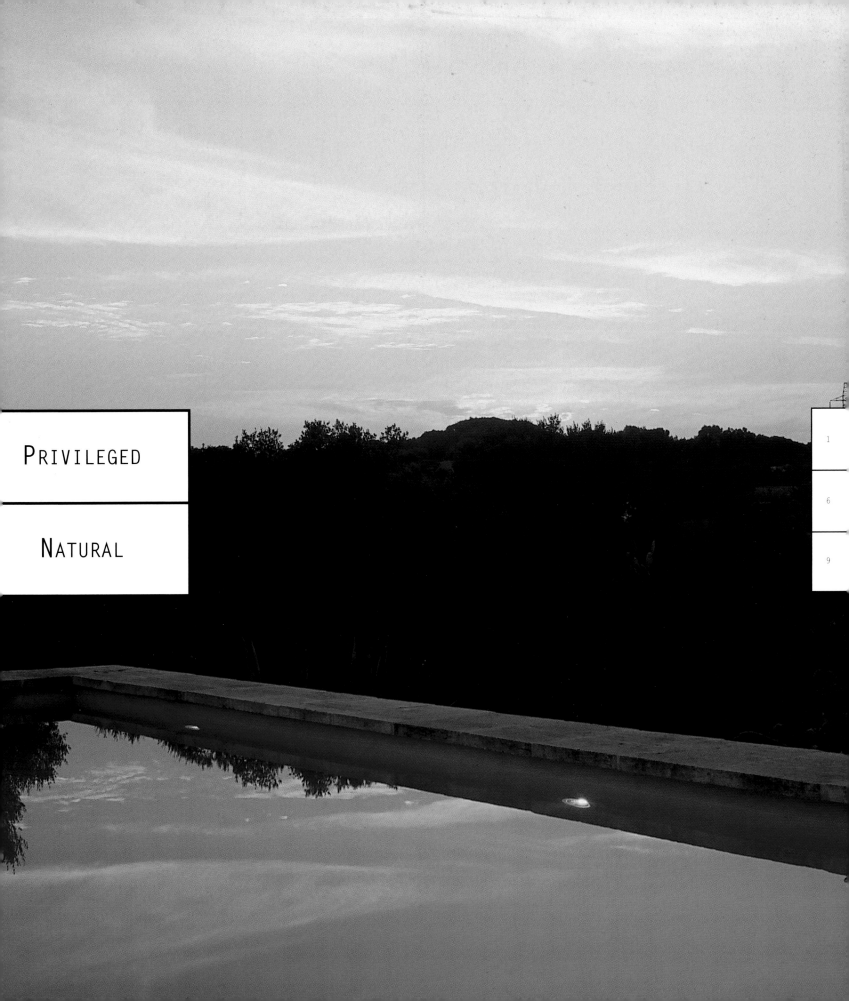

PRIVILEGED

NATURAL

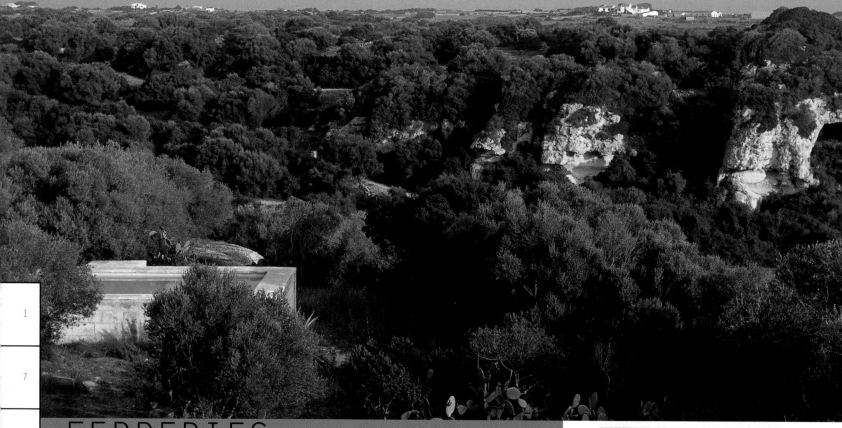

FERRERIES, MENORCA. SPAIN

In this almost untamed spot on the island of Menorca, the architect did not try to fight nature but opted for a more balanced approach, by challenging but also joining forces with it. The decision to integrate architectural forms into the natural lanscape resulted in a pool that extends from the large oblique rock that marks the boundary of the property. The swimming pool is set at almost the same level as this rock and fits into it perfectly. The casing of the pool, made of the Menorcan marés sandstone, blends into the natural surroundings, while the interior, painted pale gray, recalls the typical local house fronts. On top of the rock, a platform made of treated, water-resistant, non-slip pine provides a privileged position from which to enjoy the sun and the expansive view of the landscape. A low step links the wooden structure with the pool which, in its turn, contains interior steps shaped to echo the waves of the sea.

This rural property is set off by a garden of prickly pear trees, which combine with the local vegetation to emphasize that here it is nature that rules supreme.

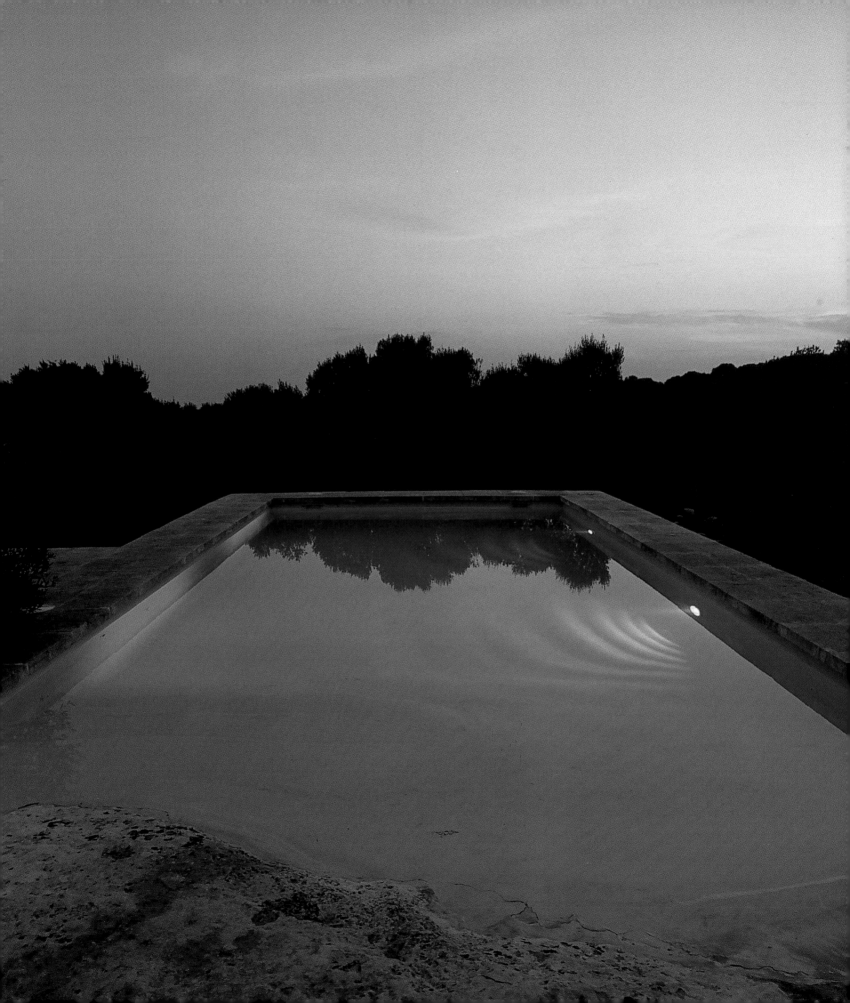

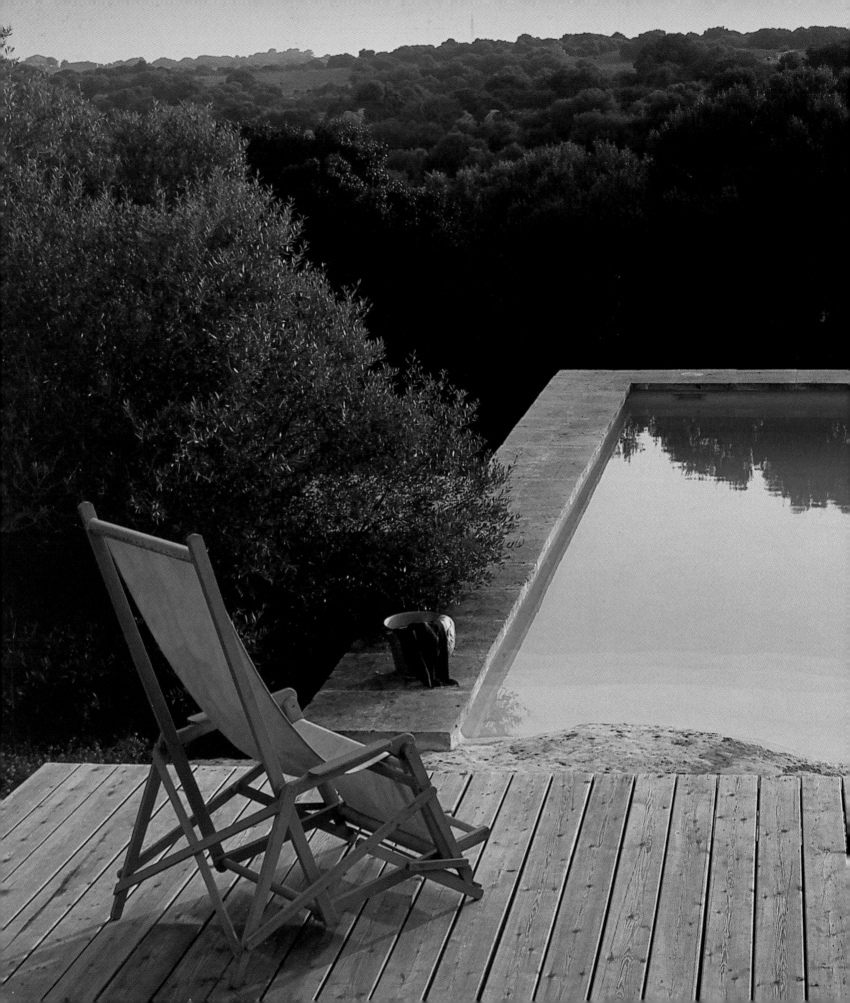

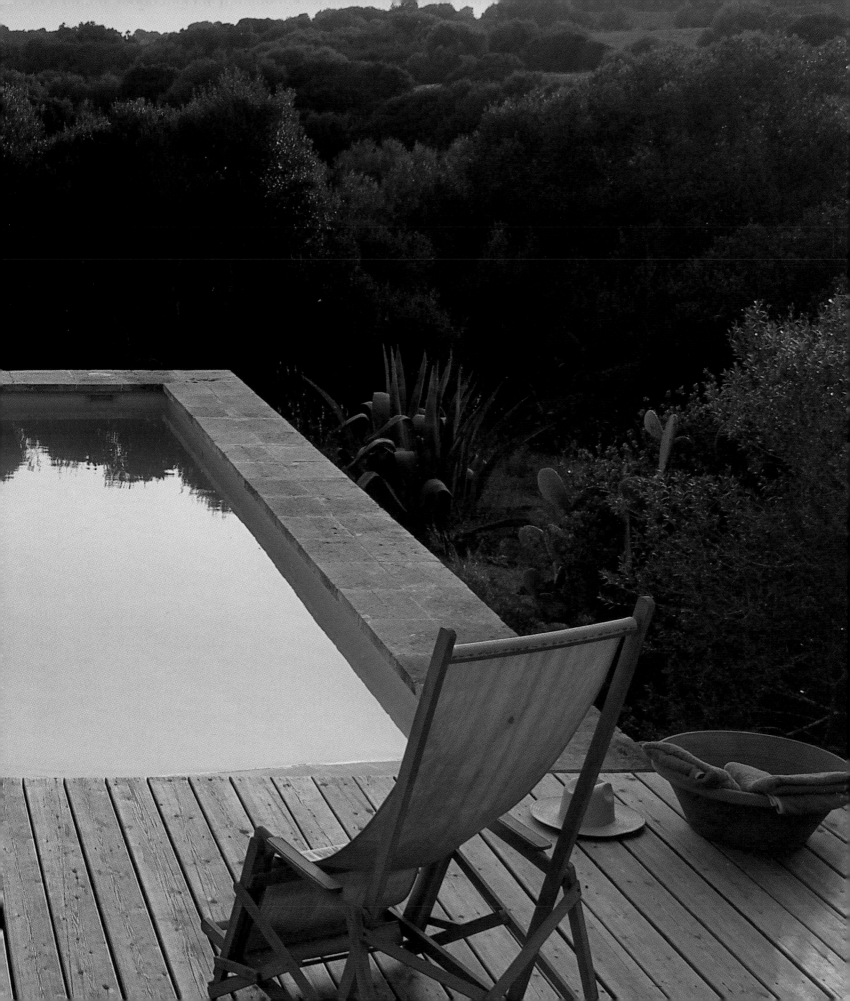

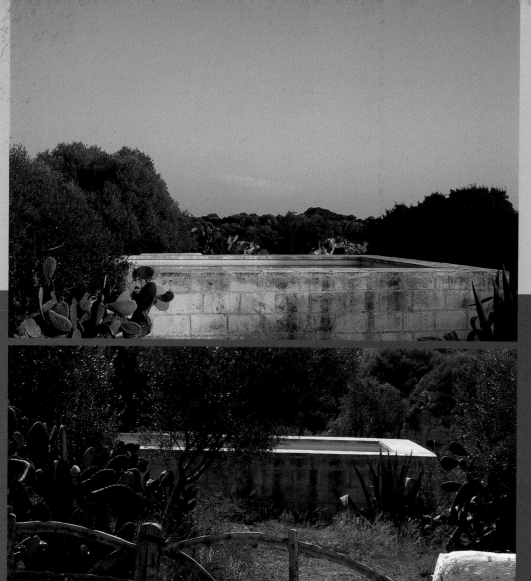

The property is situated
on very uneven terrain.
The steps to the pool,
reminiscent of waves,
highlight the intention
to fuse the project
with nature.

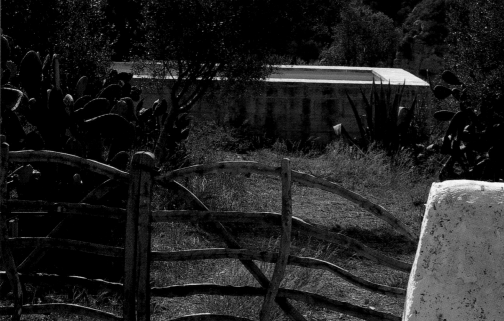

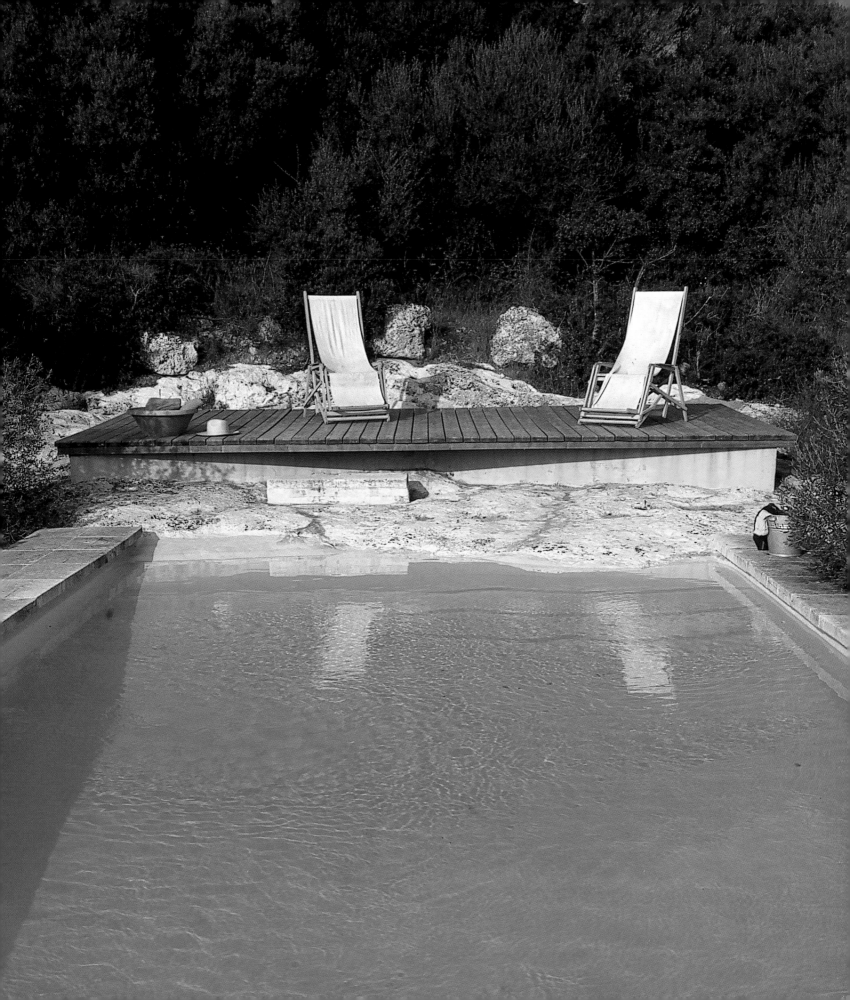

Directory

Gratefully

The authors would like to give special thanks to the homeowners for opening their doors, to the professionals for their creativity, and to the following people and groups for their help and collaboration during the development of this book.

Antonia de Sert

Carole Katleman

Castell-Planells family

Cristina Montes

Eva & Tomás Millet

Feducchi family

Garry Rust

Gloria & Peter Tescher

Hotel Le Corbusier, Marseille, France

James Goldstein

Joan Lluís Arruga & Judith López Martín

Johnson-Jones family

Kamila Regent & Pierre Jacaud

La Pauline, Demeure d'hôtes. Aix-en-Provence, France

La Quinta des Bambus, Maison d'hôtes. Aix-en-Provence, France

Laure Jakobiak

Lucca "antiguedades", Barcelona, Spain

Marc Ingla i Mas & Claudia Vives-Fierro i Planas

Mauricio Oberfeld (Dugally Oberfeld, LLC)

Michael Colpitts & Sumati

Mickey Low

Susan Tomasko

Toni Mari Torres, architect

Tracy O'Rourke

World Locations (Clare Beresford & Ivonne Grisales)